D1270647

The Colors of Rhetoric

Wendy Steiner

The Colors of Rhetoric

Problems in the Relation between
Modern Literature and Painting

The University of Chicago Press
Chicago and London

Wendy Steiner is assistant professor of English at
the University of Pennsylvania. She is the author
of *Exact Resemblance to Exact Resemblance* and
the editor of *The Sign in Music and Literature* and
Image and Code.

The University of Chicago Press, Chicago 60637
The University of Chicago Press, Ltd., London

Library of Congress Cataloging in Publication Data

Steiner, Wendy, 1949–
 The colors of rhetoric.

 Bibliography: p.
 Includes index.
 1. Art and literature. I. Title.
PN53.S74 801′.93 81-19753
ISBN 0-226-77227-6 AACR2

The poem "The Hunters in the Snow," *Pictures
from Brueghel* ©1962 by William Carlos Williams
is reprinted by permission from New Directions
Publishing Corporation.

The poem "these children singing in stone a"
(Copyright 1939 by E. E. Cummings; renewed
1967 by Marion Morehouse Cummings) is
reprinted from *Complete Poems 1913–1962* by
E. E. Cummings, by permission of Harcourt Brace
Jovanovich, Inc., and Granada Publishing, Ltd.

To Peter and Emil

Contents

Illustrations

Colours ne knowe I none, withouten drede,
But swiche colours as growen in the mede,
Or elles swiche as men dye or peynte.
Colours of rethoryk been to me queynte;
My spirit feeleth nought of swich mateere.

Geoffrey Chaucer

Preface

Some years ago I gave a talk at Harvard comparing Gertrude Stein's writing to cubist painting. It was a chapter of a book of mine then in press, and I was pleased to be able to explain in what I considered a tough, precise fashion what others had dealt with more impressionistically. But when a member of the audience asked why I should want to set up such a comparison in the first place, I had nothing to reply. Apparently the interart analogy did not speak for itself.

That speechlessness was the impetus for this book. The search for an appropriate answer has led me into unexpected paths, from the history of aesthetics, to the problem of sense-making in the arts and science, to the concept of the aesthetic concept itself, a journey recorded in the three parts of this argument. But lest this discussion seem at the outset both overly ambitious and idiosyncratic, I would point to the source of my title in Chaucer's "Franklin's Tale." Chaucer's use of "the colours of rethoryk"[1] there implicates the interartistic comparison in the very problems that I have been led to examine.

"The colors of rhetoric" is a figure of speech that itself signifies "figures of speech." Chaucer's Franklin, in the epigraph above, uses this verbal embellishment to insist on the plainness of his own words, contrasting the "legitimate" colors of nature and paint to those of language. The tale that he tells through this paradoxical plainness argues for both the virtue of conforming words to reality and the generosity of excusing people from this burden. It also implies that if rhetorical figures could only be like paint, there would be no problem in speaking truth in art, for nature's and man's painting faithfully reflect their meaning and their creator. Words, in contrast, carry no mark of either their objects or their origins, and their ambiguity opens verbal art to shifting interpretations. Through a series of paradoxes and equivocations (examined in the appendix), the plain Franklin shows the importance of the painting-literature comparison to the issue of artistic truth-telling.

As I see it, this importance lies in the fact that painting has until very recently been taken as mimetic, a mirror of the world. When theorists and artists compared the two arts, like the Franklin they were almost inevitably trying through analogical sleight-of-hand to attribute the reality claim of painting to literature. At the same time, the obvious differences between the two arts and between each and reality kept intruding, so that the history of the interartistic comparison swings back and forth like a pendulum between

eager acceptance and stern denial. In recent history, for example, Lessing's influential differentiation of the spatial from the temporal arts and the romantics' concern with art's expressive rather than mimetic capacity made the painting-literature analogy decidedly marginal in nineteenth-century criticism. But with the advent of modernism, a complete reversal took place and the analogy has become of supreme importance once again. The programmatic tension between artistic medium and represented world so crucial to Cézanne, cubism, abstractionism, and surrealism has changed the meaning of the analogy. By claiming that a poem is like a modern painting one is no longer stressing their mirroring function but their paradoxical status as signs of reality and as things in their own right. This 'semiotic concreteness' (the "res poetica" of the concluding chapter) constitutes a line of critical and artistic thinking that runs throughout the twentieth century. As Rudolf Arnheim has put it, "It is the double existence of words as a species of pure shapes and as a non-sensory carrier of sense that has made language the most telling symbol of modern civilized life. This symbolic role of language is displayed in the images and verbal weaves of concrete poetry."[2] Despite the importance of this balance, however, the boldness and novelty of the concreteness claim often made its proponents forget that it was only half of the dialectic, the mediated semiotic nature of art being ineradicable.

Thus, chapter 1 of this book follows the history of the painting-literature analogy with special emphasis on the modern period. Chapter 2 discusses post-Renaissance notions of artistic reference, particularly the contrast between scientific prose and nonsense. In this section I try to show that the ideal of scientific prose would in fact produce nonsense, that nonsense often explicitly demonstrates this fact, and that some modernist poets, in using the analogy with painting to stress only one side of the semiotic-concrete dialectic, were, like the scientists, threatening at least in theory to produce nonsense. This is not to say that modern poetry is not art or even that it is not good art, for I, at least, value the resulting poetry (including concrete poetry) very highly. It is just that the ideology underlying it is flawed. It fails to acknowledge the factors almost always present in such art that balance or compensate for the extreme concreteness that it manifests. Like the Franklin, for whom one's word is kept most adequately when one is released from it, there is an essential balancing of contradictory forces, a dialectic—or more cogently, a dialogue—that is always maintained if sense-making is to occur

and be understandable. Chapter 2 explains this idea, showing the peculiar importance of both literary and pictorial nonsense in dramatizing it and the special place of the illustrated text in exemplifying it.

Finally, chapter 3 demonstrates the homology between cubist painting, modern writing, and recent concepts of history and periodization. I try to show, in fact, that the modern concept of the concept itself might be termed "cubist" along with the main line of literary experimentation in this century, all of these being dependent on an interartistic program. The most literal rendering of this program is concrete poetry, which I discuss in the final chapter. This movement epitomizes the stress on the materiality of art downplayed in the period when the painting-literature analogy was out of favor. It is a striking example of both modernist artistic theory and its failure at times to acknowledge that *both* sides of the dialectic must be kept in play in order for effective art to result. As such, it represents the heroic striving for an inevitably doomed single-mindedness and coherence in art, indeed in all forms of communication, that has characterized recent aesthetics. By insisting on this materiality, concretism, like manifestations of the painting-literature analogy throughout time, seeks a repleteness of meaning that is never fully available in art, but only in life. No theory can explain art by adverting only to its materiality, and no art can *be* art by virtue only of its materiality. And yet, little valuable theory *or* art in the past century has resulted from the passive acceptance of these facts.

Thus, as the appendix reveals more fully, I have found Chaucer's Franklin a prophetic figure. By following in his lead I have tried to turn the painting-literature comparison from a matter of fashion to a matter of philosophy (though I am not sure that the boundaries between these two spheres are as firm as we often pretend). I have aimed at providing a theoretical context for the exciting interartistic studies now in progress, and an answer to the indifference that so often greets them. For my Harvard interlocutor was not alone in his skepticism. Other critics have written that "in order to make such comparisons, fixed likenesses must be assumed in such elusive and problematic phenomena as form, structure, and harmony. Surely the game is not worth the candle."[3] Considering that the "game" has been played throughout intellectual history, it would seem time to discover why it *is* worth the candle. If not, those concerned with the two arts become caught in a hopeless quest to assert similarity in the face of common sense, or to deny it

in spite of their intuitions to the contrary. Under such circumstances, the choice between the two finally has no more justification than personal crochet: "There are those of us who are mostly attracted by what distinguishes one thing from the next, while others stress the unity in the diversity. . . . If they are willing to listen to each other, we need them both."[4] But why we need them both remains as mysterious as ever, and it is discouraging to think that the issue is merely one of temperament.

Rather, the answer to the why of the interartistic comparison lies in the configuration of factors found in "The Franklin's Tale," the connections that it establishes among reference, figuration, sign type, and semiotic slippage. This book, I hope, will show the crucial position played by the painting-literature comparison in our attempt at understanding aesthetic—and even critical—meaning.

I am grateful to many people for guidance and support in this project: Barbara Herrnstein Smith, Robert Lucid, Charles Altieri, Reinhold Heller, Michael Holquist, and many others. The University of Michigan provided the summer fellowship that got this study started, the Josephine Keele Memorial Fellowship made possible the leave-time necessary for the real writing to begin, the National Endowment for the Humanities awarded a summer stipend to allow me to finish the job, the English Department at the University of Pennsylvania gave its secretarial aid to the preparation of the manuscript, and a grant-in-aid from that university covered the costs of reproducing the illustrations. Most of all, however, I wish to thank Peter Steiner for the wonderful Asturian conversations, one of whose fruits this book is.

Philadelphia
1980

One

Thoughts That
Fit Like Air

We have not yet made shoes that fit like water
Nor clothes that fit like water
Nor thoughts that fit like air.
There is much to be done—

Arthur Dove

The Painting-Literature Analogy

Poetry is an arte of imitation, for so Aristotle termeth it in the word *Mimesis,* that is to say, a representing, counterfeiting, or figuring foorth — to speak metaphorically, a speaking picture.

Sir Philip Sidney

In his introduction to *The Mirror and the Lamp,* M. H. Abrams confidently states that "critical thinking, like that in all areas of human interest, has been in considerable part thinking in parallels, and critical argument has to that extent been an argument from analogy."[1] The ease with which a literary critic can make such a claim is a sign of the distance the humanities have traveled from positivism, for the average scientist or philosopher would not so calmly acknowledge the analogical or metaphoric nature of his knowledge. As Max Black puts it, "To draw attention to a philosopher's metaphors is to belittle him—like praising a logician for his beautiful handwriting. Addiction to metaphor is held to be illicit, on the principle that whereof one can speak only metaphorically, thereof one ought not to speak at all."[2]

Few concepts have undergone as much philosophical debunking in recent years as the notion of similarity or resemblance, which Black himself eventually declares vague upon close logical scrutiny.[3] And yet, probably no mechanisms are as essential to the progress of philosophy, science, and literary criticism as metaphors, analogies, and models. As Charles S. Peirce pointed out, these iconic tools of thought are unique in their capacity to reveal "unexpected truth":

a great distinguishing property of the icon is that by the direct observation of it other truths concerning its object can be discovered than those which suffice to determine its construction. Thus, by means of two photographs a map can be drawn, etc. Given a conventional or other general sign of an object, to deduce any other truth than that which it explicitly signifies, it is necessary, in all cases, to replace that sign by an icon.[4]

This richness in iconic signs—metaphors, analogies, models, diagrams, pictures, and so forth—allows a system to be explored in depth or a notion to be followed in all its relations and implications, even if these tend to undermine the original thrust of the iconic formulation. It is this potential for both growth and decay that makes iconic thinking the dynamic process that it is.

This dynamism is particularly evident in the metaphor that concerns this book, the likeness between painting and literature. For this is a privileged case: it is a metaphor about resemblance itself and, even more significantly, about the resemblance between reality and the systems man has developed to represent it. Literature is so often compared to painting, I believe, because

painting has stood as the paradigmatic "mirror of reality"; the "sister arts" analogy thus permits literature as well to be considered an icon of reality rather than a mere conventional means of referring to it. The need to discover the mimetic potential in literature has been the underlying motivation for the long history of critical comparisons of the two arts. When the motivation disappears, as it did largely during the romantic period, so does the comparison. It is the resurfacing of this motivation in the modern period that has made the relation between the two arts of such consuming interest to twentieth-century critics and artists alike.

The fact that the analogy of painting to literature has a history at all is a function of the nature of analogies. Any similarity, as the theoreticians stress,[5] depends upon concurrent dissimilarities. As long as the similarity is sufficiently striking, the differences can be pushed aside. But when the analogy is explored to the point where the dissimilarities become troublesome, the current formulation of the comparison is usually discredited as a mere "metaphoric similarity" which the progress of thought has revealed as such. At that point a new metaphor takes over—but a metaphor nonetheless. W. H. Leatherdale quotes a fellow logician, C. M. Turbayne, on this matter:

"the attempt to re-allocate the facts by restoring them to where they 'actually belong' is vain. It is like trying to observe the rule 'Let us get rid of the metaphors and replace them by the literal truth'. But can this be done? . . . we can never know exactly what the facts are. . . . We cannot but allocate, sort, or bundle the facts in some way or other." This is an admission that science is irreducibly metaphorical. Accordingly, Turbayne concludes that the only way to remedy the situation is by substituting another more effective and satisfactory metaphor, but always with the awareness that we are using a metaphor. [Leatherdale, p. 138]

The painting–literature analogy has followed just such a Sisyphean pattern and is bound to continue doing so. For there can be no final consensus about whether and how the two arts resemble each other, but only a growth in our awareness of the process of comparing them, of metaphoric generation and regeneration. It is this process that I hope to uncover in the historical discussion that follows.

Before beginning it, however, I would like to provide through an example a more precise account of the way the painting–literature metaphor

grows and decays. In the latter part of the past century, critics began to base their interartistic parallels on historical criteria, the presence of a *Zeitgeist* illuminating all the arts, or of a *Formwille* expressing itself throughout the aesthetic phenomena of an era. Though the mystical elements of this approach have more or less vanished by now, such comparisons are still very common among aestheticians. One such comparison, this time of architecture and literature, proceeds as follows:

Normative classicism . . . went through similar phases in the two arts. In both we can distinguish a phase of single correctness, during which forms (orders, styles) were recovered, defined, purified: in both, a subsequent mannerist phase during which treatment of rules became more subtle and complex: and in both the possibility of a pedantic adherence to Renaissance classical orthodoxy. . . . Michelangelo's questionably Doric pilasters in the aedicules of the Medici chapel at S. Lorenzo and de l'Orme's gorgeous "French" Ionic at the Tuileries—both incorrect uses of ornament setting aside the usual grammar of the orders—are legitimately comparable with Sidney's derangement of style heights in "Astrophel and Stella."[6]

In other words, Michelangelo or de l'Orme is to the classical architectural orders what Sidney is to the classical style heights of literature. It is important to note that the term "classical" here means "normative," but with respect to different norms; no attempt is being made to equate the literary with the architectural norm. This kind of analogy thus involves four terms: Michelangelo, his norms, Sidney, and his different norms. It is the identical relation between each artist and the norms of his art that creates the analogy.

However, the initiators of interartistic periodization, Oskar Walzel and Heinrich Wölfflin, intended such analogies as three- rather than four-termed. Wölfflin proposed a distinction between Renaissance and baroque graphic art on the basis of their respective "linear" and "pictorial" qualities. René Wellek explains these terms:

"Linear" suggests that the outlines of figures or objects are drawn clearly, while "pictorial" means that light and color blur the outlines of objects and are the principles of composition. Renaissance painting uses a "closed" form, a symmetrical, balanced grouping of figures or surfaces while baroque prefers an "open" form: an unsymmetrical composition which

puts emphasis on a corner of a picture rather than on its center or points beyond the frame of the picture.[7]

Walzel then took up the terms "closed" and "open" and found them, respectively, in Corneille and Racine and in Shakespeare. The latter's numerous minor characters "unsymmetrically" grouped and his dispersal of emphasis throughout his plays make him baroque, while Corneille and Racine are Renaissance types because of their focusing on a small number of central characters and their driving of the action toward a single climax. In other words, Rubens is to the baroque as Shakespeare is to it, i.e., to "openness," asymmetry, and so on. The number of terms in the ratio has been reduced to three, and the similarity between painter and poet is felt to be correspondingly increased. For in the four-term comparison, though Sidney bears a similar relation to his norms to that of Michelangelo to his own very different norms, we are not thereby convinced that Sidney's and Michelangelo's works are especially similar. The Wölfflin-Walzel type of comparison makes us feel that the baroque paintings and texts in question have common features, innate similarities.

But the trouble with the three-term approach, of course, is that the crucial mean term threatens to dissolve upon close inspection into a homonym rather than an identity. Accordingly, Walzel is responsible for forty years of compulsive attempts on the part of critics to define the baroque, to convince each other that "openness" and such terms had a single meaning when applied to different arts.[8] The typical objection to this move can be seen in Rosamund Tuve's contention that Wölfflin's original depiction of baroque painting has had to be "translated before [it] can be applied to form as literature shows it" (see Fowler, p. 499). "Open" and "closed," "symmetrical" and "asymmetrical" mean different things when referring to paintings and literary texts. Alistair Fowler's rejoinder to Tuve, that "every interart comparison, even between two visual arts, involves a metaphor ('translation'); this is far from invalidating it, however, so long as the metaphor is sound" (Fowler, p. 499) is not reassuring. What is the difference between a sound and an unsound metaphor? And if interartistic comparison is merely a matter of spinning out metaphoric similarities, are we not thereby proving that the arts are irrevocably separate, to be accommodated only by metaphoric, 'poetic' means?

In other words, the point of coincidence in the comparison has here been revealed as homonymic, and the comparison consequently appears invalid. This is the typical pattern of developments in the history of the analogy between the two arts. We are caught between the Scylla of the unconvincing four-term relation and the Charybdis of the unstable three-term one. The history of the painting-literature comparison is thus a consequence of discoveries of three-term relations in which the mean splits into two discrete entities, or of four-term relations which fail to merge the arts because they appear merely supersubtle.

With this structure in mind, the many vicissitudes of the interartistic comparison will perhaps be more understandable. We might begin with the earlier of its two *loci classici,* the statement attributed by Plutarch to Simonides of Ceos to the effect that painting is "mute poetry" and poetry a "speaking picture." Though it has been repeated in thousands of aesthetic tracts and articles, the phrase itself has seldom been examined. Why should one want to think of a picture, on the one hand, as speaking, or of a poem, on the other, as being mute? The answer, in part at least, lies in the personification of the two arts of Simonides' phrase, for the desire for a speaking picture is the desire to destroy the barrier between art, which is limited in its mode of signification, and human beings, whose speech and physical presence combine semiosis appealing to all the senses. A speaking picture would be almost a person. And here we are back at the Franklin's moral that the signs people use should directly betoken them (and reality). A speaking picture would have all the 'reality' of its maker and at the same time signify him, or reality in general. It would be what Peirce calls an icon, or what Derrida would call a sign with "voice" or "presence."[9] The attempt to overreach the boundaries between one art and another is thus an attempt to dispel (or at least mask) the boundary between art and life, between sign and thing, between writing and dialogue. The apocryphal stories that support the speaking-picture figure—Zeuxis' painted grapes so real that birds try to eat them, or the entire topos of statues so real that they come to life—are symptomatic of this boundary-breaking between art and life, as is the realistic power of the modern "speaking picture," the cinema. The artist is presented as the rival of God, creating life without the qualification of the 'as if.' And now when the warning implicit in such stories as the Franklin's is no longer to be found, the artist may pursue his goal with no greater punishment in sight than failure.

During the Renaissance and following, the interartistic parallel and the issue of verisimilitude were inevitably connected. Sidney, for example, states in his "Apology of Poetry" that poetry "is an arte of imitation, for so Aristotle termeth it in the word *Mimesis,* that is to say, a representing, counterfeiting, or figuring foorth—to speak metaphorically, a speaking picture." And Dryden points out "that poetry, like painting, has an end, which is to please; that imitation of nature is the general means for attaining this end" (Abrams, p. 17). By Dryden's time, in fact, the connection between the interartistic comparison and the imitation of nature was consciously made, but it is implicit as well in Simonides' phrase, in the topos of the artwork that comes to life, and in aesthetic manifestos of all ages.

However, next to the "speaking picture," the mute poem seems a blighted thing; painting is poetry minus voice. The asymmetry behind Simonides' rhetoric suggests that a poem has everything to gain in the pictorial analogy—all of its own symbolic properties and the palpability of a visible medium as well: it becomes speech emanating from a body. But what has painting to gain? It acquires not a voice, but some ineffable property termed "poetic." Simonides' formulation reveals the commonest thrust of the interartistic comparison—that poetry needs to be supplemented with physical presence to be fully aesthetic, while painting has presence and is also poetic (i.e., aesthetic), without using language.

Such an interpretation, of course, is dependent upon our taking Simonides' metaphors as proposals or directives, not as descriptions. But if one believes that poetry *is* painting with a voice while painting is mere "mute poetry," then the hierarchy implied in the comparison is reversed. Thus, Leonardo felt the need to defend painting by correcting Simonides' faulty parallelism: "If you call painting mute poetry, poetry can also be called blind painting. Now think, which is the more damaging affliction, that of the blind man or that of the mute? . . . If the poet serves the senses by way of the ear, the painter does so by way of the eye, a worthier sense."[10] Leonardo here acknowledges the limits of each of the arts (a way of knowing for the blind, for the dumb) rather than asserting a heroic leaping over barriers. But he goes on to claim that painting need not use words, for it already speaks the language of things, a language known to all people and one more immediate than any words could be.

In this controversy over Simonides' figure lie the major topics in the interartistic comparison. First, is poetry in any way pictorial, or is it in fact a science for the blind? Is painting superior because it speaks a universal language, and if so, what can be done to universalize the language of literature? Or is literature superior because it actually speaks, while painting is limited to a nonassertive copying of the mere face of things? These issues beg the question of what mimesis is and the concomitant problems of the arbitrariness versus naturalness of aesthetic signs and the ontic mode of their subject matter.

We might begin with the issue of mimesis, which dominates the modern approach to the interartistic comparison as much as the ancient. The Prague School aesthetician Jan Mukařovský, for example, claims that the "capacity of expressing the phenomena of external reality through signs connected in a continuous contexture" joins the two arts "under any developmental situation."[11] Neither music nor architecture is dominated by signs capable of such reference, nor does sculpture achieve such a "continuous contexture." Though the expression of external reality in literature or painting may be only virtual, it is essential nonetheless. Indeed, its deep roots in our thinking about the interartistic connection are evident in the prevailing metaphor of the relation, the mirror, whose image is the result of an existential contiguity between referent and vehicle. One of the devices of Gothic literature, the shock created when a vampire is not reflected in a mirror, for example, lies in the fact that he stands *there before us*. The mirror's ability to reveal the existent in this case outweighs the evidence of our own eyes. And though there is just as significant a tradition of the mirror's distorting reality,[12] art as mirror claims to reveal what is 'truly' there.

The centrality of the reality claim can be seen as well in the second *locus classicus* of the painting-poetry correspondence, Horace's phrase, *ut pictura poesis* (as is painting, so is poetry). The parallel occurs twice in the "Ars Poetica," first when Horace argues that the arts are alike in containing some parts which can be scrutinized carefully and others which will not please unless viewed from a distance. In other words, as far as the exact correspondence to the extra-artistic world is concerned, both arts have their limitations. Second, Horace cautions both poets and painters against taxing the viewer's patience by self-indulgently portraying the impossible. Poets and

painters should not use figures of speech or pictorial designs that through their sign-faculty seem to posit the existence of beings not empirically existent:

Suppose a painter chose to place a human head
upon a horse's neck, to lay feathers of all colors
on organs gathered from all over, to make his figure
a black, disgusting fish below, on top a lovely girl.
Given a private view, my friends, how couldn't you laugh?
Believe me, Pisos, this painting and a kind of poem
are very similar, one like an image in a sick man's dream,
a fever image whose head and foot can't possibly belong
upon the same physique.[13]

The assumption that the artist's depictions must correspond to unities located in the world rather than impossible collocations of real elements is a tenet of Horace's realism. The artist must be sensitive to the relation between his subject matter and what actually exists.

Even now when such decorum has lost its prescriptive force, the issue of the correspondence to reality remains crucial. The whole force of surrealist art (which Horace's words describe extraordinarily well) lies precisely in its violation not only of an aesthetic convention about representation but of empirical reality itself. Though modern theorists such as Nelson Goodman are right to argue that the fact of picturing does not prove the existence of the pictured object,[14] the fact that the object does, could, does not, or could not exist is crucial to the reception of the work of art and to the discovery of the properties of the different arts. Just as Roman Jakobson claims that poetry can be grammatical, ungrammatical, antigrammatical, but never agrammatical,[15] art can be documentary, realistic, surreal, abstract, and the like, but never unrelated to empirical reality.

The gist of Horace's comparison of painting to literature then is as follows: poetry is like painting because both have as their subjects existent reality and both are limited in their mimetic adequacy to that reality. But notice that this content-oriented approach looks rather weak when expressed like the other relations that we have seen: poetry represents existent reality, just as painting represents it. The "represents" here is clearly a homonym, as it remained even in the attempts to translate it into "imitates." Aristotle, the

arch-mimeticist, was generally content to leave it homonymic. For though he urged the unity of the arts as imitations of human actions, he stressed much more the unity of their subject matter than their imitative mode. As Jean Hagstrum writes, "After the argument of the poetics has moved from the means of imitation to the *objects* of imitation, the analogy with painting is more frequently made." [16]

This splitting of form and content is the source of one major stream of argumentation in the *ut pictura poesis* controversy, "the inexplicit and symbolic power of image-working—the subterranean area of the unified roots of all the arts." [17] According to it, the common feature of the arts is that they evoke images (by whatever means), thus appealing to the senses, especially sight. Insofar as literature employs visual imagery it is a "speaking picture," and since painting's images stand before us plainly to be seen, it is a patently imagistic art.

Images create two different kinds of bonds between the arts. The first is the subject of the iconographic school in art criticism, epitomized in the work of Erwin Panofsky. Iconographic art involves a transferring from one art to another of symbols and stories. In iconographic painting, the meaning of the canvas is dependent upon our knowledge of a mythological, biblical, or literary text upon which the details of the painting are based. For example, a painting of a young winged boy with a bow must be understood as Cupid if the painting is to work allegorically, and it can do so only because the winged god is a topos in mythical-literary texts. Or alternately, the details of a poetic description may be taken from a tradition of pictorial representation. Both these possibilities characterized a significant portion of Renaissance art. It was the combination of visual detail and abstract concept in the symbol that facilitated interartistic sharing. Painting could provide a specific, paradigmatic appearance for a concept, while literature could establish the relation between a concept and its sensuous manifestation. Symbolic or allegorical art thus seemed a natural point of convergence and cooperation between painting and literature.

The other interartistic connection created by the form-content split is the more general claim of a shared visual appeal in the two arts. This was the central argument during the baroque and neoclassical periods, formally termed the *ut pictura poesis* argument. According to it, the function of art was to evoke images, and painting and literature approximated each other insofar

as they did so. Several reasons are given for stressing the visual, such as Platonic notions of the superiority of seeing as knowing and light as knowledge. Abrams points out (p. 57), moreover, the connection between the prevailing theories of perception in this period and the mirror metaphor: "the mind in Locke's *Essay* is said to resemble a mirror which fixes the objects it reflects. Or (suggesting the *ut pictura poesis* of the aesthetics of that period) it is a *tabula rasa* on which sensations write or paint themselves." But, as I stressed earlier, the visual also contributes to the claim of presence in the literary work, helping it to approximate the being quality of things. It was not just that "the appeal to painting corroborated the concept that poetry is a reflection of objects and events" (Abrams, p. 34), but that poetry would thereby have the vividness of existing things. "Critics for two centuries believed that it was in pictorial vividness of representation, or, more accurately, of description—in the power to paint clear images of the external world in the mind's eye as a painter would record them on canvas—that the poet chiefly resembled the painter."[18]

The rhetorical term for this vividness of presentation is *enargeia,* a crucial concept for distinguishing the baroque and neoclassical notion of presence in art from that of the moderns. Professor Hagstrum helpfully differentiates *enargeia* from its opposite, *energeia:*

Enargeia implies the achievement in verbal discourse of a natural quality or of a pictorial quality that is highly natural. *Energeia* refers to the actualization of potency, the realization of capacity or capability, the achievement in art and rhetoric of the dynamic and purposive life of nature. Poetry possesses [Aristotelian] *energeia* when it has achieved its final form and produces its proper pleasure, when it has achieved its own independent being quite apart from its analogies with nature or another art, and when it operates as an autonomous form with an effectual working power of its own. But Plutarch, Horace, and the later Hellenistic and Roman critics found poetry effective when it achieved verisimilitude—when it resembled nature or a pictorial representation of nature. For Plutarchian *enargeia,* the analogy with painting is important; for Aristotelian *energeia,* it is not. [Hagstrum, p. 12]

What we shall discover in the course of this book is that the moderns exchanged the notion of *enargeia* for *energeia* in determining how art could be

like reality. The more the work was a self-contained entity rather than a sign, the more it could resemble the other entities of the object world. And paintings and literary works were similar then insofar as they achieved this object status.[19] For modern literature, the analogy with painting *is* crucial to *energeia*.

But this is to jump ahead of myself. The trouble that arose for the baroque and neoclassical critics was that vividness is, if you will forgive me, in the eye of the beholder. On the one hand, we find those, like John Hughes, who claim that "the reason why descriptions make livelier impressions on common readers than any other parts of a poem is because they are formed of ideas drawn from the senses . . . ; but the beauty of proper sentiments . . . is more remote, and discerned by a kind of second thought or reflection."[20] On the other hand, we find Johann Jacob Breitinger claiming that the advantage of poetry over painting is "that it consists of words, which are 'artificial signs of concepts and images,' and which, therefore affect the mind directly and not by way of the senses" (quoted in Schweizer, p. 25). Images are more direct because they are drawn from the senses; ideas are more direct because, unlike sense objects, they contain what is already in the mind. What do the words "direct" and "the senses" mean under such circumstances? We are once more in the presence of homonyms, exposed as such. Moreover, some, like Locke and Burke, argued that words could in no way evoke images and, more radically, that words and things were irrevocably split. Such observations were to lead to a much more technical awareness of sign-functioning.

It is important to note, however, that the analogy in the last paragraph succumbed because of the inclusion of the notion of presence through *enargeia*. That is, instead of accepting the four-term relation: painting is iconically connected with reality, and literature is in some (different) way connected with reality, the *enargeia* approach makes a stronger similarity claim: painting is as vividly visual a representation of physical reality as literature is. The failure of "vividness" to remain nonhomonymic is another defeat of the merging of sign and thing so crucial to the poetry-painting parallel.[21]

If there was some doubt cast on the idea that verbal imagery exists, and if it does, whether it lends any quality of visuality or *enargeia* to the poem, a similar problem arose in the humanist attempt to see painting as mute poetry. For as long as the point of comparison in both cases was content, the

question of what constituted innately poetic subject matter had to be faced. The traditional answer was gleaned from Aristotle's maxim that the arts should imitate noble human actions. And the idea was susceptible to the same interpretation along the lines of *enargeia* as the imagistic or pictorial approach to writing. Just as a poem gains the immediacy of an actual object by making us think of physical objects, painting gains the lifelike property of motion by making us see bodies in action. In both cases the arts approach each other by appropriating a crucial feature from the other that it lacks—visuality in poetry, motion in painting.

So important was the moving subject during the *ut pictura poesis* period that the practitioners of the various painting genres were valued according to the dynamism of their subject matter. "The lowest type is the painter of still-life, and thence one proceeds through painters of landscape, of animals (a better subject than landscape, because animals are living and moving, not dead!) and of portraits to the *grand peintre*. He, imitating God whose most perfect work is also man, paints groups of human figures and chooses subjects from history and fable" (Lee, pp. 18–19).

But it is one thing to use living subject matter and quite another to capture motion in painting. The discrepancy between the properties of the pictorial medium and those of its most valued subjects provoked the first clear-cut technical objection to the painting-poetry comparison, Lessing's *Laokoön*. Whereas the baroque and neoclassical periods had allowed the "is to" in "painting is to action as poetry is to action" to remain vague, homonymic, Lessing stressed its polysemy. He focused on the mode of representation of reality and not the aspect of reality represented. Though it is probably an exaggeration to claim, as Joseph Frank does, that Lessing discovered "the relation between the sensuous nature of the art medium and the conditions of human perception,"[22] since in the *Laokoön* neither medium nor perception receives a very searching treatment, it certainly is true that the terms of the argument were now different. The relation of the arts was not to be determined by their subject matter, but their subject matter by the relation of the arts, the latter identified with their media.

With an implicit assumption that the arts should employ *enargeia*, lifelikeness, Lessing argues that the only subjects the arts should adopt are those whose properties are already among the properties of their media:

I reason thus: if it is true that painting and poetry in their imitations make use of entirely different means or symbols—the first, namely of form and colour in space, the second of articulated sounds in time—if these symbols indisputably require a suitable relation to the thing symbolized, then it is clear that symbols arranged in juxtaposition can only express subjects of which the wholes or parts exist in juxtaposition [i.e., bodies]; while consecutive symbols can only express subjects of which the wholes or parts are themselves consecutive [i.e., actions].[23]

Thus, painting is *not* like poetry in that it does *not* represent the same reality. But at the same time, painting is to bodies as poetry is to actions. The "is to" here is much less obviously homonymic than previously—indeed Lessing would claim that it was an identity—but we are back with a four-term ratio. Hence, though the arts are similar in being imitations, they do not imitate the same things. This is a relational rather than a substantive similarity, and Lessing is accordingly known for his distinguishing rather than connecting the two arts.

The distinction between the arts that he makes, however, is utterly dependent upon the premise of mimesis, and in fact on the more precise notion of iconicity, as a common feature of the arts. If it were not important for painting and literature to imitate reality, i.e., to be like it, to contain some of its properties, then it would not matter whether bodies or actions were taken as subjects. And why must "these symbols indisputably require a *suitable* relation to the thing symbolized" if not to insure presence in the work of art? Thus, underlying Lessing's definitive disjunction of the arts is a hidden analogy: painting is as lifelike as poetry is; both are iconic of reality.

The compelling force of Lessing's argument, I believe, lies in the acceptability to his time of this hidden analogy. This is part of the motivation, I think, for Goethe's much quoted statement that the *Laokoön* "transported us from the region of slavish observation into the free fields of speculative thought. The long misunderstood *ut pictura poesis* was at once set aside. The difference between picture and poetry made clear—the peaks of both appeared separate, however near might be their bases."[24] Though Wimsatt sees this common base as imagery, the true shared ground of the arts in Lessing's reasoning is their assumed iconicity, the mimetic argument. In this respect,

as Abrams points out (p. 13), Lessing ironically shared the assumptions of the arch-exemplars of the *ut pictura poesis* ideology: "like Batteux, Lessing concludes that poetry, no less than painting, is imitation. The diversity between these arts follows from their difference in medium, which imposes necessary differences in the objects each is competent to imitate. But although [painting is static and literature is dynamic]...Lessing reiterates for [poetry] the standard formula: 'Nachahmung' is still for the poet the attribute 'which constitutes the essence of his art.'"

Lessing's objections to the neoclassical *ut pictura poesis* argument contributed to the general shift in aesthetic thinking that marks the romantic period. By this time, art was no longer prized as an imitation of reality, but as an expression of the human spirit. Fully elaborated in *The Mirror and the Lamp,* this development caused a corresponding deemphasis of the painting-literature parallel. "The use of painting to illuminate the essential character of poetry—*ut pictura poesis*—so widespread in the eighteenth century, almost disappears in the major criticism of the romantic period; the comparisons between poetry and painting that survive are casual, or, as in the instance of the mirror, show the canvas reversed in order to image the inner substance of the poet. In place of painting, music becomes the art frequently pointed to as having a profound affinity with poetry. For if a picture seems the nearest thing to a mirror-image of the external world, music, of all the arts, is the most remote" (Abrams, p. 50).

As a result, Simonides' formula had to be reinterpreted. "Friedrich Schlegel was of the opinion that when Simonides, in a famous phrase, characterized poetry as a speaking picture, it was only because contemporary poetry was always accompanied by music that it appeared superfluous to him to remind us 'that poetry was also a spiritual music'" (Abrams, p. 51). If Schlegel truly understood the connection between painting and literature as parallel to the one he posits here between literature and music, then he saw it as a relation of accompaniment rather than similarity. And in fact, simultaneity was the prevalent notion of the interartistic connection in the last century. Wimsatt describes it as "the mélage or harmonious union of more or less analogous arts in various assembled arts *(Gesamtkunstwerke)*—as song, drama, opera."[25] It manifested itself as well in the renewed interest in illustrated books (a symptom also of the nineteenth-century nostalgia for the middle ages).

Wimsatt warns against confusing the coexistence of two artistic media in one composite art with the actual analogy of the two arts in question, but it seems to me that this notion of mélage or assemblage is not as mechanical as he would have it. By combining the visual and the verbal (or musical), the resultant art work was achieving the vividness and completeness of the spiritual states it was meant to express. It is no accident that Alice's boredom with "a book without pictures or conversations" propels her into the interior landscape of Wonderland! (See chap. 2.)

Not only did the painting–literature analogy lose its authority during the romantic period, but when a theory of this relation did arise, it explicitly disregarded the connection of the arts to empirical reality. I am speaking of the periodization of the arts arising from romantic philosophy, which Walzel and Wölfflin were instrumental in initiating. If the romantic analogy with music served the notion of art as an expression of the individual spirit, periodization may be seen as an expressionism of the national spirit or the age. We have already seen the fate of one such period concept, the "baroque," with its "merely metaphoric" application across the arts. But even allowing a four-term analogy here, René Wellek, among other careful historians, has criticized the temporal assumptions behind the comparison. The periods occurred at different times in each art, and in a given society one art may flourish while its sister art remains in the shadows:

The various arts . . . have each their individual evolution, with a different tempo and a different internal structure of elements. No doubt they are in constant relationship with each other, but these relationships are not influences which start from one point and determine the evolution of the other arts; they have to be conceived rather as a complex scheme of dialectical relationships which work both ways, from one art to another and *vice versa,* and may be completely transformed within the art which they have entered. [Wellek, "Parallel," p. 61]

The problem of periodization has remained, despite its conceptual difficulty, one of the major bases for comparing the arts, and is destined to go on doing so (more on this subject in chap. 3). But the period argument can be effective only if scholars examine the host of hidden presuppositions that lie behind it. Take, for example, the following pronouncement by Jean Laude on the comparability of the arts: "Absolutely everything distinguishes

a literary text from a painting or a drawing: its conception, its method of production, its modes of appreciation, its identity as an object irreducible to any other object, and its autonomous functioning."[26] On each of these grounds—conception, production, reception, ontology, and function— critics have, of course, argued for the correspondence of paintings and poems, and yet, on the face of it, the common sense of Laude's view is appealing. It is the same old story: things that require a comparison must in fact be different to start with. But the admirable absolutism of Laude's stance crumbles in the face of periodization: "A text and a painting cannot be dissociated from the synchronous series to which they are linked and within which they are juxtaposed. The poetry of Reverdy is contemporaneous with the painting of Picasso, but it could not be contemporaneous with the paint- ing of Delacroix" (Laude, p. 471). Why it could not we are not told, and our only recourse is to assume that there is something in the conception, produc- tion, reception, ontology, or function of Reverdy's and Picasso's work that neither is found nor could be found in Delacroix's, because of the configura- tion of cultural factors separating the two. In other words, the appeal to period criteria as the link between the arts is an argument inevitably de- pendent upon some other mode of comparison. No matter how convinced we are that interartistic correspondences are time- and hence culture-bound, the correspondence itself must be sought in some factor other than chronological coincidence.

 With the advent of modernism, the painting-literature parallel has once more been connected to the question of aesthetic reference. One sign of this tendency is the modern stress on the impersonality of art. The romantic comparison of literature and music made art an analogue of the artist that it expressed. But modernists such as Eliot, Joyce, or Ortega y Gasset denied this correlation and turned to the painting metaphor for support. Like the seventeenth-century poet Cowley, they could use the visual analogy to argue that in poetry, "the mimetic mirror is turned strictly outward . . . : 'It is not in this [expressive] sense that *Poesie* is said to be a kind of *Painting;* it is not the *Picture* of the *Poet,* but of *things* and *persons* imagined by him. He may be in his own practice and disposition a *Philosopher,* nay a *Stoick,* and yet speak sometimes with the softness of an amorous Sappho'" (Abrams, p. 372).

 By claiming for the artist the role of documentarist rather than diarist, however, the moderns did not intend a return to the mimetic theories of the

eighteenth century. Art was not to be conceived of once again as a copy—
and hence inevitably an imperfect copy—of reality, but instead as an in-
dependent object with the same degree of 'thingness' as objects in the world.
This is the move discussed before in connection with *enargeia* and *energeia,*
and it is vividly presented in the following statement by Apollinaire: "we are
moving towards an entirely new art which will stand, with respect to paint-
ing as envisaged heretofore, as music stands to literature. It will be pure
painting, just as music is pure literature."[27] It is significant that the art
clarified in this analogy is painting rather than literature, since, as we have
seen, the comparison usually works the other way around. Painting,
paradigmatically referential, is here to exist in "pure" form, as literature had
done in its musical purity. Though this sounds like a denial of reference, the
fact that reference itself is again the issue in this painting-literature parallel is
symptomatic of the modernist preoccupation with the art-life relation. The
true means of representing reality was not to *re*present at all, but to create a
portion of reality itself. And the way to do so was to stress the properties of
the aesthetic media in question, since these are palpable, thinglike. This
thinking is the basis of the modernist movement toward concreteness dis-
cussed in the last chapter of this book, and it immediately revived the dor-
mant painting-literature analogy.

 Read against this notion, the following modern characterization of the
interartistic relation takes on new meaning: "What links the individual arts to
one another is the community of their goal. In general the arts are activities
with a prevailing aesthetic consideration; what separates them from one
another is the difference in material" (Mukařovský, p. 208). Much as this
statement resembles a distillation of Lessing, within the framework of ideas
here described it is actually a call for a new exploration of media. For the
Prague School structuralism from which this argument proceeds makes it
impossible to separate medium and aesthetic teleology: it is precisely
through its teleology that a medium is defined (witness the difference be-
tween communicative and poetic language), and, per contra, it is precisely
the medium that circumscribes the goals of each art. In asking at this time
what the relation between painting and literature is, we are in effect testing
the modern notion of "expressive form" or the "functionality of art," just as
previous eras used the interartistic comparison or its disavowal to illustrate
the form-content split or the contrast between human and divine creativity.

The answer to the question posed in the introduction of "why this game is worth the candle" is that the interartistic comparison inevitably reveals the aesthetic norms of the period during which the question is asked. To answer the question is to define or at least describe one's contemporary aesthetics, and this is the value of entering once again the history of analogical insight—and disappointment—that characterizes the painting-literature connection.

The Contribution of Sign Theory

Structuralist aesthetics is a part of the general theory of signs, or *semiotics*. . . . [Its] essence and goal is to elaborate the system and method of the *comparative semiotics of the arts.*

Jan Mukařovský

At the beginning of this century, the *ut pictura poesis* controversy stood as a mere historical curiosity. Irving Babbitt's denial of interartistic similarity in *The New Laokoön* of 1910, for example, received wide critical approbation. But if we turn half a century later to the conference programs of institutions of literary studies (the Modern Language Association or the International Comparative Literature Association, for example), we find the comparison of painting to literature a major topic of concern. A revolution in critical thinking has taken place, a revolution that seems clearly related to the spread of structuralism and semiotics during the last two decades, and the corresponding interest among recent philosophers in linguistic and aesthetic issues.

These disciplines, structuralism and semiotics in particular, have provided the basis for an organized framework for comparing the arts. As Leatherdale (p. 142) points out in connection with any model, "Presumably because it is more systematic, a model is able to provide syntactic rules as well as semantic ones." It is this syntax, if you will, this structured set of interrelations, that has made the comparison of the two arts seem both a possible and a valuable enterprise. It has allowed contemporary theoreticians to discover what they consider 'real' similarities—real because they correspond to structures in other areas of human experience and because they can be discussed in the privileged terms of science. The two arts can now be divided into minimal units which are compared and contrasted according to their syntactic and semantic properties. Rules for combining these units can be discovered, and new four-term analogies between the arts spawned. Structuralism, or more precisely its French and Danish varieties, might be seen in fact as the triumph of the four-term analogy, of relationality over substance as the basis of similarity. And it is modern semiotics and philosophy that have raised the concept of resemblance to the level of critical consciousness.

In his pioneering work in semiotics, Charles Sanders Peirce outlined three major sign types differentiated according to the kind of relations existing between their material aspect (sign or representamen) and referent (object). If this relation is a matter of convention, as in the case of most words, the sign is termed a symbol. Thus, "house" is a symbol because there is no particular reason, except for social convention, for those phonemes to refer to that concept. A finger pointing at a house, in contrast, is related to it existentially; if the finger is not reasonably close to the house, in an uninterrupted line of

vision and cotemporal with it, it will not fulfill its semiotic function. Such a sign, existentially or causally related to its object, is called an index. The final category is that based on a relation of similarity. This is the icon, of which there are three varieties, two corresponding to our three- and four-term analogies. A sign which *substantially* replicates its object, e.g., a model of a house showing doors, windows, and other house properties, is called an image (the three-term analogy); a sign whose *relations* replicate those of its object, e.g., a blueprint of a house, is called a diagram (the four-term analogy); and a sign that represents what Peirce terms the "representative character" of another sign through a *parallelism,* e.g., "snail shell" used for "house" to stress the house's protective nature, is a metaphor (Peirce, 2:157).

If people are reluctant to credit the diagram with a mimetic capacity, finding four-term analogies merely supersubtle, they greet the claim that metaphors are icons with open disdain. The discerning theorist prides himself on distinguishing 'real' from metaphoric similarities and balks at the idea that a metaphoric similarity is a crucial tool of analogy and not just an error in logic. Peirce's paradoxical depiction of the metaphor as a "conventional icon" does little to help matters. Indeed, he felt that all three kinds of icons were somewhat tainted with conventionality (he called them "hypoicons" at times to express this impurity). "Speaking picture," "mute poem," and *"ut pictura poesis"* are all metaphoric formulations, which thinkers have tried to motivate into images, or at least diagrams, throughout history. The paradox of the "conventional icon" is the real engine driving the interartistic comparison, as it lurches back and forth between three- and four-term analogies. It postulates a ground of similarity, a "representative character," without stating what that in fact is. And into this blank aestheticians have been able to insert whatever the times or their own needs have dictated. The flight away from metaphor toward image and diagram has thus been seen as the only "legitimate" basis for engaging in the interartistic comparison.

This legitimacy, as we have seen, is almost inevitably connected to the desire to find immediacy, *enargeia,* in the artwork. For the image and the diagram are relevant not only to the question of how poems can be like paintings, but also to how either complex sign can be like the reality it depicts. In the ancient anecdotes of animated statues or painted grapes so real that birds pecked at them, the mimetic potential of the visual arts is presented as that of the image, whereas in the most sophisticated versions of the *ut*

pictura poesis approach, the potential is that of the diagram. Dryden claimed
that a lively imitation of nature gives more pleasure than true knowledge
about it because painting and literature "are not only true imitations of
nature, but of the best nature, of that which is wrought up to a nobler
pitch."[28] In John Dennis's words, "Nature 'is nothing but that Rule and
Order, and Harmony, which we find in the visible Creation'; so 'Poetry,
which is an imitation of Nature,' must demonstrate the same properties"
(Abrams, p. 17). Art reflects nature by echoing the ideal system of rules that
lies behind it.

Other neoclassicists made the diagrammatic relation even more compli-
cated by locating these rules in ancient art. "Scaliger, for instance, following
Vida, carried the un-Aristotelian notion of the imitation of models to a
dogmatic extreme in practically deifying Virgil. Why bother with nature at
all, he says, when you have everything you may want to imitate in Virgil
who is a second nature" (Lee, p. 12). In this case, ancient art is a diagram of
nature, and painting and literature become comparable because they both
imitate (imagistically or diagrammatically) the earlier works in each of their
arts. That art can truly imitate art is, on the face of it, uncontroversial, except
that what each artist selects as the factors to carry over into his work may
vary. In that case, the "true" Virgil may be as elusive as "true" nature, and
different interpretations will strike different ages as more accurate approxi-
mations. Moreover, when the model is in a different language (e.g., Greek
or Latin) or in a different .form (the classical models for painting were
inevitably statues), then imitation was a matter of translation and involved
precisely the same problems as the painting-poetry comparison itself.[29]
Hermeneutics and the interartistic comparison may truly be called the sister
arts!

But to return to Peirce, image-icons, by directly embodying aspects of
their referents, create a more immediate awareness of those referents than
would other signs, since some aspect of the referent is physically present in
the sign. Indexes, in contrast, point out such presence (the pointing finger,
smoke signalling the presence of fire), and in order to make a viewer aware
of the actuality of an icon's referent, the sign must have some indexical
properties (e.g., the existential relation that holds between camera and sub-
ject in a photographic portrait). But symbols lack this feeling of presence;
even the ,inclusion of descriptive symbols in a passage ("big," "red") is not

properly imitative, iconic, or immediate, although the use of such words is usually a technique of verbal realism. Almost no individual words are iconic—except onomatopoeias. Verbal art achieves whatever iconicity and presence it can claim through relational, diagrammatic means, or, problematically, through metaphors.

Jakobson compared visual and auditory signs for the relative prevalence in each of icons, indexes, and symbols. He found that,

in our everyday experience, the discriminability of visual indexes is much higher, and their use much wider, than the discernments and utilization of auditory indexes. Likewise, auditory icons, i.e., imitations of natural sounds, are poorly recognized and scarcely utilized. On the other hand, the universality of music, the fundamental role of speech in human culture, and, finally, a mere reference to the predominance of word and music in radio suffice to prove that . . . the supremacy of sight over hearing in our cultural life is valid only for indexes or icons, and not for symbols.[30]

Accordingly, language is poor in indexical and iconic signs, whereas painting is primarily iconic (and indexical). With language as its medium, literature turns to diagrams (and metaphors) to achieve iconicity.

The symbolic nature of literature and the iconic-indexical nature of painting were much remarked upon during the *ut pictura poesis* period under the headings of artificial *versus* natural signs. Natural signs, according to Addison or the early eighteenth-century Abbé du Bos, appeal to the senses as the natural objects they represent do, whereas artificial signs have no innate relation to things but depend upon social convention. Paintings are natural signs, while poems use words, which are artificial. Natural signs in painting are more powerful because they work through Leonardo's "power of sight," while the only poetry that approaches this effect is drama. As Lee explains,

it was in the writing of Du Bos, who was deeply influenced by the empiricism of the English philosopher John Locke and by Addison's essays (themselves owing much to Locke) on the effect of visual experience on the imagination, that we first find in the criticism of painting any well-formulated theory that is opposed to the abstract doctrine of the [*ut pictura poesis*] Academicians. For in applying the rules of poetry to painting, critics like Félibien and Le Brun had so intellectualized the pictorial art that its

primary character as a visual art capable of affecting the human imagination only through its initial power over the sense of sight, was largely neglected. [Lee, p. 59]

However, though Lee sees the distinction between artificial and natural signs as a wedge driven against the *ut pictura poesis* tendency in criticism, it was just as much a help to it. For if the whole "virtue" of natural signs lay in their appeal to sight, then a poem could take on the same virtue if it appealed to sight through its metaphors and images. And it would do so only by separating itself from 'normal' language. Thus, the development of an *ars characteristica* (Schweizer, p. 34), a theory of how the media of the arts signified, has as one of its implications the differentiation of literary from communicative language. If poetry were as fully artificial as other language usage, then its approximation to painting would at least in this respect be impossible. But if poetic language was somehow special, 'natural,' then a perfect basis for comparing the arts would exist.

The literal approach to this naturalness gave rise to an interest in pattern poetry during the baroque period, poems whose typography physically represented the theme handled by the words in the pattern. Another focus of attention was the concept of universal language, for example, among the members of the Royal Society in England and the Port Royal School in France, where not just poetry but all language was examined with a view to naturalize, motivate, its relation to things. The effect of the English "plain style" movement was eventually to separate irrevocably poetic from nonpoetic or scientific language (at least in the eyes of early modernists), since unambiguous correlation rather than similarity between word and thing was stressed. However, much of the thrust of the word "universal" was toward the "iconic," because the only way to create such immediacy, it was presumed, was to have words mirror what they referred to. And in poetry too, just as Addison's "colors speak all languages," verbal material was sought that would speak to all people. Wimsatt characterizes the poetic theory of this period as natural-sign oriented: "artificial signs, as Lessing and his century would put it, strive in poetry to become natural signs" (Wimsatt, p. 42). The onomatopoeia, no matter how abnormal a sign in language or how limited a figure in poetry, was always a proof that language had possibilities in the realm of direct sensory appeal.

This argument was closely echoed in our century. It was an essential tenet of imagism and vorticism that poetry must be remodeled in order to become iconic of reality. To do so, it must become like Chinese script, whose characters are pictorial icons—at least in Pound's eyes—of their referents. Chinese writing was supposedly universal in its intelligibility; thus Pound praises Henri Gaudier for being able to understand Chinese ideograms spontaneously, though totally ignorant of the language. The aim, then, was for poetry to achieve this same universality through its imagery. The New Critics too were intent on a poetry that would embody reality rather than merely refer to it,[31] and I. A. Richards worked toward the development of a simplified English that would function universally and unambiguously.

In the sphere of modern linguistic theory, this opposition between linguistic arbitrariness and motivation (artificiality and naturalness) characterizes the split between Saussurean and Jakobsonian semiotics. For Saussure, the cardinal fact about language is the arbitrariness of its signs, and the post-structuralists that follow in his wake, e.g., Derrida, find the attempt to motivate sign relations in art a touchingly doomed struggle to regain a state of perfect communication, a pre-Babel. Jakobson, in contrast, has demonstrated through intricate analyses precisely how iconic language is capable of being, particularly in art.[32] He isolates the poetic as a distinct function of language, the effect of which is to project the principle of equivalence from the axis of selection to that of combination.[33] That is, poetic language is constituted of iconic relations; its parts are similar both as image and diagram to each other and to the whole text, and Jakobson even argues that these relations often match those of the ideas referred to.

The American semiotician Charles Morris used the notion of the icon to characterize art as a whole. He claimed that a work of art is fundamentally iconic and that its referent is a value. As an icon, it contains its referent within its physical sign vehicle, and hence signifies itself, has itself as one of its denotata. But because values are also part of the extra-artistic world, the artistic sign is linked to that world too and signifies it. It thus has a double semantic thrust—toward itself and toward external reality.[34] This notion was echoed in the thinking of the Prague structuralists[35] and the New Critics.[36]

Theorists have searched for iconic properties in literature in order to show its similarity to painting, seemingly an indisputably mimetic art. But the contrary possibility—that if literary signs are not necessarily artificial,

painted ones are not necessarily natural—has both a long history and an important place in contemporary aesthetics. From the viewpoint of the *ut pictura poesis* tradition, a great many important aspects of "significant human action" are not directly imitable in visual signs, in particular, the actions of the body and the passions of the spirit. The first was the source of the "pregnant moment" as a pictorial device, and we shall accordingly dwell on it at some length later on. The second, the need to signify emotion, gave the painter a special mission. He had to discover the correlation between physical signs and mental states, i.e., the language of gesture, which has become the modern branch of semiotics called kinesics. "It is precisely here," Lomazzo long ago argued, "that painting most resembles poetry; for the inspired genius of both arts lies in the knowledge and power to express the passions" (Lee, p. 23).

As a result, Le Brun and other members of the French Academy of his day postulated the existence of *esprits animaux,* vapors produced by the circulatory system in response to emotions. These supposedly effected subtle changes in the physiognomy, each change correlative with a different emotion. Thus, physical configurations would have a minute correspondence to mental states, and the meticulous painter could signify each state by painting a different physical configuration. If this exact correspondence existed, the kind of sign involved would be an index, a material pointer to the presence of some nonmaterial state. However, such one-to-one correlations unfortunately do not exist; emotions affect the musculature of different faces in different ways, and anthropologists tell us that even the smile is not a universal sign of pleasure.[37] Thus, the Academy was actually establishing a set of conventions, arbitrary signs, all the while claiming for them a unique natural motivation

This desire for a natural correlation between physical and mental states was also part of the ideology of many early modernists. Eliot's objective correlative, for example, calls for poets to depict emotions only through such objective situations as would give rise to them. He thereby assumes that such an absolute correlation between situation and emotion exists. But at best, it would obtain only among those with a similar upbringing and temperament, if even there; it is an arbitrary correlation. Eliot's approach is symptomatic of an academic conservatism intent on finding nature and universals where culture, in all its variability, reigns.

Lessing, in contrast, had realized that both arts had their complement of artificial and natural signs, but he argued "that painting decreases in perfection in proportion to an increase in its content of 'artificial signs,' while the reverse is the case with poetry. In other words, poetry approaches perfection according to its ability to transform its 'artificial' signs into 'natural' ones . . . and only through this process does it distinguish itself from mere prose" (Schweizer, p. 73). Both arts approach perfection, then, when they approach the natural, because to be natural is to "speak all languages," to appeal universally, like the world of things. As we have seen, the artificial-natural distinction controls even Lessing's division of the arts according to their temporality or spatiality,[38] because it is the quality of similarity that makes painting a natural sign of bodies and literature a natural sign of actions. And underlying the natural, as stated earlier, is the notion of presence. What modern approaches to interartistic comparisons tend to discover more and more is the similarity of the two arts in being such thoroughly mixed signs, and what modern artists seem intent on doing is perfecting a natural poetry of presence, or showing that an artificial painting of absence is more 'truly' natural than nature.[39] The fluidity of these categories in the presence of aesthetic intention has itself become a theme of modern literature and art.

Just as complex as the argument about *how* artistic signs signify reality is the issue of *whether* they in fact do signify it. The iconic theory of art proposed by Morris depicts a delicate dialectical balance between internal and external reference, but it has been easier to postulate than explain. And much of modern criticism has rested on only one side of the pairing. Fearful lest art lose its specificity in becoming externally referential (what would distinguish it from communicative discourse in such a case?), formalist critics have stressed the absolute self-containment and uniqueness of meaning, a meaning untranslatable, unparaphrasable, and nonutilitarian. This is the essential principle for several New Critics, though most were unwilling to face up to its consequences.[40]

Where such an approach leads is apparent in Edward Casey's two phenomenologically oriented articles, "Meaning in Art" and "Truth in Art," which contain the claim that "Artistic truth is not communicated but *expressed;* and as expressed, it cannot be tested (if it can be tested at all) apart from its actual embodiment."[41] As a result,

Art is not true to any specific independent objects; it does not relate corre-spondentially to anything actual or possible. Nor does its truth depend on a relation of conformity to essences or universals. . . . truth in art is founded on a relation of meaning to meaning; but both kinds of meaning are co-present in the work's import. Neither sort of meaning transcends the work proper. Instead, a symbolic circuit is established through which the work affords insight. ["Truth in Art," p. 361]

How the work could be *in*adequate to itself, or *un*truthful to itself is hard to imagine, as is the meaning of "insight" in such a self-enclosed sphere of reference. Under the circumstances, the word "truth" has been deprived of any meaning. But on the other hand, to insist that art refers to reality would permit one to say that it was true or false in the way that normal propositions can be, and this would not only make literature indistinguishable from other utterances but contradict our intuitive sense of the terms "true" and "false."

A less troublesome way of handling the peculiar semantic thrust of art grows out of the Whorf-Sapir theory of language.[42] According to it, the world is directly reflected in language and the particular language one speaks determines the world one lives in. The first implication of the idea is that language is the base upon which all other semiotic systems are founded (including painting); it is a "primary modelling system"[43] in the Soviet semiotic terminology, or the semiotic system par excellence for the French structuralists.[44] Art builds on the linguistic given and creates new models for organizing reality.

A beautiful rendering of this sign-thing interaction is found in Howard Nemerov's depiction of Paul Klee in "The Painter Dreaming in the Scholar's House":

Being a man, and not a god, he stands
Already in a world of sense, from which
He borrows, to begin with, mental things
Chiefly, the abstract elements of language:
The point, the line, the plane, the colors and
The geometric shapes. Of these he spins
Relation out, he weaves its fabric up

So that it speaks darkly, as music does
Singing the secret history of the mind.
And when in this the visible world appears,
As it does do, mountain, flower, cloud, and tree,
All haunted here and there with the human face,
It happens as by accident, although
The accident is of design. It is because
Language first rises from the speechless world
That the painterly intelligence
Can say correctly that he makes his world.[45]

The double thrust of this argument—that on the one hand all artistic creation proceeds from language and creates the world, while language, on the other hand, necessarily proceeded from a preexistent speechless world—gives some idea of the direction that the Whorfian argument takes in regard to art. The artistic sign (dependent on language signs) would seem to have a built-in diagrammatic relation to reality. But since every sign system creates a different reality, the relation is cultural, conventional, and not natural. In other words, the art-thing relation is not a matter of iconicity at all. What seems to be a Peircian diagram is only a correlation that has become natural to its users, or in different terms, there is nothing inherently diagrammatic in language or literature; the similarity is merely an agreed upon correspondence.

There are at least two paths that this argument takes. The more radical denies that art is iconic in any way. Almost always returning to E. H. Gombrich's brilliant discussion in *Art and Illusion,* this position holds that everything in art is a matter of convention. Even vanishing-point perspective is a correspondence to reality that must be learned. Nelson Goodman, for example, argues that "pictures are normally viewed framed against a background by a person free to walk about and to move his eyes. To paint a picture that will under these conditions deliver the same light rays as the object, viewed under any conditions, would be pointless even if it were possible."[46] Moreover, resembling and representing are not, Goodman argues, the same thing. Identical twins do not represent each other, nor does an object represent itself by virtue of its identity to itself. "The copy theory of representation, then, is stopped at the start by inability to specify what is to be copied. . . . In representing an object, we do not copy . . . a construal or interpretation—we *achieve* it" (Goodman, p. 9).

In Goodman's view, what we take as artistic "mirroring" is merely the reinforcing of conventions of correspondence. Sol Worth, too, says that correspondence "is not correspondence to 'reality' but rather correspondence to conventions, rules, forms and structures for structuring the world around us. What we use as a standard for correspondence is our knowledge of *how people make pictures.*"[47] And Goodman finds that "how literal or realistic [a] picture is depends upon how standard the system [for correlating it to the object world] is. If representation is a matter of choice and correctness a matter of information, realism is a matter of habit. . . . Representational customs, which govern realism, also tend to generate resemblance. That a picture looks like nature often means only that it looks the way nature is usually painted" (Goodman, pp. 38–39). We might compare such statements to Roman Jakobson's paradoxical attempt in 1919 to define realism in art,[48] where he postulated five familiar but contradictory approaches to the concept that would end, as a group, by including virtually every work of art.

A summation of the relativist approach is presented eloquently by Nelson Goodman:

we have read the painting as well as the poem, . . . and aesthetic experience is dynamic rather than static. It involves making delicate discriminations and discerning subtle relationships, identifying symbol systems and characters within these systems and what these characters denote and exemplify, interpreting works and reorganizing the world in terms of works and works in terms of the world. . . . The aesthetic "attitude" is restless, searching, testing—is less attitude than action: creation and recreation. [Goodman, pp. 241–42]

Opposed to this relativism is the position of the universalists. For them, similarities not only exist but **help** similars to signify one another. Though the universalists would find horribly physicalistic Goodman's 'proof' that no picture can produce a physical image identical to that produced by its subject, they themselves offer such cases as the length of suffix corresponding to the degree of the adjective—more verbal material for more physical material (Jakobson, "Quest," p. 30)—as proof of sign-thing similarities (this is Jakobson in a universalist phase some forty years after the article on realism).

The universalists would also find the refusal to consider correspondence as similarity a failure of relational thinking on the relativists' part. Similarity is not just a matter of the same physical material inhering in two objects, but of

similar relations holding within them. Thus, if the patterns of relations in a painting or a work of literature can be shown to match existing elemental relations, then art mirrors life. And the more precise the correlation, the more intense the iconicity. In the same way, if similar relations hold within a painting and a poem, then the two are similar. The world is pervaded with similar structures tied to the innate structures of the mind. And if this seems to lead to another kind of relativism—just apply the mind to any phenomena and it will discover like structures in them—these structures will at least have the specificity to allow for empirical verification, manifesting binary oppositions between marked and unmarked elements, hierarchical arrangement, and so on.

A typical example of such thinking is Dora Vallier's comparison of colors and phonemes. Vallier discovers similarities between color relations and vowel relations, on the one hand, and achromatic and consonantal relations on the other (this comparison is presented in more detail in the last section of this chapter). Whether we are thereby convinced that much similarity exists between one particular vowel and one particular color is irrelevant. The system of relations in which they operate is the issue. And Meyer Schapiro argues the same way when he disagrees with those who hold that colors have no specific meanings: "the familiar argument . . . that color symbolism is entirely conventional, ignores that a color is not a simple elementary feature but a complex of qualities of which certain ones become more or less pronounced in a particular setting and according to a perceiver's experience and attitude."[49] It is the set of relations into which an element enters that creates its meaning. Such arguments, epitomes of the structuralist approach, are a glorification of four-term relationality. But they are also accompanied by claims of a similarity of substance, an image-relation. For example, Schapiro argues that vanishing-point perspective is not an arbitrary organizational structure; "it is readily understood by the untrained spectator since it rests on the same cues that he responds to in dealing with his everyday visual world."[50] And similarly Jakobson compares "Veni, vidi, vici" to its referent as a perfect temporal likeness, a three-term analogy.

It is only in the conjunction of the universalist and relativist positions, I believe, that we can arrive at an understanding of the relation between the two arts and between each of them and reality. Considering the array of languages and other models of reality, and the changes in them throughout

history, one could not argue for a fully iconic representation of reality through any sign system. All sign systems are conventional. But once a system *is* conventional, its artificiality is largely invisible, and the system is perceived as a model, a diagram of reality. A work of art that imitates a model of reality thus seems to be imitating reality itself. The conventionality of the model still gives it the flexibility to change and develop, but even such a development can be plotted in terms of diagrammatic relations.

This dynamic concept of sign function is true of language in general and not just of the interartistic comparison. It is a function of the metaphor itself, which, like all icons, has the complexity to reveal truths not specified in their initial formulation. Chapters 2 and 3 of this book will develop this dynamic notion of the interaction of convention and iconicity, but for the moment we should be aware of what the alternative to it is. The argument between universalists and relativists is endless. No sooner does the former propose a 'real,' 'substantive' resemblance between two systems or phenomena than the latter points out some way in which the resemblance is merely a social convention. The onomatopoeia is a case in point. The universalist identifies "bow-wow" as an icon of a dog's bark, in contrast to the merely symbolic word "bark" itself. The relativist then compares the dog's actual utterance and "bow-wow" on an oscilloscope and finds them widely divergent. He also points out that in other languages dogs are not perceived as saying "bow-wow," but instead "oua-oua" (French), "haf-haf" (Czech), and so on: "bow-wow" is an English convention. The universalist counters by showing that each of these expressions may contain different phonemes, but that they are arranged in some form of reduplication; they are thus diagrammatically similar. The relativist then either goes off in search of canine onomatopoeias that do not reduplicate (a search that is inevitably successful), to which the universalist responds that he is at least statistically validated; or else the relativist assents to the diagrammatic similarity but finds it unconvincing as an icon in the face of the wild diversity of phonic material in words that all supposedly mimic the dog.

To return to the painting-literature analogy, the belief that paintings picture reality has made theorists feel that a "speaking picture" must be iconic too. And semiotics has offered the precision of its terminology and the sophistication of its philosophical basis to this search. But the results of the newfound sophistication are perhaps not all that the traditional humanist

could wish. If the only way to compare painting and literature is to prove that they are both iconic of reality, all the time maintaining that "iconic" and "reality" are univocal terms, perhaps the game is indeed not worth the candle. But the mistake here is to pin one's hopes on the outcome of the game rather than the process of playing it. Having redefined and systematized the terms, semiotics has made the painting-literature analogy once more an interesting area to investigate, for even the dissimilarities that emerge are different from those understood to exist before. Sign theory, we might say, has changed the rules of the game, and so made it worth playing. Artists in this century have responded to this stimulus, producing new orders of phenomena to be studied from this new angle. The concrete poets, for example, quote an astonishing array of semiotic theories, and at least one, Max Bense, is himself a semiotician who composes concrete poems often in order to realize the theories that he has previously proposed. The complexity in the interartistic theory that emerges—the confusion, many would say—is proportionate to the long history of unsatisfactory solutions that already exists. But it is a complexity that is illuminating about the nature of the two arts, their relations, and relationality itself.

**The Temporal versus
the Spatial Arts**

A very short space of time through
very short times of space.

James Joyce

When modern artists and theorists began to revive the painting–literature analogy after its relative dormancy in the nineteenth century, the most immediate obstacle in their path was Lessing's distinction between the spatial and temporal arts. No one has managed to obviate this disjunction entirely, but the moderns' treatment of the issue has superseded Lessing's, leaving it a much more sophisticated problem than what they found. This revision illustrates very clearly the dynamics of analogical thinking that I have been describing.

In examining the modern discussion of artistic space and time we might begin with one of the most dramatic presentations of it: Stephen Dedalus's monologue, spoken as he walks along the seashore contemplating the "ineluctable modality of the visible." Through the protean workings of his mind, this modality is transformed into the "ineluctable modality of the audible." The problem of the monologue is thus that of the interartistic comparison itself—the translation of one sensory mode into another. And Stephen effects this metamorphosis by reenacting a good portion of the history of philosophy—Aristotle, Saint Augustine, the empiricists, Lessing, and Kant, with a little mysticism thrown in for good measure:

Ineluctable modality of the visible: at least that if no more, thought through my eyes. Signatures of all things I am here to read, seaspawn and seawrack, the nearing tide, that rusty boot. Snotgreen, bluesilver, rust: coloured signs. Limits of the diaphane. But he adds: in bodies. Then he was aware of them bodies before of them coloured. How? By knocking his sconce against them, sure. Go easy. Bald he was and a millionaire, maestro di color che sanno. Limit of the diaphane in. Why in? Diaphane, adiaphane. If you can put your five fingers through it, it is a gate, if not a door. Shut your eyes and see.

Stephen closed his eyes to hear his boots crush crackling wrack and shells. You are walking through it howsomever. I am, a stride at a time. A very short space of time through very short times of space. Five, six: the *nacheinander*. Exactly: and that is the ineluctable modality of the audible. Open your eyes. No. Jesus! If I fell over a cliff that beetles o'er his base, fell through the *nebeneinander* ineluctably. I am getting on nicely in the dark. My ash plant hangs at my side. Tap with it: they do. My two feet in his boots are at the end of his legs, *nebeneinander*. Sounds solid: made by the mallet of *Los Demiurgos*. Am I walking into eternity along Sandymount strand? Crush, crack, crick, crick....

33

Open your eyes now. I will. One moment. Has all vanished since? If I open and am for ever in the black adiaphane. Basta! I will see if I can see.

See now. There all the time without you: and ever shall be, world without end.[51]

Beginning with the medieval Catholic notion that the perception of the world is the perception of signs, "thought through my eyes. Signatures of all things I am here to read,"[52] Stephen lists the seaside objects before him as manifestations of the symbolism of their colors: "seaspawn and seawrack, the nearing tide, that rusty boot. Snotgreen, bluesilver, rust: coloured signs." Each of these colors does in fact become a crucial symbol in the book, and so justifies Stephen's depiction of them as "limits of the diaphane." Through their palpability, colors delimit the 'transparent' world of ideas. It is the substantiality of the symbol, the sign, that orders and bounds the nonmaterial world of thought.

But no sooner does Stephen formulate this notion than a third-person voice intrudes to reveal Stephen in a different conceptual scheme: "But he adds: in bodies." Colors exist only in bodies; the Aristotelian primacy of extension over the "accident" of color forces Stephen to conclude that he has been seeing bodies rather than colors (or color symbols), or at least that "he was aware of them bodies before of them coloured." And the means of this awareness is Dr. Johnson's proof of the existence of a world outside the mind: the physical collision of our bodies with it. Stephen becomes "aware of them bodies" "by knocking his sconce against them, sure." "Sconce" here means head, but it also means a lantern or a candlestick—a light-bearer. Thus, at the same time that Stephen presents the physicalist stance, he undermines it by implying an antagonistic meaning: we know the world because we cast our senses and the light of our minds upon it, because we interpret the world as the signifier of ideas.

Stephen then considers the opposite extreme to materialism, asking why the limits of the diaphane must exist in anything, why colors, conceptual limits, must be embodied at all. The question he addresses is why the sign is necessary. Why not live in a world of pure ideas without physical correlates to mark them off or manifest them? Stephen decides to close his eyes to see how it would be to live in such a world. Deprived of his body and the bodies about him, he at first cannot report his situation, and so again the third-

person narrator does so: "Stephen closed his eyes to hear his boots crush crackling wrack and shells." Despite the fact that he has eliminated the visual world, the palpability of sound is still with him, identifying sensory objects and ultimately ideas. Thus, the physicalist side of Stephen reminds him, "you are walking through it howsomever." And then the original first-person Stephen is forced to agree: "I am, a stride at a time."

The same argument for the sign that prevents Stephen from lapsing into mysticism transforms the visual into the auditory, the spatial into the temporal. Stephen has replaced the color limits of the diaphane with the temporal limits of it imposed by his footsteps: "A very short space of time through very short times of space." He has discovered the ineluctable modality of the audible, which he terms the *nacheinander* (the one after the other), in contrast to the *nebeneinander* (the one beside the other) of the visible. But whereas for Lessing these were two incommensurate realms, for Stephen temporal sequence and spatial contiguity have proved interchangeable. He experiences the solidity of the ground by listening to the sequence of taps of his ashplant upon it. And when he fears that the auditory signs might be false, that he might be locked in a "black adiaphane," a material darkness, he, unlike poor Gloucester, can open his eyes and recover the visible world which has been "there all the time without you: and ever shall be, world without end." The Christian notion of the sign with which he began has been validated by the transformation of one sense into the other and back again. Time and space are merely alternate modes of the same thing; both physicalism and mysticism must be qualified by the mediating structure of the sign, an entity both material and ideal. Stephen's intersensory experiment is thus dependent upon a semiotic relation between thought and world, just as the interartistic argument depends upon the semiotic relation between art and extra-artistic reality.

The tack that Stephens's argument takes is typical of romantic and modern corrections of Lessing in that it stresses mental process as the locus of the temporal-spatial interchange. Not that previous ages were utterly unaware of this factor. Dryden, for example, mentions it in praising painting for its simultaneity. "The action, the passion, and the manners of so many persons as are contained in a picture are to be discerned at once, in the twinkling of an eye; at least they would be so, if the sight could travel over so many different objects all at once, or the mind could digest them at the same instant, or

AE Series of now-points
EA′ Continuum of phases (now-point with horizon of the past)

point of time" (Dryden, pp. 304–5). The limitation in Lessing's argument discovered in later centuries, that the much-vaunted simultaneity of the painting exists in the material artifact but not in its perception, is thus present in Dryden's words. Modern science supports this criticism; the eye can in fact focus on only relatively small portions of visible objects and must scan them in order to build a unified image. Pictorial perception is thus a matter of temporal processing, like literary perception, with the difference that the ordering of this perceptual sequence is not predetermined by the painting itself (at least not as far as we know).[53]

But beyond such physiological and psychological observations regarding the perception of spatial objects, phenomenology has developed purely "logical" theories about the perception of temporal objects. Its claim, in a nice mirror-image of the newly discovered "pictorial sequence," is that the sequential processing of a temporal object must end in a simultaneous synthesis[54] if the temporal object—sentence, poem, melody, event, and so on—is ever to be perceived as a whole. The mental mechanisms for this synthesis, phenomenologists argue, are two processes called "retention" and "protention," the first storing each passing moment in a sequence within the short memory, the second setting the mind ahead in expectation of the succeeding elements of the series until an end point is reached. As a result, by the time the last element of the series has been registered, the entire sequence is present in the mind, as visualized in the diagrams above.[55]

A beautiful description of this process is to be found in the writings of Saint Augustine, whose insights into sign-functioning and perception are often quite astonishing:

I am about to repeat a Psalm that I know. Before I begin, my expectation is extended over the whole; but when I have begun, how much soever of it I shall separate off into the past, is extended along my memory; thus the life of this action of mine is divided between my memory as to what I have repeated, and expectation as to what I am about to repeat; but "consideration" is present with me, that through it what was future, may be conveyed over so as to become past. Which the more it is done again and again, so much the more the expectation being shortened, is the memory enlarged: till the whole expectation be at length exhausted, when that whole action being ended, shall have passed into memory. And this which takes place in the whole Psalm, the same takes place in each several portion

A A' Sinking into the past *(Herabsinken)*
E→ Series of nows which possibly will be
filled with other objects

of it, and each several syllable; the same holds in that longer action, whereof this Psalm may be a part.[56]

Indeed, one of the prime benefits of art is its actually increasing our retentive and protentive powers. As Rudolf Arnheim points out ("Unity of the Arts," pp. 8–9), "a viewer of limited skill will grasp little more than a single movement of a dancer's performance; with better understanding he will survey a complete phrase, and the expert can apprehend the entire composition in simultaneity." The intricate structuring of art, with its redundancy and overdetermination, is designed, I have argued elsewhere (Steiner and Steiner, pp. 69–70), to enlarge our ability to turn sequence into simultaneity, to allow us to form ever larger temporal flows into unified, atemporal structures.

We should note in passing that the time-space opposition of the arts has an importance beyond the interartistic comparison as well. Ferdinand de Saussure's fundamental distinctions between synchrony and diachrony and the paradigmatic and syntagmatic axes of language are a matter of spatial simultaneity versus temporal successivity. When Jakobson argues that every linguistic sequence is perceived as a synthesis and that every phoneme is a bundle of simultaneously perceived distinctive features,[57] he is trying to discredit the simple opposition inherent in Saussure's system, just as his discovery of the iconic features of language is meant to disprove Saussure's thesis of the essential arbitrariness of linguistic signs. The temporal modes of the various arts are thus part of a larger discussion in contemporary linguistics and structuralism, a discussion as we shall see in chapter 3 that is essential to the understanding of the concept of the artistic period and particularly of modern art.

Another, and very popular, objection to Lessing's time-space division of the arts is the notion of the "spatial form" of modern literature. This is similar to the idea of simultaneous synthesis, but it is not based on an analysis of mental process. According to its originator, Joseph Frank, the characteristic feature of modern literature is its spatiality. The usual temporal flow of verbal art is not perceived as such there because of violent disruptions in narrative and logical sequence. Meaning is dislocated from the temporal or logical unfolding of the text, and the reader is asked "to suspend the process of individual reference temporarily until the entire pattern of internal refer-

ences can be apprehended as a unity" (Frank, p. 13). The text does not make
sense as a sequence, but only as a finished whole, and thus its perception is
analogous to that of a painting.

 Now obviously no text makes sense as a whole until it is completed, but
Frank's point is that certain texts disrupt the partial syntheses, partial refer-
ences, and hypotheses of wholeness made along the way to completion. This
interruption renders both protention and retention difficult. A similar effect
results from stream-of-consciousness writing, where pure linear sequence,
without any of the structuring devices of redundancy and syntactic pattern,
make the text proceed as a set of discrete moments rather than a whole that
can be synthesized.

 There is a crucial problem with "spatial form"[58] however—the word spa-
tial" itself. Frequently it means nothing more than "atemporal," as in Frank's
statement, "all these writers ideally intend the reader to apprehend their work
spatially, in a moment of time, rather than as a sequence" (p. 9). In fact,
"spatial" means almost its antithesis in Frank's reasoning:

Depth, the projection of three-dimensional space, gives objects a time-
value because it places them in the real world in which events occur. Now
time is the very condition of that flux and change from which . . . man
wishes to escape when he is in a relation of disequilibrium with the cosmos;
hence non-naturalistic styles shun the dimension of depth and prefer the
plane. If we look only at the medium of the plastic arts, it is, then, abso-
lutely spatial when compared with literature. But if we look at the relation
of form and content, it is thus possible to speak of the plastic arts as being
more or less spatial in the course of their history. Paradoxically, this means
that the plastic arts have been most spatial when they did not represent the
space dimension and least spatial when they did. [Frank, pp. 56–57]

What "spatial" means then is "acontextual" and "atemporal." The
metaphoric quality of this term is worth noting; applied to literature it seems
to lend writing one of the qualities of painting while in actuality denying it.
To be momentary is not to be spatial, and to be divorced from a spatial
context is also not to be spatial! "Spatial form" in no sense overcomes the
space-time barrier between the arts.[59]

 However, one notion implicit in Frank's argument goes beyond the
purely figurative. This is the tendency to see the synthesis of a temporal

perception as ipso facto spatial. Arnheim, for example, says that "the contraction of any sound sequence into one moment would produce a shapeless noise. It follows that in order to survey a work of music [or literature] as a whole, one has to imagine its structures as a visual image—an image pervaded by a one-way arrow, to be sure" ("Unity," pp. 8–9). But is every synthesis a diagram? Or, at least, is there a spatial analogue for every temporal object? Nelson Goodman studies the relation between the arts and the schemes upon which they are constructed in *The Languages of Art*. Unlike music, literature has no notation by which a work can be represented.[60] But even if it had, such a notation would be, first, arbitrary (like music's) and second, sequential (like music's). The synthesis formed at the end of literary perception is ideational; it becomes spatial only if it is translated into an invented spatial form, as in *Tristram Shandy*. But such diagrams are hardly a commonplace of art or criticism.[61]

Despite the modification of Lessing's position made by phenomenology, physiological psychology, and such critics as Frank, modern theory has not been able to overcome certain spatial-temporal barriers between painting and literature. In the first place, Jakobson points out that the synthesis created out of a painting has a physical correlate present in the painting itself, while a literary synthesis, or that of any temporal object, occurs when its object is no longer present. "There exists a profound dissimilarity between the spatial and temporal arts, and between spatial and temporal systems of signs in general. When the observer arrives at the simultaneous synthesis of a contemplated painting, the painting as a whole remains before his eyes, it is still present; but when the listener reaches a synthesis of what he has heard, the phonemes have in fact already vanished. They survive as mere afterimages, somewhat abridged reminiscences, and this creates an essential difference between the two types of perception and percepts."[62] How essential this difference is in terms of literary art is perhaps debatable. For at the time of the synthesis, the *written* poem still lies before us. Though it could be claimed that the typographical representation of the poem is in no way equivalent to the synthesis of sound and meaning that we make of it, we can as easily claim that the physical configuration of the painting is not equivalent to our synthesis from it of color, shape, and meaning. Jakobson's formulation leaves unanswered the question of whether there is a difference between a painting conceived as a visual image or a construction of meaning. In any case, we

should note that the intense interest in typography among artists and poets of our century is aimed at making the relation between poetic synthesis and printed poem more obviously approximate that between pictorial synthesis and physical painting.

The other temporal barrier between painting and literature is stated in Arnheim's observation that the ordering of perceptual process in literature is predetermined by the text, whereas the painting does not have such prescriptive power over the sequence of our eye scans. What *is* present in the painting is the "directed tension" of all shapes; "this dynamics is inherent in the work and quite independent of that of the subjective exploration" ("Unity," p. 9). Whether a prescriptive force upon our scanning could be discovered behind such visual dynamics remains to be seen, although there has been much speculation about the way the eye is "led" by diagonals or attracted first to warm colors. In any case, the discovery of sequence in painting still leaves us with the question of whether normative sequence— either culturally or physiologically based—in fact exists, as it appears unmistakably to do in literature. And again, the most experimental poetry and even novels of our day have programmatically eliminated prescriptive sequence, often in order to approximate visual art.

To summarize, modern attempts to clarify the temporal and spatial natures of the arts have frequently focused on mental process, whereas earlier ones (epitomized by Lessing) focused on what we might call artistic semantics—the representation of temporal or atemporal subjects. Lessing made the latter appear unpromising as a source of similarity between the arts because of his insistence on iconicity. But, interestingly, others of his day found semantic devices in painting that seemed to incorporate temporality. Shaftesbury, for example, advised painters that certain signs—what we would now call indexes—could link the present of the painting with what preceded or followed it: "The traces of tears on the face of a person full of joy for having found a friend believed lost forever may indicate that person's suffering in the recent past" (Schweizer, p. 36). More generally, the temporal limits of painting could be overcome by isolating a moment in the action that revealed all that had led up to it and all that would follow. This is the so-called pregnant moment, and is obviously associated with historical and iconographic art, since it usually cannot function with full effect unless we already know the story captured in the moment of the painting.

Dependent as it is on literary sources, the pregnant moment in painting has in turn generated a literary topos in which poetry is to imitate the visual arts by stopping time, or more precisely, by referring to an action through a still moment that implies it. The technical term for this is *ekphrasis,* the concentration of action in a single moment of energy, and it is a direct borrowing from the visual arts.

The coordination of process and stasis, movement and permanence, time and space, tends to result in this relativistic stance of potential energy, of being always poised for movement or action in a stance of stationary flux. The most famous example of this perspective in the plastic arts is the Greek discus thrower crouching forever on the verge of unleashing the disc. In poetry the readiest examples are Keats' storied urn and T. S. Eliot's Chinese jar, oval symbols which contain in themselves a tense fusion of permanence and change, circle and sequence.[63]

The atemporal claim of ekphrastic poetry is figurative, of course, since the poem still occurs in time, though it refers to the timeless. Critics often take the claim literally, however; for example, "Keats proved himself the poet of still-life and quietness; perhaps no other poet in English literary history has drawn so much movement from stillness or so much music from silence."[64] Impressionistic as this statement is, it reveals at least that the assumptions behind the still-moment topos are paradoxical. Ekphrastic poetry signifies motion through a static moment. This signification, moreover, is usually not a mere symbolic reference but often an attempt at an iconic embodying of stillness.

It is, on the face of it, rather strange that literature should try to mimic the stillness of painting, when it has the property of movement and temporal flow that painters yearn for. Keats's famous ode, however, suggests a partial explanation: the translation of temporal flux into the stasis of the visual arts saves action from the impermanence and death that all time-objects suffer. The ephemeral is permanently fixed, becoming a hypostasis of ephemerality, and as such the Grecian urn "doth tease us out of thought." Shelley's "Ozymandias" plays on the same theme, but shows how art reveals the folly of those who would perpetuate a temporal state: the art that celebrates that state remains in mocking ruin long after its temporal referent has disappeared, and the inscription, "Look on my works, ye mighty, and despair," belittles reality through the empty indexicality of art.

Interestingly, these poems echo Jakobson's idea that in painting, the visual artwork remains at the time of concretization, while the poem has disappeared by the time its perception is complete. The very perception of a literary work is thus a reminder of temporal impermanence, with the poem, unlike the physical canvas, sharing in the impermanence of humanity itself. It can overcome that doom only by persisting in the memory—of the individual who reads it and of the generations that perpetuate the reading. As Roman Ingarden argues, the literary work differs from concretely existent bodies in that it is a "purely intentional object": "The purely intentional object is not a 'substance.' . . . Some of the elements assigned to [it] fool us with the outward appearance of a 'carrier'; they seem to play a role which according to their essence they are truly not capable of playing. . . . In comparison with any ontically autonomous object [the intentional object] is an 'illusion' . . . that draws its illusory existence and essence from the projecting intention . . . of the intentional act."[65] Hence the importance of mental process in discussions of poetic experience and the anxiety created by the problems of hermeneutics. It is this ephemerality that accounts for literature's nostalgia for the visual arts, and so the topos of the stopped moment.

But many poems using this topos have been content to express the idea of art's overcoming time without themselves overcoming it. They fail where the visual arts seemingly succeed; what they gain from the topos is an example of what they can merely aspire to do. For whatever social mechanisms do exist for the perpetuation of verbal art—and they are obviously extensive, beginning with the repeatability of print itself—the outcome is lacking in spatial extension and in the coincidence of aesthetic experience with artifact characteristic of painting. Thus, the literary topos of the still moment is an admission of failure, or of mere figurative success.

There is little wonder, then, that modern poets, so unwilling to settle for anything short of literal success, have reexamined the topos. Some employ techniques that exploit those deceptive "carriers" that Ingarden mentions to lend the work the air of an ontically autonomous object. This is the approach of concrete art discussed in chapter 3. Others attempt to forestall closure in the ekphrastic poem. In the following work, for example, E. E. Cummings provides a more literal realization of the still-movement topos than Keats or the elegantly discursive Eliot ever attempted.

these children singing in stone a
silence of stone these
little children wound with stone
flowers opening for

 4

ever these silently lit
tle children are petals
their song is a flower of
always their flowers

 8

of stone are
silently singing
a song more silent
than silence these always

 12

children forever
singing wreathed with singing
blossoms children of
stone with blossoming

 16

eyes
know if a
lit tle
tree listens

 20

forever to always children singing forever
a song made
of silent as stone silence of
song[66]

 24

Cummings treats ekphrasis so literally here that the poem reveals the basis of the topos and the technical features upon which it depends. Accordingly, I shall spend some time examining this work.

As with Eliot's *Four Quartets,* this poem uses the child in symbolizing the overcoming of temporal flux, rather than Keats's scenes of lustful pursuit. The child is a familiar symbol of natural renewal, becoming, and potential; however, the mere choice of symbolism can never be enough to save a poem from the ephemerality that haunts it. Instead, Cummings has marshalled a number of techniques to disrupt the units that demarcate temporal flow, the inevitable ending of things in time. Stanzas run into each other, lines are

enjambed, and the poem as a whole need not end with the last line but could be read as a circle poem, a possibility symbolized by the flowering wreath carved around the stone children. A good many of the enjambments, moreover, are pivots, puns which play on our expectation that a syntactic unit will end with the end of a line. For example, in line 3, the children are wound with stone; they are thus an artwork, unmoving and unliving. But then by line 4 we learn that they are wound with stone flowers, an oxymoron that carries the central topos of the poem. One could just as easily read "wound" as an active verb, that children wound *us* with stone flowers, affecting us through their paradoxical state. Like the pivots, the homonymic "wound" creates a simultaneity of meanings that trips up the sequential flow of the syntax. Such homonyms abound in this poem.

More striking than these two techniques individually is their combination. Lines 7–12, for instance, are an amalgam of two sentences: "their song is a flower of always" and "always their flowers of stone are silently singing." The pivotal word here is "always," which is stretched homonymically to function as a noun as well as an adverb. It thus contributes to a sense of eternality, since it prevents the syntax from either beginning or ending and mingles the stasis of a noun with the act of verb-modifying. Such techniques fuse continuity with simultaneity in imitation of the atemporal hypostasis they represent. In this way they are icons, and insofar as they force the reader to continue reading, to become perpetually involved in this continuity of the poem, they are like visual art, whose perpetuity before the eye creates a continuity of concretization rather than a discrete, beginning-to-end experience.

Another feature of the poem increases its claim to atemporality: the constant repetition of words, rhythmic units, and phrases in a pattern that strongly resembles permutational poetry. I am thinking particularly of this sequence of phrases: "singing in stone," "silence of stone," "wound with stone / flowers," "song is a flower," "flowers / of stone," "children of / stone," "a song made / of silent as stone silence of / song." The final phrase, which gathers up a number of earlier ones, is the strongest cause of closure in the poem, but its very disruptions of syntax at the same time disrupt completion. In this sequence of phrases, words are limited in number and easily permutable within a small number of syntactic patterns. The effect is to make words and phrases synonymous; they seem to take each other's place effortlessly and hence to foil our ability to discriminate among them.

Try to memorize this poem and you will see what I mean. The singsong result—obviously suitable to the subject of the poem—goes on and on, spreading the meaning throughout the poem rather than dividing it into the discrete stages of a developing argument. The contrast here to Cummings's sonnets, not to speak of more normative works of that genre, is instructive. This technique is an extreme case of Jakobson's projection of equivalence from the axis of similarity onto the axis of contiguity; the poetic sequence is composed of comparable elements whose suspension from syntactic differentiation makes them appear as almost a linguistic paradigm, a substitution set, existing as an atemporal simultaneity. Though Jakobson argues that this paradigmatic property is the differentia of all poetic language, the effect is certainly more literally realized here than is normally the case.

Moreover, on the thematic level, the elements undergoing this process are particularly appropriate to the topos involved. The poem describes a statue of singing children encircled with a wreath of flowers (perhaps a carving on a gravestone). The static nature of the stone artifact is infected with movement through participles that become permutable with nouns, words extended homonymically to function as several parts of speech, and the extensive alliteration and assonance that link antitheses, for example, "silent," "silence," "silently," "stone," "song," "singing." The substitutability of similar sounding words is part of the more general technique of paradox. The children sing but are silent; the blossoms sing; the song is more silent than silence; the flowers are opening forever; the children's eyes blossom; and so on. Like Cummings's famous "love is more thicker than forget," this poem literally "teases us out of thought" with its paradoxes, making it all but impossible for us to concretize continuous meaning from the flow of words. It is a technique also used by Gertrude Stein, who consciously developed it as a way of overcoming discursive meaning and the usual temporal build-up of linguistic sense.

The one exception to all this is the stanza placed off-center in lines 17–20. Suddenly we find two finite verbs, "knows" and "listens," rather than the participles used before, along with shorter lines and predominantly monosyllabic words. In fact, one of the two disyllables is divided, "lit tle," but this time within a single line rather than between two, as in lines 5–6. It thus contains within it the silence, the stoppage, that the poem has been avoiding so energetically. But this silence is encircled with a phonic mirror

image, /lɪt/ and /təl/, as if it were merely a seam or angle joining the beginning and end of the sequence into a circle. The /t/ and /l/ occur again in "tree listens" and the word "silent" itself. And the meaning here—that only the children know if the little tree listens—is teasingly open too. We do not know whether the tree listens, although we know that the children know. The absoluteness of knowledge is shifted into the eternal world of the stone children but refused to us temporally limited observers. If the little tree does listen, moreover, unlike us it listens "forever" as the next stanza reveals, picking up once more the rhythm and polysyllables and vocabulary of the earlier stanzas. The finitude of the penultimate stanza is thereby gathered into the atemporality of the poem as a whole, just as the silence of stone, through art, becomes the vehicle of eternal singing.

I am quite aware, of course, of how limited and figurative the overcoming of temporality in this poem really is. The poem still ends with its reading; it is not any more literally spatial than other poems; it manages whatever embodying of the still-movement paradox it achieves through rhetorical sleight-of-hand. But insofar as the temporality of a poem is in part created by the demarcation of temporal units through syntax and versification and ordered semantic 'sense,' this poem does manage to prevent such demarcation from functioning fully. And to that degree, to the extent that it obliterates many of its potential endings, it captures a little of the feeling of eternity. And that is all that poems using the still-moment topos ever aspire to do; for, as we noted earlier, it is a humble and conservative topos in terms of the claims of literature. Cummings has managed certain technical advances over the generally thematic and imagistic treatment of the topos by other poets, but his poem nevertheless accepts the boundaries of verbal art that make its surmounting of temporality virtual at best.

And just what are those temporal bounds? First, time is apparent only through temporal objects, physical elements of the word or of the represented world, which occur in time. As Ingarden states, "Only the representation of that which fills out time evokes the representation of the time filled out by it. . . . It is always—to echo Bergson—only *isolated* 'segments' of 'reality' that are represented, a reality . . . which is never representable in its flowing continuity. The reason for this lies precisely in the fact that the represented world has the source of its existence and essence solely in a *finite* number of sentences. Consequently, the represented time phases never com-

bine into *one* uniform, continuous whole" (p. 237). We can see from Ingarden's explanation why literature fails in representing the eternity of temporal flow and why Cummings resorted to some of his special techniques in "these children." Wherever a temporal unit threatens to reach its natural ending, he extends it or fuses it with the next unit. Thus, a major obstacle to achieving the supposed presence of the visual arts—the finitude of the temporal elements of literature—is somewhat mitigated.

The units that demarcate temporal flow can be any finite element of a poem. Individual sounds follow each other in sequence, but each one ends before the next can begin. However, insofar as meanings arise only through the combination of speech sounds, meaning unites these elements into the larger temporal flow of the word. The same holds for each successive combinatory level—the phrase or idiom that extends duration across words, the intonation pattern and the syntactic structure that extend duration across phrases, the verse line that extends duration across feet, the stanza, and so on to the poem as a whole. Each larger unit triumphs over the stasis of the next smaller one, only to create a new ending.

Within these various units, a number of different temporal strata are enshrined. First, there is the actual lived time of the reading, the period it takes to process the work from beginning to end. This is partially a function of the internal structure of the work and partially of the reader's make-up and the accidents of any particular reading (whether there are interruptions, whether the reader makes a mistake and must backtrack, and so on). Insofar as the text is 'difficult,' i.e., demands more from a reader than other texts in concretizing its meanings, it may increase or otherwise alter the reader's lived time in experiencing it. Indeed, a good many critics feel that this is one of the essential differences between aesthetic and nonaesthetic uses of language. Levin, in his foreword to Ingarden's *Literary Work of Art,* for example, argues that to understand how a literary work functions, we must illuminate "the various possible ways in which its given structures . . . can serve to *modulate* the lived time of an inevitably temporalizing—and always already temporalized—consciousness" (pp. xxi–xxii). The lived time is finite, but our experience of it, or of the temporal work flowing through it, can be quite different. If the work successfully extends our retention and protention as described above, the reader can experience the illusion of the poem as a single perceptual now

Beyond the lived time of the reading subject, the literary work represents a temporal flow through its referential stratum. In the novel, this flow is explicit in the sequence of events depicted; in the lyric poem, its absence is definitional. Instead, the lyric pretends to represent one now-point in its speaker's consciousness. It is supposedly a single present, a suspended moment in the flow of time which is unified despite whatever temporal dimension it inevitably has. This definitional atemporality of the lyric is another motivation for the comparison with the visual arts through the topos of the still moment. Like the reader, the speaker's consciousness is suspended from time's depredations. Thus, the use of this topos inevitably is a metaliterary statement, a theme corresponding to the temporal givens of the lyric genre.

The still-moment topos in the visual arts, however, is not doomed to definitional failure: the moment of action caught in the perpetuity of the work is literally stopped; it is presented in a medium that does not function temporally (although of course it is processed by the receiver over a period of time). Why, then, do modern visual artists not glory in scenes like the one Keats "copied" from the Grecian urn? The answer, I think, is obvious. Despite the value accorded it by literature, this capturing of the epitome of motion has also been recognized as a compromise; it is only a figurative way of claiming that motion is present in painting. Moreover, the ease with which a camera manages to capture moments of real action makes the complementary act in painting seem not only metaphoric but lacking in immediacy. This is an important way in which the camera has changed the priorities of painters in this century. Hence the profusion of more literal treatments of motion in the visual arts, such as Balla's famous dog on a leash pictured as an amalgam of several moments of motion, as if a camera shutter had exposed the film a number of times. Hence also the cubist combination of views of an object that could not be seen simultaneously, so that we are forced to acknowledge the presence at one moment in time of various discrete moments of perception. The cubists were mimicking the process of visual concretization in which our scanning of objects is fused into a unitary conception not equivalent to any single perceptual moment. And correspondingly, the abstract expressionists' spattered canvases betoken the painterly acts that generated them.

These experiments and so many others in this century raised the content of the work to a meta-artistic statement rather than a view of the object

world. The still-moment topos in literature was also metaliterary in thrust. Gone from such treatments in either art is any great interest in the depicted motion itself, which as often as not was utterly and deliberately banal (Balla's dog on a leash, the cubists' still lifes of everyday objects, and even Keats's frenzied lovers, if we think of it). This was a far cry from Aristotle's precept that the proper subject of art be significant human actions. Motion in its relation to the picture plane had clearly become more interesting than any particular motion, and the historical or narrative painting became correspondingly déclassé in our time, demoted to that very interesting interartistic genre, the comic strip (and then reelevated, lifted out of its narrativity, in the hands of the high pop artists).

As a result, painting is engrossed in formative principles and frequently dispenses with naturalistic subject matter altogether. It tries in the case of cubism, to raise to the level of subject matter the process of visual concretization in which time is a factor, while in the abstractions of, say, Malevich, the *only* time is that of the perception, since black circles and such exist in a timeless realm. In the extreme form, op art also isolates perception from content, juxtaposing certain colors in patterns that affect the eye physiologically so as to produce the illusion of motion. The sequence of the picture scans becomes confused with a seeming jerkiness in the content of the painting, and the viewer stands marvelling at the fact that what he sees as moving is in fact static. In this way, the interrelation of the perceived object and the act of perception, of *noema* and *noesis,* is raised to viewer consciousness in modern art!

But if modern painting has concentrated on clarifying the fact that motion is in the eye and not the canvas, modern sculpture has defied Lessing more literally. And it is here that the difference between two- and three-dimensional media is crucial. If one wants to make a two-dimensional painting that has a temporal content, one ends up with a new art—the cinema—which has, following the traditional program that spawned it, a generally mimetic content rather than a self-reflexive one. The few attempts at paintings with moving parts have never gained a place in the modern canon, not even in the modern avant-garde canon. But mobiles and electric sculptures are very much at the center of contemporary art, as their prices testify. Since sculptures are not illusions of bodies, but bodies as such, the barrier between them and life is animation itself, motion; and machine and

computer technology have provided the means for compensating for that lack. The wind and even the viewer can introduce randomness into the motion of a man-made body, rendering it almost a part of nature. And gravity, engines, and computer programming can lend it an innate pattern of motion, as if it "had a mind of its own." But unlike the situation in painting, here no one feels compelled to designate the result a new art; it is treated as a logical development within sculpture.

It is the double removal of painting from living objects—the fact that it neither moves nor is itself a body—that makes Lessing's position on artistic spatiality inevitably limited. It explains what we already know—that Lessing was primarily concerned with sculpture in the *Laokoön*. This double removal also makes Simonides' "mute *poem*" a more meaningful designation than one at first suspects: painting is nonlinguistic yet thoroughly semiotic. Its removal from the world of things makes painterly temporality *and* spatiality different from that in the natural world. And so a painter cannot blithely imitate bodies, as Lessing advises, matching a static medium to a static subject matter. The sign relation intrudes in numerous ways into this relation, forcing us to acknowledge the disjunction of painting from the things it depicts.

As with sign function in general, the modern reexamination of time and space has uncovered unanticipated complexity. Time and space in fact relate to three very different aspects of the work: the physical artifact, the perception of it, and the meanings it represents, and each of these may involve extremely complex sublevels. It is clear that in some way both arts contain both temporal and spatial properties which artists may exploit to suggest the interartistic analogy. But it is only in extreme cases, e.g., concrete poetry, that the precise correspondence of a verbal text to the spatial-temporal norms of visual art is even conceivable. This is not to say that we should abandon the comparison of the arts, but rather that artistic structure is so complex that a poet intent on a speaking picture or a painter intent on a mute poem has a vast array of technical properties to play with, any one of which, turned from its normal spatiality or temporality, may provoke the interartistic analogy. "The spatial versus the temporal arts" begins to appear too gross a characterization to be useful, and we are forced into a much more technical scrutiny of the way the media of the two arts function, a scrutiny that lies at the center of structuralist aesthetics.

The Structuralist Approach

He paints his language, and his
 language is
The theory of what the painter thinks

Howard Nemerov

Structuralism, especially its French and Russian schools, has turned to language as a model for understanding all cultural phenomena. And since literature is constructed of language, this model is particularly crucial to the interartistic comparison. The various structural strata of language—the minimal sound unit (phoneme), the minimal semantic unit (morpheme), the rules for their combination (syntax), reference (semantics), and the relation of the sign to the participants in its communication (pragmatics)—may all be examined for their applicability to painting.

Let us begin with the minimal nonsemantic unit. A phoneme is the minimal unit of speech. It is systemic and rule-governed in its occurrence within a given language. It is not meaningful in itself but serves to distinguish meaning. Because literature is made of language, phonemes might appear to be its minimal units too. But what would correspond to them in painting? The most obvious possibility is the brush stroke, but this is not invariably a discrete component of a painting, and varies greatly in size and function. Meyer Schapiro explains that

in a picture the technical-artistic means of suggesting modelling and illumination affect the scale of correspondence. There is in the hatched lines a small unit that does not represent anything by itself through its form, yet when repeated in great numbers in the proper context vividly evokes a particular quality of the object. On the other hand, in Impressionist paintings fairly large elements have acquired a non-mimetic aspect. An extensive object-space, a landscape, is represented on a small field, with a consequent increase in the relative size of the units, *i.e.,* relative to the whole complex sign of which they are part. In the picture the parts of the painted tree are flecks without clear resemblance in shape or color to the parts of the real tree. Here the painting seems to approach a feature of verbal signs. The tree-sign as a whole is received as a tree, often through its context; but the parts are hardly like leaves and branches. ["On Some Problems," p. 239]

However, artists are free to choose whether their part-whole relations will be 'linguistic' in this way or not. In primitivist painting, for example, the parts of the tree would be identifiable as such.

A much older correlation of minimal units is that between colors and speech sounds, and the substantivist basis of this comparison, versus the relational basis of the Jakobson-Schapiro approach is obvious. Gérard

Genette's book *Mimologiques* chronicles the history of such theories and shows how poorly they correspond to each other.[67] Similar attempts to match musical tones and colors brought similarly disappointing results, as when Alfred de Musset found it necessary "to argue with his family to prove that *fa* was yellow, *sol* red, a soprano voice blonde, a contralto voice brunette."[68]

Mallarmé's color-vowel correlation attempted to match the symbolic values of colors with symbolic values of sounds. Thus, yellow is bright and sunny, and so is the vowel /i/. Unfortunately, as Eisenstein has argued at great length, yellow is also associated with the cowardly and sinister, and in fact all colors have at least two, usually opposed, semantic valences.[69] The inability of artists and scholars to agree on any matching of phonemes and meanings is just as marked, and in fact the essential advance of Jakobson's concept of the phoneme over earlier classifications of speech sounds is that it is *not* meaningful but only meaning-distinguishing.

This fact has led Schapiro to suggest that colors gain meaning through oppositions within particular contexts, somewhat the way Gombrich has explained phonemes through the famous "ping/pong" experiment in which we are asked to match these syllables to paired objects. Invariably "ping" is a cat and "pong" an elephant. In poetic contexts in particular, phonemes are frequently linked to a specific semantic opposition through careful word choice, as in Auden's "Doom is dark and deeper than any sea dingle" where 'dark' back vowels are used for doom and 'bright' front ones for the dingle (sea cave) that is not as dark or deep as doom. Color and phoneme could then be seen as minimal units without an absolute one-to-one correlation to each other, but with a similar special structuring in works of art. In such a case, one could compare a poet's use of phonemes with a painter's use of color insofar as they each took advantage of this differential semantic potential.

Perhaps the most technical correlation of speech sound and color is Dora Vallier's equation of the phonemic triangles of vowels and consonants with triangles of the chromatic and achromatic tones,[70] which I mentioned earlier (p. 30). Red, yellow, and blue are like phonemes, Vallier argues, in that they are irreducible units; out of their combination arise all possible colors. The colors are organized from light to dark (red to violet) just as in the white-to-black range, but the two ranges exclude each other. The achromatics are found only "at the level of pigment," since they are not part of nature; they

underlie the principle of spatiality in painting, since "painting degree zero" is the sketch. Gray has a pivotal position as both the limit of chromatism (mixtures of colors come out gray), and also the "seat of achromatism" (a mixture of black and white). Thus, the achromatic triangle with white and black at the base and gray at the apex is an epitome of painting; the base "delimits the very condition of printed space—the disposition of light and darkness, while gray at the apex signifies the mode of functioning of painting—a precise mixture of colors" (Vallier, p. 290). Vallier superimposes color triangles on phonemic triangles, claiming that just as spatialization precedes chromatism, consonants precede vowels in children's acquisition of language.

The comparison is based on rather technical features and is, unfortunately, not completely worked out. Nor does it justify at long last the equation of an instance of "a" in a poem with the presence of red in a painting. Vallier's argument may be instructive, however, in alerting us to the opposition between chromatism and achromatism in painting, and vowels and consonants in poetry, though perhaps not in explaining how we are to relate the two pairs.

In any case, this discussion demonstrates that literature does not present the problem regarding minimal units that painting does. In painting there is no general consensus about whether minimal units are colors, geometrical shapes, brush strokes, figures, and the like, nor is there much hope for one. It is not that individual paintings do not contain such units, but that these units differ from work to work and painter to painter. In fact, the minimal unit of painting is a matter of choice, a stylistic factor, whereas no poet can choose whether phonemes will build his language sequence. Thus, many a theorist, as Jiří Veltruský notes, "states that painting, drawing, and sculpture are semiotic systems that, unlike language and music, are not founded on units (the difference between language and music consisting in [the fact] that units of one are signs and those of the other are not)."[71]

But Veltruský continues: "Nonetheless, it is in my view somewhat rash to conclude that the semiotics of painting should not be founded on the identification and analysis of the simplest components of the picture. . . . This disregards the very important fact that every component, as soon as it enters a picture, acquires a differential value which it does not have in itself, as a material." This contention is certainly true. But phonemes have this differ-

ential value, or at least some differential value, as a material *before* they enter a poem. According to Jakobson,

> the verbal or musical sequence, if it is to be produced, followed and re-membered, fulfills two fundamental requirements—it exhibits a con-sistently hierarchical structure and is resolvable into ultimate, discrete, strictly patterned components designed ad hoc. . . . No similar components underlie visual sign sets, and even if some hierarchical arrangement ap-pears, it is neither compulsory nor systemic. It is the lack of these two properties that disturbs and rapidly fatigues us when we watch an abstract film, and which inhibits our perceptive and mnestic abilities. ["Visual and Auditory Signs," p. 336]

Just as with the ordering of the perceptual sequence, what is predetermined for literature is a realm of free play in painting. But the fact that paintings contain minimal units, however these may vary from work to work, means that there is some basis for comparing them to phonemes, and indeed this is an area where painters can choose to be more or less 'linguistic.'

Depending upon what a painter's choice of minimal units is, his work will be comparable either to a phonemic or morphemic structure. Seurat's paint-ings might be termed 'phonemic' in that their smallest units are abstract and related in oppositions determined by the color spectrum (fig. 1). Primitive art, in contrast, might be considered to have morphemes as its smallest units (fig. 2). In Seurat's case, then, the structural link between phoneme and morpheme that exists in language might seem to hold, the nonsemantic minimal units combining to form larger units which are semantic. But since a painting may contain nothing but 'phonemic' units (Malevich at times, Pollock, fig. 3) or nothing but 'morphemic' ones (Rousseau, much of syn-thetic cubism), the structure of painting is not dependent on the phoneme-morpheme relation that holds in language. Again, the relation between these units in painting is a matter of choice.

As for the syntactic level, again the correspondence is not rule-governed on both sides. In language, morphemes are combined by the rules of syntax, which in poetry must compete with the combinatory rules of versification. These two systems may be in harmony, as in neoclassicist end-stopped lines, or in conflict, as in the frequent enjambment of modern verse. Units in painting, in contrast, are combined according to 'laws' which may or may

55

Fig. 1.
Georges Seurat, "Side Show." The
Metropolitan Museum of Art, New York
(Bequest of Stephen C. Clark, 1960)

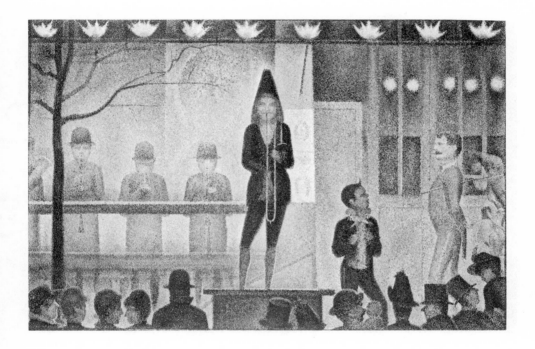

Fig. 2.
Henri Rousseau, "The Dream." The
Museum of Modern Art, New York
(Gift of Nelson A. Rockefeller)

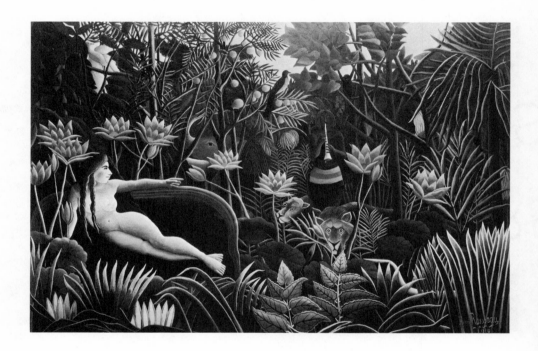

not be invoked. The laws of the physical world do not permit an un-supported object to float in mid-air, for example, so that artists wishing to project a claim for realism will not represent such an object. But other semantic orientations could demand just as readily a failure to conform to nature's laws—allegorical or surreal art, for example. Poets may defy norms of versification and still produce poetry, but in general literature tolerates very little in the way of syntactic deviance.

Another set of rules often said to govern painting is geometry. But what "govern" means under these circumstances is hard to say. It certainly does not mean "limit" or "control" as in the case of syntactic combination. The laws of geometry rather serve to describe the space relations established by the artist's composition. Despite this difference, there is a long history of grammar-geometry comparisons. Roman Jakobson has chronicled the comparison of the two in criticism and has given this approach new life by dividing words into two classes—the semantic and the syntactic—according to their part of speech (the old distinction between categorematic and syncategorematic elements). The most "relational," syntactic words are pronouns and other shifters, which compare to nonpronominal words—nouns, verbs, adjectives, and adverbs—as geometrical to physical bodies.[72] This opposition has particular value in regard to the abstractive trends in the arts, such as cubism in painting and literature. It establishes yet another four-term analogy: pronouns are to nouns, verbs, and so on as geometrical to physical bodies. However, the status of the combinatory rules in each case is not clarified in this comparison beyond the mere relation of abstract to concrete.

The relations within the plot in literature (especially drama) and within the design in painting have a long history of comparison. Aristotle is the source of the analogy, with his claim that just as plot is more essential to tragedy than character, outline is more essential to painting than color (see Lee, p. 5). This notion of priorities played into the form-content split of the pictorialists, who were fond of dividing the process of creation in the arts into distinct phases. Dryden, for example, following the ancient rhetorical legacy of the three steps, *inventio, dispositio, elocutio,* claims that the moral "is the first business of the poet, as being the groundwork of his instruction. This being formed, he contrives such a design, or fable, as may be most suitable to the moral; after this he begins to think of the persons whom he is to employ in carrying on his design; and gives them the manners which are most proper to

their several characters. The thoughts and words are the last parts, which give beauty and coloring to the piece" (Dryden, p. 300). In a parallel process, Dolce has the painter proceed from *inventione* to *desegno* to *colorito*—general plan, preliminary sketch, and final rendering in color (Lee, p. 70).

This genetic account is interestingly connected to the argument for "spatial form" in verbal art. It suggests that the plot—rising action, climax, and so forth—could be visualized graphically to produce diagrams with the same kinds of properties as the pictorial sketch.[73] Such visualizations are the basis of notions like the "harmony" or "symmetry" of the two arts. Exactly how figurative they are is a matter of dispute (see Wellek, "Parallelism," p. 57), but if plot is a way to combine entities in drama or narrative, space relations or design do combine the elements in painting, the temporality of one scheme contrasting to the spatiality of the other, and both translatable into spatial terms.

Within the literary plot, time creates two different sequences: the order in which events occurred and the order in which they are narrated. In this century at least, the coincidence of these sequences has been taken as a property of realism. Similarly, the combining of only those elements that are or can be cotemporal is a part of the mimetic claim of painting, since the picture stands, from the Renaissance to impressionism, as a unified moment of perception. Given this temporal claim, anachrony within a painting could have as seriously antinormative a force as a wild jumping back and forth in chronology in a narrative.

Another set of combinatory rules in literature is common to all writing. These are the principles of cohesion that relate one sentence to the next and demarcate one paragraph from another, while at the same time establishing their connection. The property that holds a written text together is the set of relations established between the already known and what is new, as when a pronoun-subject of a sentence indicates a carry-over of previous information from the last sentence, while its predicate introduces something new.[74] The weaving of sentences so as to make the new and the old recognizable as such is the essence of paragraphing and sentence connection. It would seem to have many potential parallels in painting—spatial breaks between background and foreground versus the smooth continuity of contiguous bodies; the juxtaposition of impossibly coexistent beings in, say, surrealism, versus the juxtaposition of conventionally associated objects in realistic styles; the

Fig. 3.
Jackson Pollock, "One" (Number 31,
1950). The Museum of Modern Art,
New York (Gift of Sidney Janis)

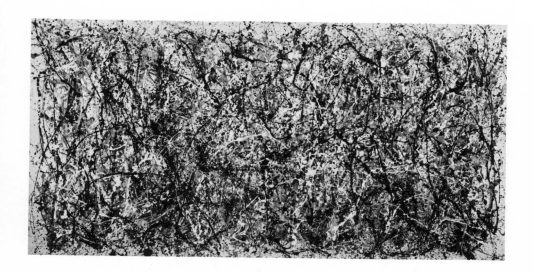

very continuity of the surface itself—whether space is represented through opposed, distinct patches of paint as in pointillisme or in smoothly modulated shading.

However suggestive the relation between literary and painted cohesion, plot and composition, or grammar and geometry may be, however, the sets of rules in each pair do not carry the same authority for each art. We would not say, for example, that there is such a thing as a geometrically ill-formed painting, while we should certainly say that a sentence, whether inside or outside of literary art, can be syntactically ill-formed. Again we are faced with the problem that poetry is created out of elements related according to fairly mandatory rules, while the material of painting is unformed, and whatever formative rules it submits to are a matter of style or semantic convention rather than necessity. To argue that the geometrical imperatives behind painting are those of reality itself—gravity, light direction, and so on—is, we might say, to confuse mechanics with mathematics.

Meyer Schapiro has pursued a more promising, though still piecemeal, approach to the relating of grammar and pictorial space. Just as Jakobson observes that "such a sequence as 'the President and the Secretary of State attended the meeting' is far more usual than the reverse, because the initial position in the clause reflects the priority in official standing" ("Quest," p. 350), Schapiro has shown that certain shape relations are noncommutative. Thus, □ □ has a different semantic weight from □ □, as do ⊟ and ⊟. "The *and* in 'A and B' where the two elements differ decidedly in size or form or color, is adjunctive, not conjunctive; and the position in the field expresses this relation, just as the pair *Father and Son* has a quality lacking in *Son and Father*" ("On Some Problems," p. 233).

Moreover, just as the initial position in certain linguistic pairings reflects semantic priority, Schapiro finds that the picture plane is organized hierarchically. Medieval "perspective" placed the most important subject in the center and made it larger than the others, indicating lesser importance by increased distance from the center and by decreasing size. As Dryden had urged even when Renaissance perspective was already the norm, "the principal figure of the subject must appear in the midst of the picture, under the principal light" (Dryden, p. 319). Poetry tends to make beginnings and endings places of semantic weight, so that a technical comparison of the two arts can consider the correspondence of position and semantic weight.

With Renaissance perspective, the positioning of objects on the picture plane and their relative size become a function of their distance from the imaginary viewer of the scene, with the result that large objects might be quite unimportant and vice versa. As a consequence, at least two organizational systems coexist in the painting, one the visual perspective tied (more or less closely)[75] to normal vision, the other the correlation of size and centrality to semantic importance. These systems may reinforce each other or they may not, so that a parallel may be seen to the two competing organizational schemes of poetry—versification and syntax— which may or may not reinforce each other, as in the case of enjambment. The relation between 'formal' and 'semantic' systems in each art can thus become a means of comparing paintings and poems, as can the separability of the 'formal' from the "semantic" in particular works of visual art. However, the painter, here as with other organizational systems, seems much freer to engage or not engage a given perspectival system.

Perspective is not only an aspect of the syntactic level of painting but of the pragmatic level as well. Unlike the semantic nature of medieval or primitive perspective, Renaissance optical perspective implies a viewer and projects a scene from a specific standpoint. It is a way of relating the perceiver to the painting, since it posits a specific viewing position by which the scene depicted achieves its organization. Perspective, then, is an important part of the pragmatics of painting and finds its literary analogue in point of view.

Boris Uspenskij's *Poetics of Composition* examines this correspondence in detail, finding one important parallel between perspective and point of view on the spatial-temporal level of the artwork. "In visual art we speak about the transferral of real, multi-dimensional space onto the two-dimensional surface of a painting; the key orientation point here is the position of the artist. In literature, the same is achieved by the verbally-established spatial and temporal relations of the describing subject (the [imaginary] author) to the described event."[76] Spatially, just as the arrangement of a scene vis-à-vis the point of vision indicates the distance of the visual perceiver from the action, the narrator indicates his distance from a scene through such techniques as the bird's-eye view, the silent scene (where he is close enough to see but not to hear), the fusion of his view with what a character within the scene is seeing, and so on. Though this may appear to be another case of equating the visuality of painting with description in literature, the impor-

tant point of parallelism here is the congruent structural relationships be-
tween a paradigmatic perceiver and what he perceives. Whether the reader or
viewer's perception of a scene is visual or not, it is a function in both cases of
this pragmatic relation within the structure of the work.

Uspenskij argues that Renaissance and pre-Renaissance perspective differ
significantly in structuring this relationship. Since the Renaissance, the artist
has stood outside the painting, his position fused with that of the viewer.
However, before the Renaissance, the painter could take a stance within the
painting as well, as Uspenskij illustrates with a medieval painting in which
the scene spreads out all around the center, appearing as if one saw simulta-
neously all around oneself. Similar to this is the system of inverse perspective
seen in medieval icons, in which "the diminution in size of objects in the
representation occurs not in relation to our point of view (the point of view
of the spectator outside the painting) but with respect to the point of view of
an abstract internal observer whom we may visualize as being located in the
depth of the painting" (Uspenskij, p. 136).

Schapiro has shown, moreover, that directionality in a painting is a func-
tion of viewpoint. If a landscape or still life is presented to us, its left and
right are our left and right; if people are in the painting, however, just as in
stage directions, left and right are reversed, and we adjust to their point of
view. Similarly, on what Uspenskij would call the psychological plane, the
subjectivity of a first-person narrative can be matched in painting to such
visionary scenes as Brueghel's "Mad Meg" (fig. 4), in which a central figure
is surrounded by the dream world of her imagination.

The impossibility of separating the pragmatic from the semantic is appar-
ent here, for notice what happens when we compare the 'knowledge-
potential' of the Renaissance versus medieval systems with their correlates in
narrative viewpoint. The viewer integrated with a physical scene "sees all
around it," and hence, so do we. The increase of information here is like that
achieved through multiple viewpoint in Cézanne and cubism. The Renais-
sance stance outside the frame limits the perceiver's knowledge to what can
be seen unidirectionally at one moment in time. Conversely, the more narra-
tive viewpoint is fused with a character participating in the action, the less
we know of it "objectively," while the more omniscient the narrator is,
standing uninvolved outside the action, the more information we are likely
to get. Interestingly, after the Renaissance, paintings were predominantly

Fig. 4.
Pieter Brueghel the Elder, "Mad Meg."
Musée Mayer van den Bergh, Antwerp

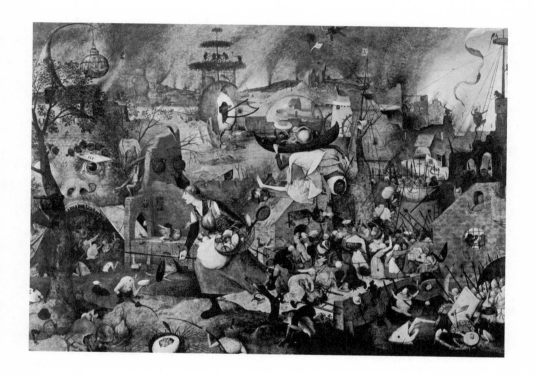

limited and therefore subjective views of a scene, even though they were governed by the 'objective laws' of optical perspective; literature, in contrast, could comfortably link the points of view of many characters into a composite fabric of knowledge simply by having the universal access of omniscience. With modernism, the trend seems to have reversed itself. Literature became obsessed with first-person narrative and the limitations of knowledge implicit in it, whereas painting became much more intent on an omniscient perspective. Symptomatically, Marinetti's daughter claimed that futurism fought for the "interpenetration of the figure and its surroundings, insertion of the spectator into the middle of the picture."[77]

Despite these correspondences—direct and inverse—many modern theorists argue that painting is much more limited than literature in what it can make us know. Sol Worth epitomizes this trend in his title "Pictures Can't Say Ain't": "pictures—paintings, movies, television, or sculpture—cannot be either true or false signs, and . . . therefore they cannot communicate the kinds of statement, the meanings of which can be interpreted as true or false" (p. 85). In part, this statement does little to separate pictures from literature, since the overwhelming majority of modern theoreticians consider literature equally suspended from true-false judgments. However, insofar as the *medium* of painting is being declared incapable of signifying "x is" or "not," it would differ from the capacity of language, the medium of literature. The partial signs of the literary text contain negations—whether they are seen as referring directly to extra-artistic reality or not, whereas the partial signs of painting contain no such negative meanings. Like the Alpers (pp. 457–58), who argue that there is nothing equivalent to tone of voice in painting, Worth claims that pictures are limited to depicting the *is*. They "cannot depict conditionals, counterfactuals, negatives or past future tenses. Neither can [they] make passive transformations, ask questions, or do a host of things that a verbal language is designed to do. Pictures depict the present even when they depict fantasies" (Worth, p. 102). And finally, "a picture cannot comment on itself. A picture cannot depict 'this picture is not the case' or 'this picture is not true'" (p. 103).

In such discussions it is essential to distinguish between innate properties of the medium and its properties when used within the semiotic system of the work of art. Just as language can be seen as losing its ability to make referential negations once it is embodied in a poem, paint gains many of the

properties that Worth denies when it becomes a picture. Hogarth's "Satire on False Perspective," for example, is a metastatement about both artistic norms and about itself, since part of its meaning is that "this picture does not conform to the rules of optical perspective"; it would mean this in western culture even without the addition of its verbal title. I think that one of the 'claims' of a Boschian or Brueghelesque vision painting is that "this painting is what the figure in it imagines, and not what anyone else would actually see." It is always futile, of course, to dispute which linguistic paraphrase is correct, since the paraphrase is in the medium with all the properties said to be lacking in painting. But Worth's argument seems wrong-headed if urged de jure, and unproven if urged de facto. I shall return to this issue in "Illustration" in chapter 2.

At this point, however, I can at least stress that one of the most fundamental features of artistic perception is the perceiver's involvement in meta-artistic meaning. This is the realization of the difference between sign and thing implicit in every artistic perception, the corollary, if you like, of Twining's "this is that." Like the Russian formalists with their "defamiliarization" or the Prague structuralists with their "deautomatization," I. A. Richards claims that the placement of familiar objects in an unfamiliar context is one of the primary values of the "representative or mimetic" arts. "Instead of seeing a tree we see something in a picture which may have similar effects upon us but is *not* a tree. The tree impulses which are aroused have to adjust themselves in a way in which they ordinarily do not."[78] Arnheim claims, moreover, that only in the fictive world can objects exist unmodified by their contexts, as in children's drawings where a tree's color is unaffected by the light emanating from the sun; thus, art sets up new figure-ground relations, the metaphor being the paradigmatic mechanism for doing so.[79] In each of these cases, the relation between reality contextualization and artistic contextualization is part of the meaning of the work of art, as is the difference between the reality continuum and the boundedness of the represented world. The work of art is a sign, not a thing, and both arts—visual and verbal—establish some degree of tension between the semiotic and the object world. To this degree at least, they are semantically and semiotically comparable.

One last semantic barrier between the arts that is often cited is the ability of painting to be utterly abstract and the corresponding inability of literature

to be so, since it is composed of words which have preexisting meanings. The Russian critic Osip Brik wrote, "Let us not confuse inscriptions with arabesques. Let us not make any inscription that is impossible to decipher. And let us be grateful to the formalists: it is through their efforts that we know that it is impossible to read an arabesque" (quoted in Laude, p. 471). This claim, like Worth's, seems valid only if the arabesque is treated outside the context of a painting. As soon as it enters a picture plane, its size vis-à-vis the frame, its position vis-à-vis the plane or any other elements of the picture, the directionality of its components, and all the other factors that Schapiro isolates will render the arabesque meaningful. And its being an arabesque, or any 'pure design,' gives it a meta-artistic significance in comparison to the nonabstractness of most paintings. Leo Steinberg, in discussing the most extreme modern abstract art, reveals how full of meaning an arabesque inevitably is: "the specific look of contemporary abstract art—its object quality, its blankness and secrecy, its impersonal or industrial look, its simplicity and tendency to project a stark minimum of decisions, its radiance and power and scale—these become recognizable as a kind of content, expressive and eloquent in their own way."[80]

In contrast, words filled with lexical potential at their point of entry into a text can be severely limited in semantic force, for example, in aleatoric verse or the typographic play of concrete poetry, and every letter of the alphabet, moreover, can be presented as an arabesque. It is impossible for either art to be totally nonsemiotic, so that the difference in the semantic potential of each of their media can be acknowledged without its rendering illegitimate the comparison of the two arts.

Beyond the semantic, syntactic, and phonemic levels that we have considered, and the pragmatic relationship of point of view and perspective, a further difference between the arts has been urged. It is also pragmatic in nature, and concerns the ways that paintings and literature are handled by their students. Some have argued that the very concept of the work of art in each case is different: "if we compare works, we find there is no single work of Rubens or Rembrandt or Poussin that can usefully be compared to *The Faerie Queene* or *Hamlet* or *Paradise Lost*. There is, in other words, a certain imbalance between 'a work' of art and 'a work' of literature" (Alpers and Alpers, p. 444). Though comparably weighted works could be discovered—a single sonnet and a single painting, or the ceiling of the Sistine

Chapel and *The Faerie Queene*—the fact that the Alperses' claim strikes us as valid suggests a difference in the orientations of art history and literary criticism. The Alperses argue that because of the scope of the work in painting, "the art historian tends to look at an individual work in order to discover the elements it has in common with other works" so as to build up a composite picture of an artist or period. The literary critic, on the other hand, tends to treat each work as an integral unit in which form and content are inseparable. The literary critic is intent on arguing that works are unique, noncomparable in meaning, and final values in themselves regardless of their place in cultural history or the development of their creator.

I suspect that the weight of the individual work in each art is closely related to the question of genre. Pictorial genres—still life, landscape, figure painting, portraiture, and historical, religious, or mythological scene—are largely characterized by their contents, whereas literary kinds—the novel, lyric, drama—are opposed more in terms of formal criteria. Of course, the literary subgenres, e.g., tragedy or the verse romance, are often mixed, [81] but there is hardly a literary genre that is defined purely in terms of its subject matter. As a result of this genre character, the relation of a painting to other paintings is a much more crucial aspect of its meaning than the relation of a literary work to others of its kind. The significance of a single Annunciation or a single still life with a bowl of fruit is miniscule compared with its significance in light of the history of treatments of the Annunciation or of still lifes with fruit bowls. A paradigmatic subject matter creates an interest in its particular handling in each canvas. The closest analogue in literary reception is the interest in seeing versions—an archetypal plot or topos engaged by a number of writers. But normally in literature, technical factors are the givens of a genre and the interest of a work lies in the meaning that emerges from that configuration of technical givens. No one but an innocent would explicate the content of a painting for its own sake—"this painting signifies an angel telling Mary that she will bear the Savior; the two are talking in her bedroom; the angel has a halo and is floating in the air...." But countless serious critics have described the represented subjects of literary works.

This contrast is not meant to validate a form-content split between the arts, for obviously an adequate analysis of both a poem and a painting depends upon the relating of their technical and thematic aspects (if we can

even make such a distinction). However, the generic basis of painting pushes interpretation toward the comparison of works, whereas the generic basis of literature does not necessarily do so. And this fact helps to explain the different paths that art history and literary criticism have taken. It does not seem a bifurcation that must exist, as, for example, Foucault's lengthy explication of *Las Meniñas* in *Les Mots et les choses* would suggest.[82]

I have presented at least a sketch of the phonemic, morphemic, syntactic, semantic, and pragmatic relations that structuralism would suggest exist between painting and literature. What emerges, far from parallel schemata for the two arts, is as complicated a set of relations as that revealed by semiotics. Though it does seem possible to discover equivalent minimal units (both asemantic and semantic), combinatory rules, and semantic and pragmatic conventions in each art, these differ considerably in the consistency with which they must be employed by either a painter or a writer. Painting seems free to choose a "literary" structure or not, whereas literature is willy-nilly articulated into all these structural levels. However, it is interesting that often the norms of pictorial *realism* are well correlated with this literary structuration—minimal units which are abstract but meaning-distinguishing, compositional conformity to the laws of perspective and the norms of visible reality, and the defining of the viewer's position and knowledge vis-à-vis the represented scene. Whatever freedom a painter exercises is thus a freedom that has consequences, and as such it is a form of constraint as well. Pictorial realism and literary sense-making are importantly connected, as we shall see in chapter 2, and this is a further indication of the importance of semiosis—specifically, the issue of reality-reference—in the interartistic connection.

Moreover, the structuralist examination of painting and literature reveals a host of ways in which practitioners of either art can invoke the norms of the other. The imperfect structural correspondence of painting to literature does not in fact preclude or even severely limit the comparison of the arts. What it does is permit an ever changing set of correlations by painters and writers, who are free to stress different elements of the structures of their art in order to achieve this correspondence. An interartistic parallel thus is not dictated by the preexistent structures of the arts involved; instead, it is an exploration of how these two structures can be aligned. This alignment is

part of the overall essential homonymity and synonymity of semiosis by which sign systems and their texts approximate one another and then diverge.

Thus, there is no question in comparing the arts of discovering "a history of whatever it is that both art and literature express or communicate,"[83] as if a set of common meanings could be extracted. Instead every comparison of a painting to a poem helps us to understand the process of correlation and disjunction through which systems of sign vehicles and meanings are constantly realigned in the ordered flux of sign-functioning.[84] With this pattern in mind, we cannot do better than look at the relation between one particular painting and one poem.

Williams's Brueghel:
An Interartistic Analysis

undying accents
repeated till
the ear and the eye lie
down together in the same bed

William Carlos Williams

"The ear and the eye lie / down together in the same bed": this is the culmination of a whole system of interartistic imagery and myth enlivening William Carlos Williams's poetry. And like "The Franklin's Tale," it holds the answer to the why of the painting-poetry comparison, the desire of western art to incorporate life and presence in the work.

As in the epigraph, Williams elsewhere uses the seashell as a symbol of poetry. *Paterson* III pictures

. . . a fossil conch (a paper weight
of sufficient quaintness) mud
and shells baked by a near eternity
into a melange, hard as stone, full of
tiny shells
—baked by endless dessications into
a shelly rime—turned up
in an old pasture whose history—
even whose partial history, is
death itself[85]

This conch is a "paper weight"; it anchors paper with its dense substance, to form a "shelly rime." But it is lifted from a pasture, a natural world, whose history is death. Elsewhere (*Paterson,* p. 236) the shell is tied to the recovery of innocence in the form of foam-borne Venus riding her scallop: "Seed / of Venus, you will return . to / a girl standing upon a tilted shell." Out of these associations, Joseph Riddel formulates the following account of Williams's poetic mythology: "Love like Eros which married Heaven and Earth in the original myth of creation out of Chaos, suggests the presence of an original unity. Yet it is also the sign of man's historicity, his temporality and therefore his movement toward death. And only 'love,' the 'song' of the possible restoration of that origin, can make 'death tolerable,' remarry man to nature's deathlessness."[86]

It is this restoration of a pure beginning, an overcoming of death, through beauty, love, and art that lies behind the "Song" from which the epigraph is taken. And the effect of this heroic return is the marriage of ear and eye, the joining once more of senses split off from each other through a fallen isolation of the arts. Here, "Beauty is a shell from the sea / where she rules

triumphant / till love has had its way with her." Love commits a violence
upon Beauty, sculpting her, like a scallop shell or lion's paw "to the *tune* of
repeating waves," the rippled surface of the shell echoing the repetitive
sound of the sea. Through these "*undying* accents," "the ear and the eye
lie / down together in the same bed"—of the sea and love.

But we should remember that Venus is emblematic not only of Beauty
but of all-conquering Love, that seashells not only look like the pattern of
waves on the sea and hence visually mimic the sound of ebbing and flowing
water, but many project the sound of the sea when held to the ear. And the
ear itself is frequently depicted as a shell—that is, both the hearer of sea
sounds and their receptacle. In other words, the dichotomies of the poem—
Beauty/Love, ear/eye, shell/sea—are revealed as identities.[87] It is not simply
that art allows contraries to coexist, but that it shows them to be aspects of
the same thing. And the ultimate triumph of art in overcoming the death of
history and time is the unification of the senses, and of the arts that appeal to
them, in a Botticellian poem. By making a painterly poem or a poetic
painting, the artist achieves a presence that rivals that of nature; he creates an
object vital enough to affect all the senses, lively enough both to speak and
body forth. As Williams himself put it many years earlier, "Poems have a
separate existence uncompelled by nature or the supernatural. There is a
'special' place which poems, as all works of art, must occupy . . . it is quite
definitely the same as that where bricks or colored threads are handled."[88]

As a result, the interartistic problem is more than a passing interest for
Williams. An amateur painter himself, a friend of many of New York's
avant-garde artists, especially Charles Demuth, and an enthusiast of cubism
and modernist movements in general, he based a number of his poems on
specific paintings and claimed to be doing with words what visual artists
were doing with paint.[89] He also characterized modernism as a fusion of the
goals of poetry and painting:

the progression from the sentiment, the thought (philosophy) or the con-
cept to the poem itself. . . . That was the secret meaning inside the term
"transition" during the years when the painters following Cézanne began
to talk of sheer paint: a picture a matter of pigments upon a piece of cloth
stretched on a frame. . . . It is the making of that step, to come over into the
tactile qualities, the words themselves beyond the mere thought expressed

that distinguishes the modern . . . from the period before the turn of the century. And it is the reason why painting and the poem became so closely allied at that time.[90]

With this insistence upon technique and material, it is no surprise that Williams's understanding of the *ut pictura poesis* simile went beyond the metaphoric linkage in the "Song," to the creation of structural equivalents of paintings in his poems. This attempt is particularly evident in his *Pictures from Brueghel,* based on ten works by the Flemish master. Unabashedly interartistic in motivation, these texts can serve as a testing ground for the structuralist and semiotic insights I have been discussing. One pairing in particular, Brueghel's "Return of the Hunters" (fig. 5) and Williams's "Hunters in the Snow" (1565 and 1960, respectively), illustrate the brilliance of Williams's interartistic virtuosity.

Williams's poem has been treated by critics as a manifestation of imagism understood in its most naive pronouncements: a pure attention to linguistic form and concrete semantic referent, without philosophical or conceptual comment.[91] If such an approach is naive with respect to imagist poetry in general, it is doubly so with respect to this 'poetic illustration' of the painting, which like any illustration necessarily conveys meta-artistic decisions in every aspect of its structure *and* meaning. And it is symptomatic of the ease with which such art seems to cover its valuative traces that Brueghel's painting as well is often spoken of by art historians as just such an 'innocent landscape'; for example, "We no longer ask whether this consummately realized impression of winter holds a deeper hidden meaning."[92] The same commentator notes the frequency of Brueghel's use of proverbs and moral and biblical lessons in his other works, and F. Grossmann claims that "the idea of Bruegel as essentially an illustrator, in a more general sense, has dominated the conception several modern critics have of his art."[93] That such an intertextual painter could be taken as a mere projector of wintry images is surprising and indicates the power of·certain techniques employed in the painting (and poem) in deadening critical response. Brueghel's work is full of semantic and formal problems, and it is upon these that Williams has chosen to focus his supposedly innocent eye.

The central problem of the painting is its subject. The title of the canvas, "The Return of the Hunters," is a later accretion (as is the other title used,

Fig. 5.
Pieter Brueghel the Elder,
"The Return of the Hunters."
Kunsthistorisches Museum, Vienna

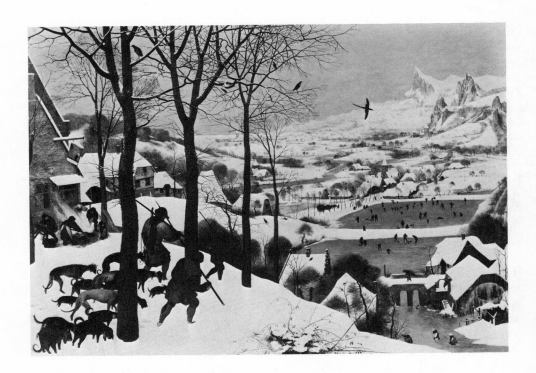

"The Hunters in the Snow"), but nevertheless one that colors our interpreta-
tion of the painting. We also know that the work stood for January in a
sequence of six paintings of the months. These two identities stress different
aspects of the work's meaning, and the discrepancy here is far from trivial;
the very genre of the painting and its relation to the norms of medieval and
Renaissance art turn on this issue:

from time immemorial [the months] had been characterized by the labors
and pastimes peculiar to each. January, for instance, was represented as a
gentleman feasting (often two-headed in recollection of the Roman
Janus). . . . In the first volume [of Jean Pucelle's Belleville Breviary, c. 1320]
and its derivations, however, [this tradition] was abandoned in favor of a
totally different principle: the character of each month must be inferred, not
from human activity but from the changing aspects of nature. . . . these
rudimentary little landscapes . . . announce a truly revolutionary shift of
interest from the life of man to the life of nature. They are the humble
ancestors of the famous Calendar pictures in the "Très Riches Heures du
Duc de Berry" at Chantilly, and ultimately, of the "Seasons" by Pieter
Bruegel.[94]

The shift in the iconography of the months from human activities to natural
states, then, is a crucial step in the development of the landscape as an
independent genre, and the credit for the latter is often bestowed upon
Brueghel himself,[95] many critics stressing the subordination of man to nature
in his work.[96] Yet Brueghel's picture is called "The Return of the *Hunters*."
Are we to read it as a landscape or a genre scene, a member of a calendar
series in the ancient tradition or the modern one?[97] In fact, its place in either
tradition is problematic: with only six paintings of the supposed series in
existence, historians are divided on whether Brueghel merely failed to paint
the other six or intended each to represent a two-month span, or saw them as
seasons rather than months. Since Brueghel played fast and loose with the
standard ancient iconography of the months, there is even some doubt about
which month "Hunters" represents,[98] although January is the usual assump-
tion.

Regardless of whether the title is an irrelevant (i.e., unintentional) accre-
tion and whether art historians might ultimately settle the generic status of
the work through research of some sort, the fact remains that there is a

discrepancy between title and genre affiliation, and this discrepancy is in-
tensified by certain technical factors in the painting. It is the same discrep-
ancy that Williams exploits in his poem, where the title and the first line,
"The over-all picture is winter," stress the genre scene and landscape inter-
pretations, respectively. In fact, the entire structure of Williams's poem is
designed to reveal and emphasize the painting's ambiguities; it is certainly
the most searching critical account of the painting that I have encountered,
and invites a technical scrutiny of the visual text as well.

The painting is divided into three diagonal bands by lines falling from
upper left to lower right. The leftmost band contains the foreground and the
entitled subject, the hunters returning to the village. The central band con-
tains the middleground, what Wolfgang Stechow terms "a wintry micro-
cosm . . . displayed in inexhaustible detail and with inexhaustible ingenuity
of accommodation" (p. 98). The rightmost band contains the background,
dramatically craggy mountains completely covered with snow and
exaggeratedly large. Thus, if the ostensible subject, the hunters, is in the
foreground, and the pre-Pucelle iconography of human activities in winter is
in the middleground, the post-Pucelle iconography of nature in winter is
shunted off into the background. But even there its impact is extremely
powerful: "The blackened red silhouettes of *The Return of the Hun-
ters* . . . exist on not quite equal terms with clouds, rocks, snow, magpies, and
thatched roofs. . . . His people—ants on the far snow—are barely more than
events within nature" (Hughes, p. 6).

Each band, then, offers a different choice of subject matter—a genre scene
of the return from the hunt, a cross section of human activities signifying
winter, and the frozen, nonhuman landscape of nature in January. And all
three are in competition, for they exploit different hierarchical conventions.
According to Schapiro, medieval and naive perspective equate pictorial size
with importance.[99] This factor is what strikes everyone, including Williams,
about Brueghel's "Landscape with the Fall of Icarus" (fig. 6), for example,
where the entitled subject occupies so small a part of the picture that the real
subject of the painting is assumed to lie elsewhere or to involve a meta-
artistic or moral statement concerning the discrepancy. With Renaissance
perspective, in contrast, size merely indicates distance from the viewer, and
importance is signalled by symbolic, iconographic, and positional means.
Thus, from the medieval point of view (which still is a part of our visual

Fig. 6.
Pieter Brueghel the Elder, "Landscape
with the Fall of Icarus." Royal Museums
of Fine Arts of Belgium, Brussels

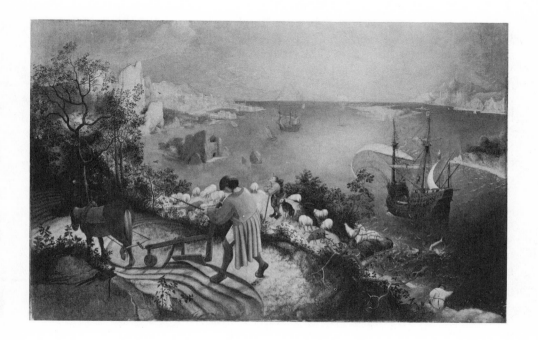

semiotics), the hunters, inn, bonfire, and so on are most important in Brueghel's picture—they are in the *foreground*. But in terms of the Renaissance system, the mountains (like Cézanne's in the various Mont Sainte-Victoire canvases) would be preeminent, given their imposing alpine[100] wintriness and their disproportionate size vis-à-vis their distance from the viewer. As with title and genre, the exploitation of the two opposite norms of hierarchy creates a conflict over what is the real subject, hunters or winter.

One particular feature of the foreground encapsulates this ambiguity. The foreground bush is both large and central, and hence dominant according to the same formal criteria as the hunters. But it is purely a part of nature, cut off from the human dwellings and the hunting party by a band of snow. Thus, even within the genre scene, the iconography of January—and a January of pure landscape force—has thrust itself in. Other factors, such as the reduction of figures to near silhouettes, so that they resemble the denuded winter trees and dark magpies, increase the ambiguity between human and natural, genre scene and landscape. And the tiny snowy village in the background is a corresponding intrusion—or merging—of the human in the natural sphere.

Stechow points to the diagonal banding of the painting as effecting a special balance between formal, two-dimensional attributes and the demands of the subject matter:

The uninterrupted diagonal procession of the hunters and their dogs, accented by the stately trees, penetrates into middle ground and distance, and yet, together with the opposing diagonal formed by the sloping contour of the foreground hill and the mediating diagonal of the background mountain, reaffirms the frontal plane of the picture and establishes that perfect balance and two-dimensional rhythmic order without which even the greatest illusion of depth and the most wonderful display of details would create nothing but confusion. Nevertheless, the powerful diagonal toward the right which is so characteristic of this picture—and only of this one in the series—strongly suggests that it was the first decoration of a room . . . ; and this also corroborates its interpretation as January. [Stechow, p. 98]

Thus, the balance between formal diagonals organizes the unusually multifarious contents of the picture by relating them to a two-dimensional spatial grid; that is, the diagonals solve an aesthetic problem peculiar to this canvas.

At the same time, the directionality of the grid suggests that the painting is the first in a series, and hence belongs to the genre of the months.

The directionality of the diagonals is also crucial to the semantic ambiguity that is our special concern. Whereas the prevailing diagonals proceed from upper left to lower right, the hunters and their dogs walk from lower left to upper right. Their contrast to the prevailing directionality of the painting forces a formal emphasis upon them. And by the same token, the jagged diagonals of the mountains rising from the plane acquire this same emphasis, with the quiet horizontals of the middleground lying between the two. In this respect, both potential subjects—hunters and mountains—acquire the same formal stress.

However, the major diagonal bands of the painting are directed so as to suggest descending motion; according to Schapiro (p. 234), a slope from pictorial upper left to lower right is normally read as a descent rather than an ascent. And indeed, the foreground to middleground movement is 'semantically' downward, from hill to valley. The movement from middleground to background, in contrast, is 'semantically' upward, from valley to gigantic crags. In fact, the expected descent from valley into even lower ground in the far distance, which is suggested by the directionality of the diagonal, is contradicted so thoroughly by the violent rise in altitude that, again, the distant background gains an emphasis perhaps incongruous with a scene 'about' hunters.

With the diagonals so prominent, each referential slice of the painting cuts across various quadrants of the vertical-horizontal grid. Still, the foreground is predominantly on the left, and the background is to the right and up. Schapiro claims that narrative sequences in painting normally proceed from left to right and up to down, like the western system of writing. As a result, what is left and upper may have some priority over what is right and lower, even in a nonnarrative sequence. This is not to say that we scan pictures necessarily in this pattern, but that there is a hierarchy attached to each of these directions. And in a painting like "The Return of the Hunters," so frequently described as a "map" or diagram, a "microcosm" (Stechow, pp. 21 and 98), or a "composite landscape" (Novotný, quoted in Grossmann, p. 49), the need to *read* the painting as if it were a series of symbols to be processed rather than a unified whole to be taken in in toto might give extra relevance to the hierarchy involved in left to right, upper to lower. In such a

case, the two competing subject matters would again share priority, since the hunters are to the left, the whole organization of movement in the painting pointing farther right and deeper toward the mountains; but the mountains, on the other hand, are the most important elements of the upper part of the canvas.

We have looked at three kinds of pictorial organization that Brueghel has enlisted in this semantic play: the inherent up-down and left-right properties of any painting, the diagonal banding and contrasting directionality of hunters and mountains superimposed over it, and the two systems of perspective, the one equating size and importance and the other organizing pictorial space according to distance from the viewer. In "The Return of the Hunters," vertical is posed against horizontal, semantic ascent against formal descent, and actual size against size vis-à-vis viewer distance and iconographic weight. Interestingly, Williams exploited the conflicts potential in his medium to create just such ambiguities.

Williams's title, even more than that assigned to Brueghel's work, sets up the thematic opposition of this poem. It juxtaposes the human hunters to nature's snow, and then shifts in the first line, as I mentioned earlier, to a purely natural account of the painting—"The over-all picture is winter." Williams then proceeds to play on the noncoincidence of syntax, versification, and semantics to enhance this ambiguity. The most striking single example of this is the third line of his poem, "in the background the return," echoing in part the words of the painting's title. "In the background," of course, belongs syntactically and semantically to the preceding line, and "the return" to the following one. But in terms of versification, the sequence insists on being read as if the return of the hunters *were* in the background, and the sound repetition in "the background" and "the return" links them further. Though the mountains rather than hunters are obviously in the "background" in the literal sense, the poem invites us to see the hunters in the background in the figurative sense of the word, as lesser in importance.

In the same way, the following lines reveal what we might call semantic versification: "broken hinge is a stag a crucifix," "between his antlers the cold," "about it to the right beyond," "the hill is a pattern of skaters." In each of these lines, the juxtaposition of words in a verse contradicts semantically some literal fact of the painting, but in just such a way as the painting covertly invites. The return of the hunters, as we have seen, is hierarchically

The Hunters in the Snow

The over-all picture is winter
icy mountains
in the background the return 3
from the hunt it is toward evening
from the left
sturdy hunters lead in 6
their pack the inn-sign
hanging from a
broken hinge is a stag a crucifix 9
between his antlers the cold
inn yard is
deserted but for a huge bonfire 12
that flares wind-driven tended by
women who cluster
about it to the right beyond 15
the hill is a pattern of skaters
Brueghel the painter
concerned with it all has chosen 18
a winter-struck bush for his
foreground to
complete the picture . . 21

in the background if winter or January is taken as the true subject of the
painting. "Broken hinge is a stag a crucifix" equates man-made object,
natural object, and divine symbol through the juxtaposition effected within
the verse. Since the broken hinge is part of the inn, and since the stag is the
name of the inn, and since antlers and crucifixes and even broken hinges
might look similar, and since a *broken* hinge and a *hunted* stag might be
parallel to the *crucified* Christ, there might even be some metaphoric import
in the crazy word-dumping that the versification achieves here.

 In "between his antlers the cold," the abstract subject of January, "the
cold," becomes reified into an element situated between the stag's antlers.
And even if we attach "cold" to "inn yard" in the next line, the versification

makes the antlers encompass the yard rather than the reverse, again creating a hierarchical alternation between dominant subjects—man or nature. Similarly, in "about it to the right beyond," the women clustering around the fire are shunted off to the right into the middleground. Their typically wintry act is thereby reinforced by association with all the other typical activities of January, and the foreground and middleground become spatially confused. The same thing is achieved in "the hill is a pattern of skaters" where the foreground becomes middleground, and in the process is reduced to a diagrammatic "pattern" devoid of human interest. The number of these semantic reversals effected by versification far exceeds Williams's usual poetic practice, even in the other Brueghel poems. There is a veritable war being waged between versification and syntax over which will determine meaning, with syntax reinforcing the title and the actual spatial relations within the painting, and versification carrying the supratextual, generic meaning of January and the corresponding shifts in hierarchy.

The specific ordering of details in the poem, that is, the inevitable temporal disposition of spatial relations, plays on the up–down, left–right, and background-foreground bandings of the painting. Leaving aside for the moment the metadescriptions, we can see Williams's overt emphasis on the formal, rectilinear quadrants of the painting and at the same time a hidden stress upon the background-foreground problem. He begins with the top ("icy mountains / in the background"), then proceeds in a left-to-right median swath ("from the left / sturdy hunters"—the inn-sign—the inn yard with bonfire and women—"to the right beyond / the hill is a pattern of skaters"), and ends with the bottom (the "winter-struck bush for his / foreground to / complete the picture"). By choosing to go from top to middle to bottom rather than from background to middleground to foreground, Williams allowed only one of the diagonal bands to remain intact—the mountains. He combined the genre scene at the inn with the microcosm of the middle distance and isolated the bush from the rest of the foreground. As a result, top and bottom are stressed, the one by the coincidence of "upper" and "background" into an integral unit, the other as a seemingly random synecdoche for the whole painting. In contrast, the middle progress from left to right, which takes up twelve lines (compared with a line and a half on the background and three lines on the foreground), bears the bulk of the poem's descriptive reference to the painting, and all the references to the painting's

human sphere present in it. It also contains most of the syntactic pivots that erratically juxtapose pictorial elements. The wealth of detail is suggested by the conclusion of the middle section—"Brueghel the painter / concerned with it all"—where seemingly the only way to refer to the diversity is through the indefinite "it all."[101] And though the middle of the poem does not correspond to the middleground of the painting in terms of what it describes, it *does* correspond to it as a microcosmic description of the painting—a metamicrocosm, just as the middleground is a microcosm of winter.

The crucial positioning of the other four and a half lines of descriptive detail at the beginning and end of the poem provides a less obvious but more emphatic focus. And, for once, in the depiction of the bush at the end, the syntax and versification are not at odds, so that the meaning on both schematic levels is identical. So powerful is this shift from busy details to the single bush that one critic has picked it, out of all the images in the ten Brueghel poems, as a "strange uncompleted" ellipsis "in which the final stanza moves to the bush, in the foreground, used to 'complete the picture'" (Conarroe, pp. 567–68).

The seeming flux and lack of hierarchy created by the antisyntactic juxtapositions in verses make the human activity much less striking than the final bush, about which all poetic levels harmonize in a single impression. (This includes the semantic: "winter-struck," "picture," and "foreground" matching "winter," "picture," and "background" from the first stanza.) Thus, the powerful positioning of beginning and end versus middle is played against the quantity of verbiage devoted to each of the two subjects in their struggle for dominance. And this opposition echoes very precisely what happens in the painting, where the natural landscape is emphasized by positional and directional factors and the human subject by absolute size. In both cases, more is not necessarily more important, as the penetration of the nonhuman bush into the lower center of the human foreground in the painting, and into the end and "completion" of the poem, testify.

Though the semantic level, as we have seen, is part of every other level, we can isolate certain oppositions which contribute especially to the general thematic oscillations of the poem. The opposition of animate to inanimate is closely related to the tripartite division of description into the top, middle, and bottom of the painting. Not until line 6 do we encounter an animate

noun or verb; in the early section, the only verbs are the copular "is" (twice), and the syntax is quite fragmented, with several noun phrases merely strung together. From lines 6 to 16, however, there is a sudden change, with complete sentences full of active verbs and participles and animate subjects: "hunters," "lead in," "pack," "hanging," "stag," "antlers," "deserted," "flares," "wind-driven," "tended," "women," "cluster," "skaters." But the final line of this middle section changes the skaters into a "pattern" and returns the initial copular "is" to the poem, in direct contrast to the previous animation of inanimates by verbs of action ("bonfire flares" and "wind-driven") or by a 'strong,' metaphoric use of the copular ("the inn-sign / . . . is a stag"). Thus, the middle section comes to an end with the deanimation of animates, appropriate to the abstraction and schematization of human action in the middleground of the painting.

In contrast, the last three lines of the poem, concerned with the bush, animate the inanimate "winter" ("winter-struck"), thus draining energy, if you will, from the human skaters and the entire human element of the painting and shifting it to the iconographic subject of the season. A similar reversal, by the way, can be seen in the contrast between the fire and the women in the middle section: the "bonfire / that flares wind-driven" and "women who cluster." The elemental fire flares outward; the women cluster inward—the inanimate one violently and dynamically expansive, the animates static, clinging, containing. Through such means, the stress that normally accrues to animates is shared with, if not shifted to, the inanimate sphere. Again, the genre scene and calendar iconography compete for dominance.

The semantic divisions of the painting into the three diagonals of foreground, middleground, and background, we should note, are the results of discontinuities in the representation of the scene. As Schapiro points out (p. 241), the discovery of Renaissance perspective gave a new meaning to the intervals between pictorial figures; they became signs of a continuous three-dimensional space. In "The Return of the Hunters" this regular expanse of receding space is broken sharply by the diagonal slope between the foreground hill and the middle valley and again by the base line of the mountains and the mountains themselves, which block off any further recession of space. These linear breaks isolate each band from the next, thereby reinforcing the changes in semantic thrust of each—genre scene, human microcosm,

landscape. In Williams's poem, metastatement has the same function as these lines of discontinuity. The "icy mountains" of line 2 are separated from "the return from the hunt" in the next line by the phrase, "in the background." The general picture section of the first four lines is separated from the long description of the middle horizontal band by "from the left." The fore-ground is separated from the middleground by "to the right" in line 18. And the entire middle description is delineated from the final focusing on the bush by the prominent metastatement, "Brueghel the painter / concerned with it all has chosen" (lines 17–18), striking as well because it is syntactically dis-tinct from the preceding text. The various disjunctions introduced into the physical details of the picture describe a kind of crosshatching over the canvas that matches the opposed thematic thrusts we have considered. Some phrases, for example, "in the background" and "to the right," stress the diagonal banding of the painting. Others, "from the left" and "Brueghel the painter," cut horizontal barriers between the middle swath and what is above and below it, and these do not correspond to any spatial discontinuities drawn in the painting. Instead, they relate to the semantic prominence of mountain and bush described above. The alternation of description and metadescription, then, has its visual parallel in the diagonal lines of the painting and the difference in semantic mode between human iconography and landscape elements.

Perhaps the most prominent of these metastatements come in the first and last lines: "The over-all picture is winter" and "foreground to / complete the picture." These lines act like a Renaissance picture frame. As Schapiro re-marks, "When salient and when enclosing pictures with perspective views, the frame sets the picture surface back into depth and helps to deepen the view. . . . The frame then belongs to the space of this observer rather than of the illusory, three-dimensional world disclosed within and behind. It is a finding and focussing device placed between the observer and the image" (pp. 226–27). Though the spatial distancing established by the pictorial frame is only metaphorically similar to the distancing created by literary framing techniques, the fact of the frame here is significant. When Williams attempts a 'cubist' depiction of a visual scene,[102] he omits the elaborate framing used in "The Hunters in the Snow," in which the scene is enclosed by references to its status as a "picture" rather than an actual scene and to the aesthetics of the artist, Brueghel. In "Hunters," the formal ordering takes us from the

picture to its contents and back to the artist who has shaped the picture, in an exterior-to-interior-to-exterior motion.

A complex system of point of view is thereby introduced. The speaker as perceiver and hence we as perceivers stand outside the 'frame' and do not participate in the scene. The bird's-eye view taken in the painting, which shows not only the valley but the hill in the foreground as if seen from a higher vantage point, increases this sense of distance; it prevents our involvement in the genre scene and, if anything, links our viewing position to the height of the distant mountains. Thus, again, a formal device is used to distance us from the human thematics of the foreground. Similarly, the literary metastatements and the lack of penetration into the psyches of the hunters and women exclude a psychologistic emphasis in the poem. It is the painter's psyche—and implicitly that of the speaker—that we enter. And though the poem switches between bird's-eye views at the beginning and end and the close-ups in lines 5–16, the phrases "from the left" and "to the right" within the close-up section signal the sweep of an eye distanced from the details mentioned. The directionality of these cues themselves reinforces the "landscape" reading of the picture, for the "left" and "right" are those of the canvas vis-à-vis an external viewer, and not the left and right of the human figures within it. Schapiro (p. 231) speaks of the switch in left-right orientation which distinguishes landscape from figure painting, the first having no point of orientation but the observer, and the second having the figures' left-right orientation replacing or at least competing with that of the viewer (unless figures stand with their backs to us). Williams never lets the hunters' spatial orientation determine ours, so that the authority of the human subjects' viewpoint is always subordinate to that of the external perceiver, as in purely natural landscapes. ·

As for the "ideological" viewpoint expressed (in Uspenskij's terms), this is the basic ambiguity of the painting, and to a degree it informs the poem as well. What human interest there is in the painting is played down in the poem by the various means that I have pointed out, although the hunters' sturdiness makes them a match for the weather and the women's clustering about the fire is a specifically human response to the cold of the month. However, these elements receive less stress in the poem than the nonhuman detail. It is on the meta-artistic level that the poem focuses on the human subject, here in the figure of the artist: "Brueghel the painter / concerned

with it all has chosen / a winter-struck bush for his / foreground to / complete the picture." The words "concerned" and chosen" suggest emotional and psychological traits, and the pronoun "his" in "his foreground" associates the painting closely with its creator. Thus, if the painting offers a complex choice between a human, symbolic, or naturalistic focus, the poem raises the first of the three to a metalevel and allows the naturalistic some dominance in the description of the pictorial scene.

It is because of this multiple thrust in the poem (and, of course, the painting) that critics are led into such contradictory judgments as the following: Williams "makes no attempt to discover meaning or message. He . . . simply records" (Conarroe, p. 572); "the bleak imagery [of "The Fall of Icarus"] is continued with the sense of winter dusk that permeates 'The Hunters in the Snow' poem III" (Conarroe, pp. 569–70); and finally, "Each [Brueghel and Williams] was what Williams called a 'Heavenly man,' a humane being with a profound respect for his animal self, open to experience of all sorts, in close contact with his native soil, a man not diminished by conventions, able to invent, to laugh, and to affirm" (Conarroe, p. 566). Williams's "The Hunters in the Snow" and Brueghel's "The Return of the Hunters" project what Bakhtin and Uspenskij call a polyphony of viewpoints.[103] Inhuman landscape, the seasonal iconography of human life, and an individual, personal response to experience (especially in the poem) all compete for dominance.

In concluding this comparison, we might test out the value of the color-phoneme correspondence that Dora Vallier has outlined. First, in terms of color, the painting is highly schematic. It is dominated by white and black, the former shaded with blue in much of the snow, the distant mountains, the frozen river, and the sky, and the latter in trees, shadows, and magpies, shading to red-brown in houses and other buildings, and mingled with red in the hunters and dogs. There is no red in the painting beyond this, a factor to which Williams seems to have been particularly sensitive; in the ninth poem of the Brueghel series he writes, "This horrible but superb painting / the parable of the blind / without a red / in the composition." The suggestion is that the lack of red has something to do with the horror of the painting, its lack of vitality and warmth. In "The Return of the Hunters," too, this semantics seems to be actively employed as part of the painting. For the *only* red in the painting is that belonging to the humans, dogs, and human habita-

tions, whereas natural objects are overwhelmingly black or white (or bluish white), except for that enigmatic bush in the foreground.

The painting is split between largely achromatic nature on the one hand and the chromatic human sphere on the other, the latter threatening at any moment to converge with nature (the figures are so dark as to appear almost black in many reproductions). Given what we have already seen of the human-natural opposition, the coloration thus seems to enhance the fragility of the human claims to attention. Indeed, Aldous Huxley sees the humans as equivalent to the blasted trees and magpies, merely the dark element in a formal balance:

Snow scenes lent themselves particularly well to Brueghel's style of painting. For a snowy background has the effect of making all dark or colored objects seen against it appear in the form of very distinct, sharp-edged silhouettes. Brueghel does in all his compositions what the snow does in nature. All the objects in his pictures (which are composed in a manner that reminds one very much of the Japanese) are paper-thin silhouettes arranged, plane after plane, like the theatrical scenery in the depth of the stage. Consequently in the painting of snow scenes, where nature starts by imitating his habitual method, he achieves an almost disquieting degree of fundamental realism.[104]

Huxley goes on to say that we might very well be looking at Jack Frost himself in the figures before us, a statement in seeming conflict with his stress on realism, but the almost schematic quality of the human figures is thereby made explicit. If we are looking at humans, the coloring enhances their iconographic nature as part of January or winter in general; much more prominent is the black-on-white layering of the winter scene and the blue-white mountains.

Williams's poem does not make any reference to color, but if Vallier's suggestion is to be considered seriously, a technical correspondence to coloration should be sought instead in the relation between vowels and consonants. The former, we recall, are correlated to the chromatic triangle; the latter to the achromatic one. The reduced chromatism of Brueghel's painting would suggest some lack on the vowel side, and indeed, there is a surprisingly small proportion of long vowels and diphthongs and a curious dis-

tribution of them throughout the poem. They tend to cluster in the meta-
statements: "overall," "background," "evening," "right," "Brueghel,"
"painter," "chosen," "foreground," and "complete." Of the rest, a number
occur in syncategorematic words or else in words stressing the inanimate,
wintry side of the poem's opposition: "icy," "mountains," "inn-sign,"
"broken," "crucifix," "cold," "huge," and "bonfire." Only "lead" and
"skaters" apply to the specifically human, animate sphere, and even if one
wanted to include the "inn-sign," "crucifix," and "huge bonfire" within the
human side of the opposition, they are inanimate objects; the sign is of a stag
(a part of nature), the crucifix is encircled by the stag's antlers, and the fire
flares out because of winter winds. In other words, the long vowels and
diphthongs are predominantly used in conjunction with those elements of
the poem that make either the winter or the work of art the focus of atten-
tion.[105] The rest of the poem is carried by short vowels, many of them
centered to schwas. And whether all this supports Vallier's hypothesis or
not, the vowel organization, like the coloration, does throw up a few
strongly marked elements against a background of 'neutral' short vowels and
consonants, just as the painting has a few touches of color in a predominantly
achromatic scheme. The color highlights, however, stress the human com-
ponent of the painting, while the long vowels and diphthongs stress the
nonhuman elements of the poem, so that if there is a correspondence here it
is the reverse of Vallier's.

It seems obvious that there are extraordinary correspondences between
Breughel's painting and Williams's poem, and that these similarities have
little to do with period relations, mere thematic coincidence, cultural in-
fluence, iconographic correspondence, the *Gesamtkunstwerk* notion, or any of
those possibilities that history has tested in its processing of the *ut pictura
poesis* simile. What we see with Brueghel and Williams's two works is that
correspondence of technical properties which linguists, psychologists, and
philosophers in our century have made critically imaginable. Whether Wil-
liams was consciously aware that "in the background the hunters" con-
stitutes as technical an oscillation of theme as Brueghel's opposition of fore-
ground and background diagonals—whether he was aware of any genre
problem at all in the Brueghel painting—is quite irrelevant. As Williams

claimed, "it is in the intimate form that works of art achieve their exact meaning,"[106] and the meaning of the painting transmitted by its poetic form is one of competing messages and artistic-semantic codes.

Though one could just as easily, like Lessing, stress the barriers between the structural schemes in each art—more separates the color and phoneme than connects them, after all—the argument for structural correspondence has so much explanatory power in our determining why those words of Williams's are in any sense equivalent to the painted canvas of Brueghel that it is hard to disregard. Why twentieth-century artists should have attempted such structural imitations—beyond the general desire for sensory repleteness expressed in Williams's poetic myth—is a question that I shall address in the chapters to come.

Two Nonsense

Granted, I am a babbler, a harmless
annoying babbler, like all of us. But
what is to be done if the direct and
sole vocation of every intelligent man
is babble, . . . the intentional pouring
of water through a sieve?

Dostoevski

Introduction

In the Renaissance and baroque periods, the point of contact between paintings and poems was their subject matter and the assumed iconicity of the artwork to this subject matter. The literature-painting comparison thus depended upon the conceptual splitting of form and content. Today such a split is untenable. Not only literary scholars but philosophers now argue that form and content are inseparable in art and that poems are iconic, unparaphrasable. For Hans-Georg Gadamer, poetic truth "is experienced in the work of art—truth which is attainable in no other way,"[1] and for Heidegger, "Poetry is the establishing of being by means of the word."[2]

Language, in contrast, is commonly seen as a system of arbitrary signs in which a given meaning is expressible in more than one phonic shape[3] and a given utterance is paraphrasable. What holds sounds and meanings together is mere social convention rather than any intrinsic bond. Thus, poetry performs the feat of returning semiotic motivation to language, of rescuing the word from its failed merging with the world. As a result, poetry becomes analogous to the visual icon, painting, which not only signifies the world but seems to embody it—in Nelson Goodman's terms, both expressing and exemplifying it. Manifesto after manifesto of modern art claims that poetry should be like a Chinese ideogram that both signifies and pictures meanings (Pound, Eisenstein, the concrete poets) or that it should produce the "light of the image" (Breton) which bursts forth unbidden by and unavailable to reason in a spontaneous and untranslatable vision.[4]

But in return for this service to language, literary meaning runs the risk of self-annihilation, and the theory of art underlying it flirts with self-contradiction. The proposed self-containment of art would divorce it from the continuum of speech and render it hermetic, unsharable. It would become a thing, that in the very act of embodying meaning risks opacity. For an unparaphrasable sign is a sign of silence.

This danger has made nonsense one of the greatest themes and modes of modern literature. Humpty Dumpty presides over *Finnegans Wake* and countless other fictions of our day as the genius of the paradox that language can be both arbitrary and motivated, a self-sufficient system and one affected by extralinguistic meaning, a social and an individual tool. Since nonsense inevitably raises the issue of how language and verbal art 'mean,' semantic aberration is a constant temptation for fictions intent on both being meaningful and constituting the unique conditions of that meaning. It may well be

that the self-containment theory of art so pervasive in this century is in fact a theory of nonsense.

The implications of this state of affairs are important to the painting-literature comparison, for much of canonic nonsense is illustrated. That illustration should be tied so closely to a particular semantic mode is puzzling, raising the question of what illustration in fact is, whether of nonsense or of any other text. Is an illustration of a nonsense work itself nonsensical, and ultimately, is there such a category as nonsense in the visual arts? What sort of traits would a nonillustrational painting have to have to be considered nonsense? And on the other hand, can a painting make sense at all if it is not allied with some verbal text, even as minimal a one as its title?

These are, I am afraid, enormously involved questions, in that they depend upon the answer to a corollary question: what constitutes sense in the two arts and in their interrelations? Some help is available to us here in Susan Stewart's fine study of verbal nonsense. It assumes the existence of a commonsense view of the world against which there are increasing degrees of divergence: realism, myth, irony, metafiction, and nonsense. Stewart refuses to specify the content of this view because it is constantly changing, instead choosing to define sense relationally against the various degrees of divergence from it.[5] But this decision makes it difficult to extend her approach to the visual arts. The commonsense view of the world is not only referred to in painting but institutionalized in its technical norms. Unlike grammatical or stylistic norms, the Renaissance conventions of vanishing-point perspective, chiaroscuro, and so forth, which were in force until postimpressionism, are also conventions of pictorial realism, of how the world actually looks. Their content can be specified, and they have not changed considerably since their invention (or discovery, depending upon your point of view). Thus, a nonsense painting, if such existed, could have been identified as such throughout a four-hundred-year span by its subversion of formal conventions as well as its defiance of what Stewart's "everyday lifeworld" at any given moment was taken to be. If we are to establish a correspondence between nonsense in the two arts, we must be able to state as specifically for literature as for painting what formal assumptions about reality it contains. And to do so we must turn to the 'opposite' of literary nonsense, nonfiction prose.[6]

The norms of nonfiction prose provide a referential standard for literature similar in function to the norms of pictorial realism. Though prose has certainly changed over the centuries, the ideology behind it has not. A set of assumptions about English prose was laid down in the seventeenth century, determining our thinking about nonfiction ever since. Regardless of whether these assumptions accurately describe prose writing, they have become so ingrained in our minds as the form of truth-telling that they, like the Renaissance conventions of painting, are equated with thought and perception as such. Thus, the philosophical essay is understood as the expression of the logical mind at work, and logical discourse is taken as a diagram of truth relations. More important for this discussion, the definition of art that concerns us here—the self-contained, unparaphrasable work whose being is its meaning—arose in response to the modern belief that an aesthetic blight had been inflicted upon literature through the seventeenth-century definition of scientific writing. Thus, to explain the modern conception of verbal art and its fascination with nonsense, we shall have to begin with its stolid opposite, nonfiction prose.

Nonsense and the Plain Style

> Real communication is so very rare,
> for plain speech is unconvincing.
>
> T. E. Hulme

According to T. S. Eliot, the rise of science and its British institutionaliza-
tion, the Royal Society, created a "dissociation of sensibility" that has
marked western man ever since. It split the emotions from the intellect, and
housed each in a different form of discourse—the poetic and the scientific,
respectively. As a result, poetry has been either sentimentally soft-headed or
dourly sententious, with no fusion of the sort that marked Shakespeare and
especially the metaphysical poets, with their archfigure of fusion, the
metaphysical conceit.[7] The New Critics proceeded from Eliot's position,
blaming Bacon and Hobbes for what they took as the failure of post-
metaphysical poetry to attain fullness of being, from becoming what John
Crowe Ransom called "the world's body."[8] Hulme, Blackmur, Tate, and
Wimsatt all affirmed this notion.[9] It is perhaps summarized best by Cleanth
Brooks:

The weakening of metaphor, the development of a specifically "poetic"
subject matter and diction, the emphasis on simplicity and clarity, the sim-
plification of the poet's attitude, the segregation of the witty and the ironi-
cal from the serious, the stricter segregation of the various genres—all these
items testify to the monopoly of the scientific spirit. This process of
clarification involved the *exclusion* of certain elements from poetry—the
prosaic, the unrefined, and the obscure. The imagination was weakened
from a "magic and synthetic" power to Hobbes's conception of it as the
file-clerk of memory.[10]

The truth of the matter, of course, is much more interesting than the New
Critics' account would suggest. For if a poetry deprived of fantasy was
diminished, a prose deprived of any figuration was barely a linguistic possi-
bility. But what is most surprising is that the scientists' ouster of metaphor
was motivated by precisely the same desire as the modernists' embracing of
it. Both wanted a language that would capture, contain, express, organize,
and ultimately replace, *be,* the thing-world.

Even the language of the seventeenth-century theorists on this subject
resembles that of modernist poets and critics. Bishop Sprat, the historian of
the Royal Society, which had taken upon itself the task of formulating the
principles of scientific discourse, pointed out the abuses that had arisen from
the careless use of figurative language. Swept up in a purely verbal logic,

seekers after truth often formed conclusions that had nothing to do with the object world. In response, the reformers of prose have

been most rigorous in putting in execution, the only Remedy, that can be found for this *extravagance:* and that has been, a constant Resolution, to reject all the amplifications, digressions, and swellings of style: to return back to the primitive purity, and shortness, when men deliver'd so many *things,* almost in an equal number of *words.* They have exacted from all their members, a close, naked, natural way of speaking; positive expressions; clear senses; a native easiness: bringing all things as near the Mathematical plainness, as they can: and preferring the language of Artisans, Countrymen, and Merchants, before that, of Wits, or Scholars.[11]

Certain *topoi* emerge in this account: the belief in an archaic purity of language in which words and things were intimately connected, and the need to recover that purity by simplifying, by eliminating mere ornament in order to come down to a "mathematical plainness." Hence the name for the new prose: the plain style.

Plainness was a call for a one-to-one correlation of words to things. A. C. Howell shows that in talking about the referential nature of language, the seventeenth century imperceptibly shifted from speaking of words and subject matter to words and things, substituting for the represented object or image the physical object itself.[12] Linguistic semiosis thus came to be understood as the linking of sounds and things rather than sounds and meanings. Bacon had warned the scientist against the mistake of Pygmalion, who fell in love with the image of a woman that he had himself created; in the same way, words must be used as a way of reaching things, not stopping in an autonomous world of verbally generated ideas.[13] By reforming language so that it led one back to the world, Bacon thought, one could obviate in some degree "the fall, [in which man] lost at once his State of Innocence, and his Empire over Creation, both of which can be partially recovered even in this life, the first by Religion and Faith, the second by the Arts and Sciences."[14]

The belief in a previously unfallen state of language led theorists to call the vocabulary and grammar of languages redeemed to purity "real." "For the seventeenth century, the names Adam gave to creatures were the *real* names, for he could 'view essences in themselves, and read forms without the comment of their respective properties'—a power seventeenth-century philoso-

phers longed to imitate."[15]Bacon expressed this notion through the analogy with Chinese ideograms: "characters real, which express neither letters nor words in gross, but things or notions" (*Advancement,* p. 131). G. A. Padley argues that "in the *Advancement of Learning* these non-verbal signs or *notes* represent mental concepts, are 'notes of cogitations', but in the later *De augmentis* they have become simply 'notes of things', consonant with Bacon's theory that phenomena can be reduced to a limited number of elements or 'simple natures' each capable of being represented by a non-verbal symbol" (Padley, pp. 185–86).

That unfallen language and the reformed language of science could attain to the presumed nature of an ideogram, an icon of a thing rather than a mere unmotivated symbol, was precisely what Pound, Eisenstein, the imagists, and the concretists saw as the promise of modern poetry. Pound's edition of Fenollosa's *The Chinese Written Character as a Medium for Poetry*[16] established the ideogram as the prevailing metaphor of poetry in our day, intended to bridge the gap between word and world that Joyce so anxiously connected by his telephone line to Edenville at "Aleph, alpha: nought, nought, one."[17] T. E. Hulme urged the beauty of "small dry things";[18] Ransom advocated a poetry that would form the "world's body"; the desire for concreteness in virtually every experimental movement in painting and literature in this century arises from just such a train of thought. And of course, the modern use of the interartistic comparison has the same function. How paradoxical then that the moderns locate the Fall, the Tower of Babel, in precisely that moment and spirit that set out to redeem language through the forging of a scientific prose!

This aim led the seventeenth century to equate a "real" language with a universal language. At first philosophers attempted to establish unambiguous correlations between words and things by reforming natural languages. However, this approach soon gave way, according to Benjamin De Mott, to "the belief that such a pattern must derive from a correct description of the order of reality. . . . Its most striking feature was the 'technical word'—a symbol whose components express various aspects of the thing or idea to which it refers. . . . [For example,] the word 'Zana' in [John] Wilkins' spoken language is composed of the following elements: 'Za,' the genus fish; 'n,' the ninth difference (squamous river salmon); 'a,' the second species (largest, red-fleshed kind)."[19] The formulation of such a language was thus equivalent

to the formulation of an exhaustive ontology. In fact, insofar as a philoso-
pher believed that his ontology was true, that is, a uniquely accurate descrip-
tion of reality, then the distinction between language and reality became
problematic. Language would have all the complexity of element and rela-
tion found in reality itself.

It is no wonder that such attempts were never fully elaborated nor univer-
sally shareable. They would require their users to relearn the world rather
than merely to recognize it. And this would seem to be an infinite task. We
might see the universal-language movement as a version of what Susan
Stewart terms the "nonsense of the search for a comprehensive mne-
monic . . . the nonsense of any attempt to use a system to account for all
universes, to enclose the infinite within the finite" (p. 187). Nevertheless, the
belief that prose should reflect the system of the thing world still stands at the
center of modern logic and language philosophy. When Ogden and Richards
outline their six conditions or "canons" of sign functions designed to elimi-
nate all but true statements, they claim that these "control the System of
Symbols known as prose."[20]

The advantage of such a writing style, as the word-thing correlation
would suggest, is its absence of ambiguity. The seventeenth-century philos-
opher Ward expressed this idea as follows: "'if the first and most simple
things & notions are so few as is the number of consonants, & the modall
variations so few as may be expressed by Vowels and Dipthongs [sic],' the
language would not have to admit 'Homonymies and Synonimies'" (De
Mott, p. 9).

This elimination of homonyms and synonyms might seem at first glance a
minor aspect of the universal-language movement, but it is in fact the central
feature of a thing-language, and interestingly one that would make com-
munication an utter impossibility. Without the existence of more than one
term per meaning and more than one meaning per term, language would
turn into a reified system of labels, inflexible and impossible to apply to the
ever changing thing-world. On this basis, Merleau-Ponty equates the
thing-language with the universal language: "forget the myth of a universal
language; it would include in advance everything that it could say, since its
words and syntax would reflect [all] the fundamental possibilities and their
connections: the consequence is the same."[21] This consequence is noncom-

munication, for a language in which all possible meanings are systemic would be a language precluding the necessity of speech. Even the claim of internal consistency within this world has been denied by modern developments in logic. Kurt Gödel has shown that a system cannot be both complete and consistent, leading Whitehead to respond that "Our only way of understanding the rule [of logical types] is nonsense" (quoted in Stewart, p. 30).

The Prague School linguist Sergej Karcevskij, in fact, located the essence of communication and language change in the dual process of homonymity and synonymity. He wrote that the totally motivated sign, like those in the thing-languages that we have discussed (but also in the modern concept of the thing-poem), would eliminate homonymity and synonymity, functioning instead as an undecomposable phonic block. As such, it would lie outside "the life of language" created by the play of these two functions, which, "by rendering the sign mobile, . . . assure it of a permanent adaptation to a reality which is always new."[22] Karcevskij thus pictures the linguistic signifier and signified in a state of unstable equilibrium in relation to each other: "it is thanks to this asymmetric dualism of the structure of its signs that a linguistic system can evolve: the 'adequate' position of the sign being constantly displaced as a result of its adaptation to the exigencies of the concrete situation."[23]

Divergent as Karcevskij's notions might appear compared with the traditional position on language and prose, they are directly related to dialectical and dialogic theories of communication that have recently begun to arise. This kind of approach is essential for an understanding of nonsense, for nonsense has long used the contrasting rigidity of the universalist stance as the butt of its humor. Swift revealed the pointlessness and cumbersomeness of a thing-language by having his Laputan philosophers dispense with words altogether, carrying instead a bag from which they could pull whatever things they wished to signify.[24] And Lewis Carroll has an even more elaborate parody of 'transparent' prose in the episode of the Mouse from *Alice in Wonderland*.[25] This and *Through the Looking-Glass* are among the most thorough explorations of nonsense possibilities, no doubt because their author was a logician familiar with the philology and philosophy of his day. I shall thus take some time with the poor Mouse, and later on with other sections of the Alice books.

In order to dry off Alice and the creatures spawned in her pool of tears, the Mouse tells them the "driest thing" he knows, a passage from a history text about the Norman Conquest. Unlike the moisty world of Wonderland, this text is to be nonfigurative, nonwhimsical, and emphatically nonnonsensical. The Mouse implies that there is some connection between these traits and efficacy in extratextual reality, for the history is intended literally to dry the characters off. But it fails to do so and the company turns to a caucus race, an 'actual" political struggle, to effect this drying. Clearly, we are to see that textuality is textuality, whether it have real or imagined events as its subject.

But the Mouse's history fails to be dry even as a case of plain style writing. On the surface it is as representative a piece of formal, nonfiction prose as one could wish, replete with the passive, impersonal, and subordinate constructions that mark a speaker's desire to efface himself from his discourse: "William the Conqueror, whose cause was favoured by the pope, was soon submitted to by the English, who wanted leaders, and had been of late much accustomed to usurpation and conquest" (Carroll, p. 36). However, even this utterly plain utterance is open to the abuses of reason that characterize nonsense. The Duck interrupts the mouse to find out the antecedent of "it" in "Stigand, the patriotic archbishop of Canterbury, found it advisable." The Mouse appeals to the Duck's knowledge of the linguistic code, saying "of course you know what 'it' means." But the Duck remains obtuse, saying that he knows what "it" is when *he* finds a thing—a frog or a worm, but not when it comes to an archbishop. At the appearance of the noncorrespondence of language to reality the poor Mouse closes his eyes: "the Mouse did not notice this question, but hurriedly went on." Even the driest, most referential, most nonfigurative text contains components that are purely linguistic, and hence purely nonsensical, in that they have no referential value at all. A nonfiction text is still a fabric of language, and as such it is not homologous with the thing-world.

Were this not the case, there would be nothing problematic about the Duchess's advice to Alice that she should "Take care of the sense, and the sounds will take care of themselves!" (Carroll, p. 97). This is a play on "Take care of the pence, and the pounds will take care of themselves,"[26] and certainly, the difference in the implicature of pounds and pence and sounds and sense is crucial here. Pence are components of pounds, but the relation

between sense and sound, signified and signifier, is a social convention and not a mathematical one. If language were a one-to-one correlation of words and things one could ignore signifiers—sounds—for they would automatically arise in conjunction with the things signified. But given the fallen state of language, the focusing on sense alone would conjure up a synonymic set of expressions that, ultimately, would be as large as all of language. The Duchess accordingly uses this sound-sense advice as an explanation for her equating of "love makes the world go round" with "minding your own business makes the world go round." In the ultimate synonymic set, even contradictions would be equivalent.

But there is another source for the Duchess's statement about sounds and sense. Cato the Elder allegedly said, "'Rem tene, verba sequentur,' which may be translated, 'take hold of things and words will naturally follow, or will take care of themselves'" (A. C. Howell, p. 131). The Duchess's idiosyncratic advice thus constitutes both an implied criticism of the seventeenth-century approach to prose and a direct parody of the classical source of the thing-word equation. To assume that the relation between sound and sense can take care of itself is to open the door to nonsense. Thing-language understood literally is nonsense language.

But all of us know that nonfiction prose is not a perfect merging of word and thing. Much as writers of English have mouthed the virtues of conciseness, clarity, nonfigurativeness, and verbal transparency, it is only in the extremes of scientific-language reform and modern literary-language reform that the spectre of such nonsensical claims arises. What is it that prevents prose from becoming the ravings of Wonderland characters? In large part, the capacity of prose to make sense depends upon a balance that every prose writer and every normal speaker strikes between seeing language as an utterly self-sufficient labyrinth of meaning which never need reach outward for completion and, on the contrary, an utterly thing-determined system, a copy of the world it refers to. Karcevskij describes these two tendencies as follows: "A language always presents the spectacle of a struggle between lexicology (the tendency toward the arbitrary sign and phonology) and syntagmaty (the tendency toward the 'motivated' sign and morphology); neither one ever controls it totally, but the importance of each differs from one period to another."[27]

Each of these extremes is the object of mockery in the Alice books. The self-containment of language is connected with the claim that the linguistic sign is arbitrary. In this Saussurian view, words no more control or condition reality than a set of dogtags does the soldier wearing them. The absurdities to which this notion can lead are personified in Humpty Dumpty: "'When I use a word, . . . it means just what I choose it to mean—neither more nor less.' 'The question is,' said Alice, 'whether you *can* make words mean so many different things.' 'The question is,' said Humpty Dumpty, 'which is to be master—that's all'" (p. 214). Humpty Dumpty's utter disregard for shareability is semiotic arbitrariness gone wild: after all, if there is no inherent connection between words and their referents, one can make words mean anything. But, of course, under such circumstances, communication would be an impossibility. Instead, one is led to insist upon coded—if arbitrary—meanings and a prescriptive approach to language. This is Karcevskij's lexicological stance, the tendency toward arbitrary signs and phonology. What Humpty Dumpty has done is to 'seize the power' and take arbitrariness at face value. This turns him into a dictionary, for every time that he uses a word he must be on hand to explain what it means to him, and the possibility of an infinite regress under these circumstances is all too apparent.

Given Humpty Dumpty's point of view, the Red Queen's remarks to Alice early in her trip through Looking-Glass Land are prophetic. In a testing of Alice's ability to tolerate semantic willfulness, the Red Queen plays with the categories of the metaphor, oxymoron, and contradiction in terms:

"I only wanted to see what the garden was like, your Majesty—"
"That's right," said the Queen . . . "though, when you say 'garden'—*I've* seen gardens compared with which this would be a wilderness."
Alice didn't dare to argue the point, but went on: "—and I thought I'd try to find my way to the top of that hill—"
"When you say 'hill,'" the Queen interrupted, "*I* could show you hills, in comparison with which you'd call that a valley."
"No, I shouldn't," said Alice, surprised into contradicting her at last: "a hill *ca'n't* be a valley, you know. That would be nonsense—"
The Red Queen shook her head. "You may call it 'nonsense' if you like," she said, "but *I've* heard nonsense, compared with which that would be as sensible as a dictionary!" [P. 163]

Alice has no reply to this, for indeed the Queen has managed a very clever suspension of any objections.

The Queen's first claim, that a garden can be a wilderness compared to other gardens is unusual, but not totally deviant: a rather disorderly garden could earn such a metaphoric designation, and a garden in which flowers talk does have a certain wildness to it. But since Alice does not rise to the bait, the Queen goes one step further, claiming that there are hills compared to which this hill could be termed a valley. Unlike the previous case, where orderliness is a matter of degree, there is no continuum linking hills and valleys. In other words, no real content could intervene to render this designation meaningful. The Queen has created a contradiction in terms—a statement about reality that neither the language code nor reality permits one to make. (In fact, the only place where hills and valleys are equivalent is, interestingly, in etymology, the history of words themselves, whose 'logic' often mocks the object world. Etymologically, "valley" is related to "wale," the raised strips, for example, of corduroy, and hence to any raised object, even a hill. I am indebted to Jonathan Arac for this observation.)

Despite Alice's objection, the Queen remains undaunted, arguing that she has heard nonsense compared with which her last statement would be as sensible as a dictionary. This comparison creates an oxymoron—sensible nonsense—and is much less troublesome than the earlier contradiction, since again there are degrees of sensibleness. Presumably one could always think of some statement more illogical than "that hill is a valley, compared with other hills." And in fact, as I write this, I begin to transform the Queen's shocking contradiction into a quite harmless hyperbole.

Yet if the archcase of sensibleness is, as the Queen claims, a dictionary, her oxymoron becomes more interesting. To be sensible under such circumstances would amount to being faithful to coded definitions, to usages unaffected by any contexts—linguistic or real. The Queen is espousing the very lexicological tendency that makes reality and language utterly independent code systems. But by its very insensitivity and rigidity, a dictionary would rule out any of the Queen's three statements. And even to speak of a dictionary as sensible seems a contradiction, since sense is a function of sentences, not individual words, whether those sentences have application to reality or not. A dictionary cannot be sensible, so that the Queen has involved us in multiple levels of contradiction. Her statements are just as willful a use of

language as Humpty Dumpty's but they are not arrived at through his honest arbitrariness. She goes the route of those who argue for motivated relations between words and reality—metaphoric extension. But by utterly violating the principles of this process, by ignoring the dictionary and the need for a *tertium comparationis,* she threatens to produce almost as arbitrary a form of discourse as Humpty Dumpty. In such a case, reality and language would each go its merry way and there would be no question but that the language of a text was in control, with the codes of reality present only through their referential violation.

You will recall that Karcevskij identified this first tendency with "lexicology" and phonology. The examples mentioned so far show the lexicological thrust of nonsense, but we should not ignore the phonological one. The two Alice books and almost any nonsense text are demonstrations of the importance of speech sounds as such. The sisters living in the treacle well learn to draw things beginning with *M.* Virtually everything of any importance in "The Hunting of the Snark" begins with a *B.* And a thread of *H*'s runs through *Through the Looking-Glass,* from the initial hill and house to Haigha and Hatta to "I love my love with an *H.*" In fact, I wonder whether the stress on Anglo-Saxon in the latter work is not related to the fact that the principle of unity in Old English poetry was alliteration.

Perhaps the ultimate working out of this 'phonemic reality' is Carroll's game of Doublets in which one has to get from one word to another of equal length by interposing a series of words which each differs by one letter from the word before it. For example, if one must "Drive PIG into STY" (Carroll, p. 1279), one generates the string, PIG, PIT, SIT, SAT, SAY, STY. By a purely linguistic pathway (in this case using graphemes rather than phonemes), one can drive a "pig" into a "sty." Why mess with spatial-temporal contingency if one can inhabit this clean world of language? (This game has important implications for concrete poetry, as we shall see in the last chapter.)

At the other extreme from the self-contained view of language is the argument that an intimate, motivated relation exists between signs and what they signify. Karcevskij terms this the syntagmatic strain, the tendency toward motivated signs and morphology. Remove language from the world, this side holds, and you have a different world. And Carroll depicts such a place in *Through the Looking-Glass* as the "wood with no names." In this world, the fawn feels no fear toward Alice, for there they have neither class

Fig. 7.
Sir John Tenniel, "rocking-horse-fly,"
from Lewis Carroll, *Through the
Looking-Glass*

nor individual identities. But as soon as they set foot outside the wood, their names return to them and the fawn runs off in terror. Language creates identity; it is a version of the Fall, resulting in self-consciousness, isolation, and enmity.

The idea that language controls reality and reality language is what lies behind the fear of encountering nonsense in the book (as in the Mouse's "dry tale"), for such encounters reveal the failure of language and reality to coincide. Fleeing this possibility, the Alice books and much nonsense literature read like parodies of *Cratylus*. For example, in Looking-Glass logic, if there is such a thing as a horsefly, then there can be such a thing as a rocking-horse-fly (fig. 7). Susan Stewart presents this move as a typical technique of nonsense, as in Edward Lear's "botany" in which "the natural world is made to conform to the discourse. In contrast, any form of realism will attempt to make discourse conform to the 'natural world'" (Stewart, p. 98).

But it is just as likely that nonsense will result from making language conform to the world. One of the staple devices of nonsense is the folk etymology, in which reality provides the explanation for a linguistic mystery. The Mock Turtle, for instance, accounts for the word·"lessons" by

the fact that in his day they "lessened." All the puns and metaphors which are taken literally in the Alice books, and all the jingles and rhymes that come to life there are cases of linguistic motivation. If, as Emerson says, "The sensual man confirms thoughts to things; the poet confirms things to his thoughts," then the nonsense writer demonstrates the need for all of us to be compounded of both the sensualist and the poet if we wish to communicate sense.

Unlike Doublets, the syntagmatic tendency does not stress the isolated, nonsemantic phoneme or letter, but the morpheme, as in the "lessons" example. It emphasizes the linkages of semes in grammatical units that can have reference. Humpty Dumpty, who demonstrates the lexicological tendency by becoming a dictionary, explores the syntagmatic one in his "Jabberwocky," in which meaning arises from syntax in the absence of determinate lexical content.

In sum, nonsense is built on extremes whose balance is necessary to produce communicative language and its written norm, nonfiction prose. Nonsense is ultra-code-oriented, and at the same time ultra-utterance-oriented; it accepts total control of reality by language and vice versa, and then acts as if it had never heard of either relation; it pretends to be a world and a language totally alien to what we know, only to insist on the validity of our world and language norms and on its own efficacy in reinforcing them. Nonsense is thus a kind of metaprose oscillating between extremes that are necessary to maintaining communication: the linguistic mediation between individual speakers and society, and between ideal classes and specific situations.

But if the balance is destroyed, any language can become nonsensical. One philosopher of science has described the end product of the 'purifying' of scientific language as follows: "In its extreme formalized aspect, scientific language tends toward pure visualizable patterning of empty terms."[28] Whereas the Duchess's attention to sense to the exclusion of sound created unlimited synonymity where even contradictory sentences could be equated, here the attention to the logical coherence of language, to sound, leads to an utterly open sign system, a case of massive homonymity. Instead of the desired rigid label, one ends up with a universal signifier.

Following the lesson of nonsense, normal prose, even normal scientific prose, establishes a balance, paying equal attention to both sound and sense, to form and meaning, language system and reality system. A typical balance

is reflected in the foreword to the *Publication Manual of the American Psycho-logical Association,*[29] which I have chosen more or less at random. On the one hand, it sees scientific prose as the traditional thing-word correlation: "This Manual recognizes that changes in written language do not occur as fast as changes in the sciences themselves; therefore it does not prescribe for all stylistic problems. . . . It looks at the literature itself to determine forms rather than employing style to contain literature" (pp. 5–6). In keeping with this attitude, it urges a transparent, nonfigurative prose: "In scientific writ-ing, devices that attract attention to words, sounds, or other embellish-ments, instead of ideas, are inappropriate. Heavy alliteration, accidental rhymes, poetic expressions, and clichés are suspect. They are unsuitable in scientific writing because they lead the reader, who is looking for informa-tion, away from the theme of the paper. Metaphors are sometimes helpful, but use them sparingly. Avoid mixed metaphors: Literal and figurative us-ages mix badly, to the detriment of communication" (p. 28).

Not only do figurative uses call attention to language rather than ideas; so can the reference to the speaker himself. But here the conventions have been undergoing some revision, and the *Manual* attempts to strike a balance be-tween the former impersonal style of scientific prose and the current re-luctant acknowledgment of the author's psychophysical reality:

Absolute insistence on the third person and the passive voice has been a strong tradition in scientific writing. . . . Some scientists maintain that this style preserves objectivity, but the validity of this assertion is suspect. . . .
An experienced writer can use the first person and the active voice with-out dominating the communication and without sacrificing the objectivity of the research. If any discipline should appreciate the value of personal communication, it should be psychology. [P. 28]

This modest gesture toward acknowledging the author has profound im-plications. If the scientific message comes to us from the mouth of an indi-vidual who is limited spatially and temporally and psychologically, then its absolute connection with the thing-world is, if I may borrow the *Manual*'s word, "suspect." This is the risk of the balancing mechanisms of prose, since it shows the essential paradox—or tension, in Karcevskij's terms—which permits 'objective' communication to take place.

The signaling of the author's existence has as its correlate the signaling of the reader's existence. And the *Manual* follows the best Baconian tradition in this respect when it urges that "A successful writer invites readers to read, encourages them to continue, and makes their task agreeable by leading them from thought to thought in a manner that evolves from clear thinking and logical development" (p. 25). This attempt lies behind the use of the "present tense to describe and discuss the results that are literally there before the reader. . . . The present tense suggests a dialogue between author and reader" (p. 27). It is only through this *dialogue,* with its elaborate system of technical devices relating to the speech situation—speaker, hearer, and message—that the word-thing relation can be established at all. Ignore these factors and you have one of the forms of nonsense, or rather one of the forms of discourse that nonsense likes to mock.

By "dialogue" neither I nor the writer of the *Manual* mean a literal interchange among multiple speakers. What the seventeenth century did in fact was to efface the speech situation from scientific prose as much as it could. But the monologue[30] that resulted—making knowledge into a product, a package there before you, rather than the process of inquiry dramatized in the Socratic dialogue—had to sneak certain dialogic features into it in order to make communication possible. English prose in particular has evolved an elaborate system of gestures toward the reader-interlocutor: introductions, summaries, connectives which mark shifts in point of view ("however," "nevertheless," etc.), quotations introducing other speech contexts into the system of the text, and paragraphing itself—highly developed in English in particular—with its topic sentences to introduce shifts in the argument and to let the reader know the general head under which the ensuing development falls. These features are the most frequent content of writing instruction; yet the prevailing myth of prose transparency has rendered them invisible to the critical eye. Only during the last ten years or so have studies in textual cohesion come into being, despite the Prague School's suggestive notion of "functional sentence perspective."[31] The fact that words can lead to things only by signaling their 'wordness' and the social interaction that gives birth to them—in other words, by asserting that they are *not* those things—is one of the paradoxes of communication.

Officially absent as the dialogue may be from the ideology of English prose, it nevertheless can be found lurking everywhere in discussions of

philosophy and rhetoric. Charles S. Peirce writes that "thinking always proceeds in the form of a dialogue—a dialogue between different phases of the *ego*—so that, being dialogical, it is essentially composed of signs"; "all thinking is dialogical in form."[32] The dialogic quality of thought makes it definitionally semiotic, a linking of sign vehicle and referent through the existence of an interlocutory situation.

One of the most cogent statements of the importance of dialogue comes from the phenomenologist, Merleau-Ponty:

as speaking subjects we *continue,* we take up the same effort, older than ourselves, on which we are implanted onto each other, which is the manifestation, the becoming of truth. We say that the true has always been true, but this is a confused way of saying that all previous expressions live again and receive their place in the expression of the moment, so that one can, if one wishes, read it in them after the fact, or, more accurately, find them again in it. The foundation of the truth is not outside time; it is in the opening of each moment of understanding to those who will take it up and change its meaning. . . . What masks the living relation of speaking subjects is that one always takes as a model of speech the *statement* or the *indicative,* and one does this through the fear that outside of statements there is only stammering, unreason. This is to forget all that is tacit, unformulated, non-thematized that enters into the statements of science, which helps to determine sense in it and in fact gives the science of tomorrow its field of investigation. It is to forget all literary expression, where we will have to note what one might call "supersignification," and distinguish it from nonsense. . . . it is the case that every speech not only is an expression of *this,* but presents itself from the very start as a fragment of a universal discourse, announcing a system of interpretation. [Pp. 200–201]

It is in the attempt to avoid nonsense ("stammering," "unreason") that we deny the dialogic, but in the process we run the risk of misunderstanding communication altogether.

Evidentiary Devices

Perception is not a process separable from judging, nor imagining separable from the relating of signicances into concepts.

Rosamund Tuve

Bacon himself seems to have had something like monologue and dialogue in mind when he contrasted the "magistral" to the "probational" methods of argumentation. "The magistral method is dogmatic or doctrinal. It is used when a teacher wishes to convey information which is to be believed, and not questioned. . . . The method of probation is that used when the matter delivered is to be questioned and examined . . . when the bounds of knowledge are to be extended" (*Advancement,* p. 281, editor's note). The probational method involves a direct gesture to the reader and a recapitulation of the inductive method that gave rise to the knowledge in the first place. It is tied to the event of discovery and to the discoverer, for only by retaining this context will the knowledge "grow" in the mind of the reader: "knowledge that is delivered as a thread to be spun on, ought to be delivered and intimated, if it were possible, in the same method wherein it is invented. . . . For it is in knowledges as it is in plants; if you mean to use the plant, it is no matter for the roots; but if you mean to remove it to grow, then it is more assured to rest upon roots than slips . . . if you will have sciences grow, it is less matter for the shaft or body of the tree, so you look well to the taking up of the roots" (*Advancement,* p. 135).

The roots of the induction are the observations and reasoning that led to it. Their inclusion is dialogic not only because it involves the reader in the author's train of thought, but because observations can be seen as one of a class of evidentiary factors that interrupt the continuity of thought. They belong to the reality series, the infinite continuum of the object world from which they are grabbed up and forcibly inserted into the mental series of an argument. Their dimensions there are always arbitrary—one could just as easily use three examples as two—and the very commas that surround "for example" signify the intrusive quality of this argumentative strategy.

Within this class of intrusions are examples, quotations, allusions, and illustrations of all kinds. These are all primary means of achieving intertextuality, that dialogue among the world's written and spoken texts. However, they come to us, like prose in general, as pieces of the object world smuggled into the world of words, in fact, as repetitions of that world. They are both thinglike, since they are extratextual in origin vis-à-vis the new context, and innately textual. "The establishment of boundary and difference through repetition is at the center of any movement toward textuality. All verbal play as the representation of an utterance is bound up in the

113

possibility of quotation—a repetition of discourse, a detachment of discourse from its context of origin" (Stewart, p. 122).

The various evidentiary devices listed above assure the word-thing relation by making 'things' present in the text. Quotations are actual words spoken or written and reproduced in the text that talks about them. Allusions are fragments of a textual world pointed to from the vantage of another text, which itself *contains* that fragment. Examples are records of a principle visited upon a thing. And illustrations—illustrations are pictures of the thing-world inserted into verbal texts. As pictures, icons, they both signify and contain the characteristics of what they picture. They appear to entrap the thing-world among words, whereas in fact—or in addition—they entrap the pictorial world in the verbal one. By doing so, they and all the other intertextual techniques cited here maintain the crucial dialogic structure necessary to communication, that is, necessary to the maintenance of the relation among message, interlocutors, and signified world. Thus, Bacon claimed that it was appropriate for rhetoric to contain illuminations because it conveys ideas with reference to an audience, whereas logic, which does not, should be nonilluminated.[33]

This difference is reflected in the continuum of "methods" that Bacon established. At one extreme is the magistral method already mentioned, in which knowledge is transmitted as a finished product with no accompanying evidence or any signs of its spatial-temporal or authorial origins. This is an utterly static model which fits the traditional understanding of scientific prose as a thing-language. Then comes the probational method with its processual nature and its many gestures toward the reader. Bacon thought of this as the proper mode for expressing inductive knowledge to a learned audience who would continue the dialogue through new research. Beyond it, at the other end of the continuum, are aphorisms. "Bacon saw the aphorism as a way of presenting truth, in a way that invited further thought. The lack of argumentative or systematic link with other aphorisms prevented the thinking from becoming a rigid system. . . . Actual things are not arranged in any pattern, therefore observations on them are best left separate and unconnected" (*Advancement,* p. 281, editor's note). Aphorisms follow each other like separate speeches in a true dialogue or polylogue, but the separate contexts of their speakers are not connected by any of the cohesion devices that make speeches replies to each other. In contrast to magistral

discourse, which has no breaks into which the reader can enter, aphorisms
are nothing but breaks, interfaces. And yet the relatedness of these states is
apparent in the fact that the most seemingly disjointed, aphoristic writing in
the modern period—automatic writing, *Finnegans Wake*—is termed "interior
monologue."

Aphorisms are like quotations used as evidence in an argument, with the
argument itself missing, requiring the reader to discover it. The danger that
no argument can be discovered to synthesize these 'quotations'[34] is a danger
documented in nonsense—the Duchess's wild commerce in aphorisms
which do not apply to the situation in which she places them, the completely
disjointed replies in the Mad Teaparty, or the episodic nature of Alice's
adventures themselves, where there are spatial-temporal disjunctions in what
should be the continuum of the physical world and of mental experience. On
either side of the dialogic argument lies nonsense—the nonsense of the
seamless web on the one hand and the nonsense of the limitless exemplifica-
tion of an unstated theory (the world) on the other. Only by integrating
discourse and objects through linguistic argument and evidentiary intrusions
(examples, allusions, quotations, illustrations) can meaningful, true-false
discourse arise. Moreover, it is by both breaking into the seamless web and
yet establishing a gesture toward wholeness that discourse becomes in any
sense communicative and paraphrasable. It is the dialogic quality of dis-
course that opens the doors to the essential homonymity and synonymity of
all linguistic communication and change.

A fascinating version of this conclusion is visible in Jeremy Bentham's
Theory of Fictions,[35] and it is, of course, important to keep in mind that the
various argumentative methods under discussion were promulgated not
only as styles but as approaches to truth-telling. The seventeenth century's
universal languages were termed "real," whereas previous systems had been
described by Bacon "as so many plays brought out and performed, creating
fictitious and theatrical Worlds" (*Novum Organon,* p. xliv). However, unlike
Bacon, Bentham believed that a fully "real" language was impossible, in-
deed, that language depended upon fictitiousness in order to function at all.

Bentham contrasted fictitious entities to perceptible ones, the latter
known without reasoning "by the immediate testimony of [the] senses" (p.
7). The existence of fictitious entities, on the other hand, is ascribed to
language. To distinguish the two one need only test whether an entity is

capable of inflicting pain through a Johnsonian collision. It follows, then, that all of Aristotle's predicaments (place, time, and so on), except for substance, are fictions, these fictions, however, being necessary to language and philosophy. The cardinal error lies in believing that "To speak of an object by its name, its universally known name, is to ascribe existence to it" (p. 60).

The temptation to confuse names with existing things, according to Bentham, arises from the consideration of words in isolation: "the seat of the unclearness is in the words taken singly." Thus, by combining words, prose serves the function of distinguishing the fictitious from the real. "Exposition is . . . every operation which has for its object . . . the exclusion or expulsion of unclearness in any shape" (p. 76). It performs this operation through a special mechanism—the image:

By . . . a proposition which has for its subject some fictitious entity, and for its predicate the name of an attribute attributed to that fictitious entity, some sort of image—the image of some real action or state of things . . . in every instance is presented to the mind. This image may be termed the *archetype, emblem,* or *archetypal image* appertaining to the fictitious proposition of which the name of the characteristic fictitious entity constitutes a part. [P. 87]

What clarifies language, then, is the image, the evocation through language of perceptible entities which attach fictions to the real world. As Bentham's editor, C. K. Ogden, puts it, "The archetypes, which are usually actual or pictured bodies in rest or in motion, act as symbolic and logical lenses and bring fictional terms to focus on a man's experience, or dissolve them into their original nothingness. This is more than even the most highly complicated logics have achieved" (p. xlvii).

Indeed, logics proceed on just the opposite assumption, that language can be purified of fictions (metaphysical statements, in Russell and Whitehead's terms) and made compact with the world. But Bentham believed that this one-to-one fit is an impossibility and proposed the interaction of fiction (pure language with merely systemic or ideal meaning) and image (reference to perceptible entities) in order to produce clarity, to reveal the real. This triangulation between language system and thing system is the middle way of probational discourse and all dialogic prose. With its denial of the one-

to-one compactness of scientific prose and the world, it opens itself to the homonymity and synonymity that Karcevskij describes (and, it would seem, to the slippage and nonuniqueness of solution of Derridean poststructuralism). Ogden, clearly disillusioned with his earlier analytic stance in *The Meaning of Meaning*, points out the advantages of Bentham's scheme:

Bentham believed that language must contain fictions in order to remain a language, *i.e.* that a language which 'mirrored' reality would be impossible. If the logico-analysts were to believe that 'logical constructions' must *necessarily* occur in language they would profoundly modify their attitude to the problem; for it would follow that there could be no atomic propositions and all analyses would be relative. . . . we could not talk about *the* analysis of a given proposition. This is the real bone of contention between the logico-analytic temperament and the technological approach of Bentham. The latter realized that the problem is eminently a *practical* one—the classification of thought by simplifying and revealing the structure of language; and therefore a task for whose performance no eternally valid rules can be promulgated. The logico-analysts postulate an ideal language—perfect even in its well-disposed irregularities—which requires methodical articulation in accordance with a preconceived metaphysical scheme. That is why they restrict their analysis to phrases like 'This is red' which approximate to ideals of linguistic excellence, and neglect entities like 'right', 'power', etc., which so strongly attracted Bentham. Hence the sterility of their method. [Pp. l–li]

The attempt to create a thing-language, a mirror of reality, leads to sterility, the inability of logical language to engage the object world at all. As T. E. Hulme said, "Real communication is so very rare, for plain speech is unconvincing" (pp. 135–36). The only way to avoid this outcome is to create a self-consciously nonreal, fictitious language supplemented with the image.

But such a strategy is only part of what is necessary for a scientific prose, since we shall see that Bentham's tenets would describe literary utterances as well as scientific ones. Indeed, during the past fifteen years we have been bombarded with "proofs" that there is no formal difference between fiction and nonfiction prose. Norman Mailer, Truman Capote, Tom Wolfe, and other "new journalists" have written 'true' novels and short stories, and language philosophers and logicians have added to the dilemma. John R.

Searle, for example, holds that "there is no textual property, syntactical or semantic that will identify a text as a work of fiction. What makes it a work of fiction is, so to speak, the illocutionary stance that the author takes toward it, and that stance is a matter of the complex illocutionary intentions that the author has when he writes or otherwise composes it."[36] This intention involves the author's putting aside the rules of assertion: that he is committed to asserting the truth, that he will provide evidence of it, that what he is saying is not already obviously true to himself and his audience, and that he *believes* in the truth of what he is saying (p. 322). The fiction writer's text may formally resemble an assertion, but certain rules suspend the normal relating of illocutionary acts to the world, thus lifting the fiction out of the true-false continuum (p. 326).

How one learns of this suspension of rules through any but the formal properties of the text is, of course, the old objection of Wimsatt and Beardsley's "intentional fallacy."[37] But it is important to note that the locus of fictionality lies for Searle in the speech act itself, the interlocutory (or illocutionary) situation of dialogue. Not only must a text be opened up to the interaction of speech system and object world (note Searle's insistence on the asserter's commitment to *prove* the truth of his proposition) but it must make its speaker's stance apparent. It must highlight its origin in the speech of an existing individual even to be taken as true.

From the modernist viewpoint, however, the very need to distinguish the scientist's from the artist's truth is traceable to the seventeenth-century 'fall.' Prior to it in metaphysical poetry, the argument goes, the poet saw himself as a scientist (a probational one, to be sure), whose art was used to speak the truth in a convincing way. Rosamund Tuve has tried to document this claim, arguing that the sixteenth-century Ramistic reform of logic (against which Bacon, the Port Royal School, and other modern scientific approaches would later revolt) pushed a good deal of what had formerly been rhetoric into the domain of logic. Thus "there is at [the Renaissance a] . . . definite connection between logical training and the methods of forming and using images";[38] "I believe that the poets in the whole period . . . consciously attempted to control their imaginings . . . according to the laws of thinking which they were taught should govern composition; and I believe that those laws were the laws of logic" (p. 371).

Tuve describes how handbooks on poetry instructed the poet in the development of images out of logical "places." "Donne's famous compass image is based on *final, efficient,* and *formal cause,* and *from* this basis comes its force as support for a concept—which is its reason for being" (p. 374). An image in such a view is, in fact, an argument. According to Tuve, for Ramus,

> every object in nature is (not only "is the basis for") an "argument," say of order, of God [compare the Franklin's rocks or Stephen Dedalus's musings on the "signatures of things" in the opening of chap. 3 of *Ulysses*]; the qualities of anything are the "arguments" of that subject. A single word may be an "argument," in that it "hath a fitnesse to argue something." The argument is the relatableness of a word or a thing, its "reference" or "relation," by which it is ready to hook into other arguments, and by an infinite progression build up into the whole structure of truth.
>
>
>
> [Thus,] perception is not a process separable from judging, nor imagining separable from the relating of significances into concepts. [Pp. 383–84]

The linking of image and argument is precisely the process that we have been exploring, that intersection of word and thing that leads to powerful probational prose. The image in this case has the same function as the quotation, allusion, example, or illustration in bringing about truth-telling. Given this fact, it is interesting that Tuve claims that painting was not a popular metaphor for poetry during the time when poetry and logic were complementary 'sciences.' The painting analogy was unnecessary because the poetic image was conceived of as already evidentiary, rather than a mere embellishment. The mirror function of painting under such circumstances was superfluous, since poetry already possessed a link with reality and truth: "to define by these (logical) means is to produce imagery (an imagery with an expository function and character) as naturally as the attempt to paint an object produces an awareness of its sensuous qualities" (p. 374). It is not that the poetic image was unlike all painting, but only painting not enlisted in the service of an idea. The poetic image *was* like an illustration. It would have very much the function of the illustrations in a scientific text, translating, spelling out, *evidencing* the claims made therein. Moreover, the metaphysi-

cals' penchant for pattern poetry—poems arranged typographically to re-
semble a physical object, to picture it in a way quite similar to modern
concrete poetry—witnesses this characteristic fusion of visual object and
discourse.

If metaphysical poetry contained these probational mechanisms as part of
its very structure and rhetorical force, the real fall effected by the reform of
logic and rhetoric was the impoverishment of the image, the elimination of
its argumentative force. As a result, Cleanth Brooks would argue, scientific
language took on the role of modelling the thing-world, and was valued
insofar as it was precise, clear, and truthful, whereas poetry was left to play
with chimerical images sprung from the imprecision of unredeemed lan-
guage, sprung in fact from metaphor. Whereas before, metaphor was the
transcendent image-argument combination, it was now the occasion of the
not true. Poets offended by this drop in stature tried to avoid the metaphor,
aiming instead for an elaborate presentation of good sense—what Coleridge
led Richards, Brooks, and other moderns to call the "poetry of fancy."

The aim of modernist poetic doctrines of the image has been to return to
the metaphysical position. However, in stressing the image they have done
little more than lament the disappearance of the earlier world view that
permitted the image to function illustratively. This unbalanced emphasis has
resulted in an overcorrection on the discourse continuum on the side of
aphorisms, disjunctive elements wrested from the thing-world and un-
connected by any logical system. One thinks of Eliot's "heap of broken
images" in *The Waste Land,* his shoring up of his ruins with the mad jux-
taposition of polyglot quotations, and his benighted belief in the objective
correlative, a physical situation that would serve automatically as the occa-
sion for a universal emotive response. If "A poem should not mean / But
be"[39] (MacLeish's "Ars Poetica"), then it becomes of the same ontological
order as the other things that "be"—the object world. As such, it, like all
things, can be named but not embodied in language. It becomes as static and
monologic a sign as any seventeenth-century technical word. As Tuve ar-
gues, "probably the chief response the most rebellious Elizabethan or Jaco-
bean free-thinker, not understanding our poetic, would have to the images
he met within a collection of the best modern poetry would be 'and so
what?'" (Tuve, p. 395). It is not for nothing that in the modern period
metaphysical poetry comes to stand for an unattainable balance.

The desire for this balance surfaces, not surprisingly, as a call for dialogue. Cleanth Brooks's belief that all poetry is "ironic"—a confrontation between opposed contexts—arises partly from the semanticist W. M. Urban's differentiation of scientific from poetic language. Brooks quotes Urban's distinction: "all meaning is ultimately linguistic and . . . although science, in the interests of purer notation and manipulation, may break through the husk of language, its nonlinguistic symbols must again be translated back into natural language if intelligibility is to be possible. Natural language is dramatic and all meaning expressed in language must ultimately be of this type."[40] This dramatic quality is the result not only of the interaction between interlocutors but between the speech and the context of the speech act. Brooks claims that a statement like "2 + 2 = 4," whose meaning does not vary with context, is devoid of ironic and hence poetical potential: "poems never contain abstract statements. That is, any 'statement' made in the poem bears the pressure of the context and has its meaning modified by the context."[41]

It is but a short step from this interactional model of art to the aphoristic extreme described by André Breton in his 1924 *Manifesto of Surrealism*. There he claims that "the forms of Surrealist language adapt themselves best to dialogue" because "here, two thoughts confront each other" (*Manifestoes*, p. 34). The mode of this confrontation is a mutual rejection. "My attention, prey to an entreaty which it cannot in all decency reject, treats the opposing thought as an enemy." In certain pathological cases, Breton goes on, the patient merely echoes the last word of the question asked or gives a completely irrelevant response. But "there is no conversation in which some trace of this disorder does not occur. The effort to be social which dictates it and the considerable practice we have at it are the only things which enable us to conceal it temporarily. . . . Poetic surrealism . . . has focused its efforts up to this point on reestablishing dialogue in its absolute truth, by freeing both interlocutors from any obligations of politeness" (p. 35). As a result, such dialogue becomes nonsense, and surrealism an institutionalization of that mode. In discussing Breton, Susan Stewart states that "conversations without turn taking are 'absurd.' . . . In nonsense, turn taking never gets anywhere; the turn is a continual *re*turn to the beginning" (p. 208).

Dialogue freed of the need for politeness is aphoristic. And politeness under such circumstances is the speaker's commitment to modify his speech according to the context of his interlocutor's speech, and moreover to

thematize his replies, to relate them to a topic of conversation. All those phrases that we use to explain chance conversational associations—"by the way," "this is off the topic but . . ."—are signals that the social laws of cohesion are being broken by a private digression, and a special pleading for permission to be self-indulgent in this way.

But as Breton notes, the tendency of all conversation to degenerate into a set of intersecting monologues is everpresent. And the reason for the fragility of politeness is apparent in Merleau-Ponty's contrasting of thought and speech:

"I think"—that signifies; there is a certain place called "I," where to act and to know that one acts are not different, where a being is confounded with his revelation to himself. . . . He who speaks enters a system of relations which presume him and render him open and vulnerable. [P. 26]
.
To speak and to understand presuppose not only thought, but . . . the power to let oneself be undone and reformed by another actual person, several possible others, and potentially everyone. [Pp. 29–30]

Conversation, dialogue, thus involves two opposed dangers: that the parties will be destroyed as unique entities, becoming components of a monologue that need not be spoken, or, on the other hand, that they will remain utterly distinct—surrealist ships passing in the night—with no interaction having occurred at all. The first case resembles the extreme of a thing-language in which all meanings are systematized and no lack of clarity is possible; the second resembles aphorisms, reified blocks of meaning whose edges collide without giving rise to a unified system of meaning.

The modernist overcorrection on the side of aphorism is readily visible in Henry James's insistence on novelistic "showing" rather than "telling"; Joyce's and Eliot's arguments for impersonal art are similarly insistent on creating a purely evidentiary discourse at the risk of jeopardizing cohesion. As Wayne Booth summarizes, most of the arguments for authorial objectivity or impersonality "call for eliminating certain overt signs of the author's presence. . . . An astonishing number of authors and critics since Flaubert have agreed that such direct, unmediated commentary will not do."[42]

But Booth objects that the very act of story-telling is an authorial intrusion. Quoting Sartre's description of existential novels which will "exist in

the manner of things, of plants, of events, and not at first like products of man," Booth argues: "if this is so, the author must never summarize, never curtail a conversation, never telescope the events of three days into a paragraph. 'If I pack six months into a single page, the reader jumps out of the book'" (p. 17). Just as with the Royal Society view of scientific discourse, the absolute realism of writing involves an effacing of its illocutionary origins, an effacement that is never possible if the text is to be meaningful. "Any story will be unintelligible unless it includes, however subtly, the amount of telling necessary not only to make us aware of the value system which gives it its meaning but, more importantly, to make us willing to accept that value system, at least temporarily" (p. 112). Instead of receiving the novel as a direct experience of the thing-world, Booth claims that "in any reading experience there is an implied dialogue among author, narrator, the other characters, and the reader. Each of the four can range, in relation to each of the others, from identification to complete opposition, on any axis of value, moral, intellectual, aesthetic, and even physical" (pp. 155–56).

If I may summarize, the various artists and philosophers cited reveal the curious dialectic that must exist in order for communication to take place. It is curious because it is so little a part of the official account of what occurs in either scientific prose or literary art. Prose stresses system in order to assure clarity and truth, whereas poetry, in the modernist period at least, stresses phenomenon (the work of art as a thing, an unmediated experience of things, etc.) in order to achieve a higher realism, a more intense experience than the mere reference of science can achieve. But the search for the perfect system leads scientific-logical language, paradoxically, to pure self-containment and a failure to refer, a formal play that is warned against in nonsense literature. Similarly, the more modernist poetry declares itself a thing rather than a system of meaning, the more trouble it has, at least theoretically, in being meaningful, attachable to the continuous history of meanings that literature and all speech constitute. As a thing, it focuses our attention on itself as a contained system which, like Merleau-Ponty's notion of thought, both acts and knows that it acts, both is and reveals itself to itself in the process of being. Not that logical positivism and modernism are to be chastised, but as modes of truth-telling they are "suspect"; they eliminate the very constituents of the speech act that form the normal preconditions of that truth-telling. A truth that has no contingencies is as elusive as a truth of pure

contingency. In both cases we recognize the slightness of the boundary between canonized sense and nonsense.

A structuralist insight into this situation is available through Jakobson's typology of speech functions. Though he points out that these never appear unmixed in discourse, he holds that various kinds of discourse are definitionally dominated by one or another function, each corresponding to one component of the speech situation. Jakobson diagrams the elements of verbal communication in "Linguistics and Poetics,"[43] with the names of the related functions added in parentheses (see p. 125).

The poetic function dominates in literature (poetry and fiction); it focuses attention on the linguistic utterance itself (the message) rather than upon its referent, as in communicative language. "The supremacy of poetic function over referential function does not obliterate the reference but makes it ambiguous" ("Linguistics and Poetics," p. 371). The fundamental trait of poetic language is its thoroughgoing iconicity, for "the poetic function projects the principle of equivalence from the axis of selection into the axis of combination" ("Linguistics and Poetics," p. 358). The substitutability of elements (i.e., their synonymic potential) is projected in poetry from the selection sets existing in the language code to the very sequence of the message itself, the author using elements similar in sound, meaning, or syntactic function to create a sequence of symmetries. Poetic discourse thus becomes codelike in being composed of comparable elements.

The metalingual function, which dominates scientific and logical discourse, is oriented toward the code and typically creates dictionarylike equations. "Imagine such an exasperating dialogue: 'The sophomore was plucked.' 'But what is *plucked?*' '*Plucked* means the same as *flunked.*' 'And *flunked?*' 'To be *flunked* is *to fail in an exam.*' 'And what is a *sophomore?*' persists the interrogator innocent of school vocabulary. 'A *sophomore* is (or means) a *second-year student.*' All these equational sentences convey information merely about the lexical code of English; their function is strictly metalingual" ("Linguistics and Poetics," p. 356).

But if metalanguage and poetry both create equations, what is the difference between them? "In metalanguage the sequence is used to build an equation, whereas in poetry the equation is used to build a sequence" ("Linguistics and Poetics," p. 358). In metalanguage the fundamental equivalences within the code are made explicit by their shift from the simultaneity of the

```
                          Context
                        (Referential)

                          Message
                          (Poetic)

Addresser . . . . . . . . . . . . . . . . . . . . . . . . Addressee
(Emotive)                                                  (Phatic)
                          Contact
                        (Conative)

                           Code
                       (Metalingual)
```

code to the successivity of the utterance. In poetic language, the very succes-
sivity of elements is premised upon their equivalence—elements follow each
other because they are creating comparable positions (the second feet of
succeeding lines, for instance).

In both metalanguage and poetic language, the move away from reference
is apparent. The metalingual message is concerned with coded equivalences
regardless of their referents' relations in reality; "real language" movements
can thus be understood as attempts to assure that when metalingual utter-
ances are made the solidarity of code to world will make it impossible to
equate words accurately without equating things truly. (But we have seen
the impossibility of this move.) Poetic language is equally distant from
reference, since it forms a codelike structure of substitution sets: the second
foot in a line is equivalent to the second foot in the following line regardless
of the semantic content of those feet.

The self-enclosure of these functional languages—their imperfect fit with
reality—results from the nature of equivalence itself. Since both metalan-
guage and poetry are built upon it, they are inevitably built upon the paradox
that what is like is also unlike, that what is iconic is also conventional. In
other words, equivalence is the seat of the homonymic-synonymic slippage
that we have described as essential to all communication and linguistic
change. Metalanguage and poetry foreground that mechanism that we all
long to ignore in the hopes of a stable system of meaning, a knowable world
signified by a coherent code.

The Nonsense Contradiction

But if ever I meet with a Boojum,
 that day,
In a moment (of this I am sure),
I shall softly and suddenly vanish
 away—
And the notion I cannot endure!

Lewis Carroll

I have been urging, then, that metalanguage and poetic language in their pure states, uncontrolled by the discipline or politeness of dialogue, inevitably merge with nonsense. And nonsense literature has functioned often as a warning of where runaway science and art can lead. As a result, nonsense has played with all degrees of dialogicity and has shown a special concern for tropism. It often tests the point at which the 'things' that can be put into a text (quotations, illustrations, etc.) become evidentiary, and on the other hand, the point at which the system of the text becomes thing-oriented, referential. For this reason, pictorial illustration has a special urgency in nonsense, as the archcase of this interaction. By making the nonsensical hypothetically possible and, more generally, by raising the issue of correspondence between text and world, illustration is crucial to the posing of the premises of nonsense. It will help us to examine the central mechanism of nonsense art, the contradiction.

The importance of illustration is signaled from the very start in *Alice in Wonderland*. Alice's whole adventure, one suspects, grows out of her boredom with the book that she has with her in the meadow, for "what is the use of a book without pictures or conversations?" (p. 17). Such a book is "magistral"; it bores Alice, disengages her from reality, and propels her into the unreal, discontinuous, 'aphoristic' realm. The Wonderland that she enters is the text before us, complete with its pictures and conversations, so that the self-reflexiveness of the nonsense world, a world that exists and is aware of its existence, is built into this work from the very start.

Wonderland is full of conversations—reported speech, as well as poems, adages, parodies, and other forms of textual quotation. Its elaborate narrative frame, moreover, keeps rendering it its own quotation. Alice falls asleep and dreams this world, only to destroy it by waking up; her sister then daydreams about Alice, about Wonderland, and about an adult Alice narrating her adventures in Wonderland to her future children. And around all this framing lies the further frame of sentimental poetry that pictures the author and his little friends rowing down the river and inventing the tale that is told within the text. Sentimental as it is, however, it contains mock-heroic elements ("Prima," "Secunda," and so on) which place it within the frame of other works of that genre. Or does its parody of that genre place the mock-

heroic within the frame of *Wonderland?* As with the Red King in *Through the Looking-Glass,* it becomes impossible to discover who is inside whose dream frame. We shall return to the dialogic nature of framing later on.

The pictures in the text, Tenniel's illustrations, are of equal importance to the conversations. They are used for their evidentiary force, or at least they are used to highlight the problems involved in using pictures as evidence. For if, as Barbara Herrnstein Smith writes, fiction is the creation of "a fictive member of an identifiable class of natural ('real') objects or events" (p. 25), nonsense goes this pattern one better. It invents not only individuals but new classes, whose existential potential it demonstrates by drawing them. *Wonderland* makes an important point of this mechanism. "(If you don't know what a Gryphon is, look at the picture)" says the narrator (p. 100), and later on, "the King... wore his crown over the wig (look at the frontispiece if you want to see how he did it)" (pp. 114–15). These remarks are in parentheses, a further framing device in that it retreats from the narration to advert directly to the world of the book. This reality contains entities, pictures, that provide information much more convincing than the mere telling of the story.

More strikingly, the question of pictorial evidence is raised to a theme in *Wonderland.* In the mad teaparty, the Dormouse tells a tale of three little sisters who live at the bottom of a well. They live on treacle, their well is a treacle well, and the Dormouse claims that they are learning to draw treacle from the well. "'But they were *in* the well,' Alice said to the Dormouse... 'Of course they were,' said the Dormouse: 'well in.'" Theirs is clearly as much a linguistic world as a physical one. When the Dormouse continues, he feels free to play on the homonymity of "draw" and "well" to vary his story, saying that the sisters were learning to draw "'all manner of things—everything that begins with an *M*'" "'such as mouse-traps, and the moon, and memory, and muchness—you know you say things are 'much of a muchness'—did you ever see such a thing as a drawing of a muchness?' 'Really, now you ask me,' said Alice, very much confused, 'I don't think—' 'Then you shouldn't talk,' said the Hatter." And this remark precipitates Alice's departure.

The episode encapsulates the stance of nonsense on the representation of reality. The three sisters' drawing of objects beginning with *M* is not only homonymous but synonymous with their drawing of treacle from a well in

which they are living. Drawing is the extracting of essential nourishment (they live on treacle) from one's own environment, one's reality. And the objects that begin with *M* are a typology of ontological classes. Mousetraps are a class of physical objects; the moon is a unique physical entity, its designation having the status of a name; memory is a mental process whose only palpability resides in certain verifiable manifestations; and muchness is a total abstraction—moreover, one limited to a single idiomatic expression. It cannot be drawn, and serves to mark the limit of the pictorial. Its locus is strictly verbal, and when Alice is asked if she has ever seen a drawing of it she says, "I don't think." The Hatter takes her at her word and says that then she should not talk. If something cannot be pictured, it cannot be thought, and should not be spoken. Of course, this conclusion results from a series of mad misunderstandings, but it is there nevertheless and constitutes a position on meaning. Since Alice rejects it, we cannot take it as an ultimate position. Moreover, since it is enunciated by a series of mad or sleepy characters it might itself be a mad position: to speak and think only of what can be drawn would be mad indeed, as mad as having tea perpetually because the 'time' on the clock has stopped at six o'clock. There are realities which cannot be pictured and there are false picturings.

But the ontological categories related to pictures are crucial to the project of nonsense. A muchness cannot be drawn because it has nothing beyond a linguistic existence. To draw it, to demonstrate its potential existence and materiality, would be to assert a contradiction in terms. As we saw with the Red Queen, the contradiction, unlike the oxymoron and the metaphor, precludes any correlation between language and reality. And it is just here that Alice and *Alice in Wonderland* balk. At the thought of the impossibility of picturing a muchness and the attendant impossibility of thinking or speaking of it, the narration changes the subject by having Alice walk off in disgust while the Mad Hatter and March Hare stuff the Dormouse into a teapot. The text draws the line at the inconceivable—even though by doing so it makes it conceivable.

The picture of the unpicturable is the limit against which nonsense continually forces sense. The steady, logical extension of ideas inevitably reaches a blank wall and must start all over again. Thus, nonsense seesaws between the seamless web and the jagged interface, and Alice's discomfort with such rude breaks is apparent.

Episode after episode in *Wonderland* shows characters turning away from the spectre of discontinuity. When Alice is shrinking after sipping from the bottle marked "Drink me," she waits momentarily to see if the process is finished: "she felt a little nervous about this [shrinking]; 'for it might end, you know,' said Alice to herself, 'in my going out altogether, like a candle. I wonder what I should be like then?' And she tried to fancy what the flame of a candle looks like after the candle is blown out, for she could not remember ever having seen such a thing" (p. 23). And when Alice has grown so big that she anticipates difficulty in communicating with her feet, she imagines quite extensively the diplomacy required in dealing with this alienation of her body. But eventually she draws back, saying "Oh dear, what nonsense I'm talking!" (p. 27).

The reference to nonsense in succeeding sections of the text is always a signal that the limit of thought has been reached, either logically, as with the drawing of muchness, or existentially, as in the desire for knowledge about death, the ultimate unknowable. Alice offers to unknot the Mouse's 'tale,' a poem about his threatened death at the hands of a dog called Fury (fate), to which the Mouse angrily replies, "You insult me by talking such nonsense!" and walks away without finishing his story (p. 41). In the mad teaparty, Alice learns that the stopping of the clock at teatime leaves no time to wash the dishes, so that the March Hare and the others must keep moving around the table to unused settings. "'But what happens when you come to the beginning again?' Alice ventured to ask. 'Suppose we change the subject,' the March Hare interrupted, yawning" (p. 80). Or when the Queen orders Alice's head chopped off, "'Nonsense!' said Alice, very loudly and decidedly, and the Queen was silent" (p. 88). The Mock Turtle's etymology for "lessons" provokes another abrupt switch. He claims that each day as a student he had had one fewer hour of lessons—"'That's the reason they're called lessons,' the Gryphon remarked: 'because they lessen from day to day.'" Since he had started with ten hours, Alice reasons that the eleventh day must have been a holiday; but then she wonders, "'how did you manage on the twelfth?'" "'That's enough about lessons,' the Gryphon interrupted in a very decided tone" (p. 105). In each of these cases, Alice comes too near contradiction or death to pursue the subject. Like the Boojum, whose identity can be known only if it causes its seeker to vanish, the most crucial thing to know is that which undoes the knower.

All other acquisitions of knowledge in *Wonderland* are parallels of this one and symbols of it, as when Alice walks through the tree (of knowledge) after learning how to use the golden key and finally enters the garden she had seen through the keyhole. This infinitely desirable garden turns out to be an anti-Eden, a garden of experience. But it, unlike death, is safely knowable. When it turns into a nightmare, Alice makes *it* vanish by waking up, thus turning the tables on death. All the nonsense interruptions, all the spatial discontinuities and logical leaps of the book are signs of this struggle between the knower and his undoing. They include the very structure of the book, with its chapter breaks, its dashes and parentheses, and its elaborate framing.

Wonderland continually contrasts the disjunctive, nightmarish story to the unifying frame around it. This contrast is apparent in the difference between the events in Wonderland and those same events in the narrative frame of Alice's waking life. Alice herself refuses to find meaning in Wonderland, but the narrator does not leave things at that. He ties this dream story to Alice's future and the continuity of her identity, ending with Alice's sister imagining how Alice "would keep, through all her riper years, the simple and loving heart of her childhood; and how she would gather about her other little children, and make *their* eyes bright and eager with many a strange tale, perhaps even with the dream of Wonderland of long ago; and how she would feel with all their simple sorrows, and find a pleasure in all their simple joys, remembering her own child-life, and the happy summer days" (pp. 131–32). Alice, whose tumble down the rabbit hole is a version of the fall into selfhood and identity, achieves that identity through the dreaming and retelling of *Wonderland*. At the time the action of this novel ends, Alice is still a bad interpreter, noting only the disjunctions in her dream and their violation of the norms of the waking world. But *we* are not left the choice of this misreading, nor ultimately is she. We are analogues to her children, being told this story as she had experienced it and thus experiencing it as the heroine she was too. And ultimately we too will tell the story and turn nonsense disjunction into autobiographical wholeness.

This contrasting of framed story and framing life makes the form-content opposition a convertible pair. On the one hand, reality, life, may be perceived as an utterly unformed mass that art shapes; on the other, art may be seen as breaking the pattern that reality inexorably imposes upon all of us,

the pattern culminating in death. Nonsense, traditionally a sphere of imaginative freedom, appears to be a realm where writer and reader can ignore the constraints of reality and language to inhabit a pure wish-fulfilment. The conceit of the dream or the vision supposedly makes anything possible, and the framing devices, moreover, guarantee that there will be no spilling over of this uncontrolled abundance onto the finitude of life. Though much of *Alice in Wonderland* is just such an overstepping of bounds, we have seen how emphatically it reminds us of its (and our) limits. In fact, there is a tendency for critics to read Carroll, particularly *Through the Looking-Glass,* as just the opposite of the picture I have painted—a world in which there is *no* freedom, in which no pattern is broken, no ideology defied, no freedom permitted.

The limitation in *Through the Looking-Glass* is symbolized by the chess problem controlling the plot, which is laid out before the narrative begins. However, this 'fateful' plot appendage, standing as it does for the inevitable growth toward maturity of every little girl or pawn, is balanced by a host of conflicting factors, not the least of which is the foreignness of the Looking-Glass world itself and Alice's successful return from it. And with the question of whether Alice dreamed the Red King or he dreamed her left moot, the competition between individual freedom and external control ends in a standoff. It is thus quite as mistaken to see *Through the Looking-Glass* or any other nonsense work as all pattern as to take them as pure liberation: nonsense explores the interaction of pattern and freedom, as a theme about both life and art.

And this exploration is very consciously concerned with the relation between history and fiction. We have seen the parody of history accomplished in the Mouse's dry tale. The Alice books demonstrate the failure of history through its failed dryness, its lack of connection to or efficacy in reality. As with virtually every kind of textuality that enters these books, history undergoes interruption and distortion, while the framing narrative of the life of Alice triumphantly (if uninterestingly) closes about it.

One of the technical properties of narrative that echoes the life-art distinction is the difference between the referential sequence and the narrative sequence, what the Russian formalists termed *fabula* and *sjužet.* The first is the temporal-causal sequence of events as they are ordered in reality, whereas the second is the teleologically ordered sequence of episodes in narration.[44] *Wonderland* plays with this distinction. The complex syntax of the historical

passage introduces events in a sequence not corresponding to their temporal occurrence ("William the Conqueror, whose cause was favoured by the pope, was soon submitted to by the English, who wanted leaders, and had been of late much accustomed to usurpation and conquest.") But in the nonsense adventures of Alice we find a contrasting narrative procedure that is enunciated as a principle: "'Begin at the beginning,' the King said, very gravely, 'and go on till you come to the end: then stop'" (p. 126). It is the reversal of this acceptable ordering by the Queen, "Sentence first—verdict afterwards" (p. 129), that leads to the dissolution of the dream. The White Queen has a similarly disconcerting habit of experiencing effects before causes in *Through the Looking-Glass*. In such a world reversed orders are abundant, just as they are in historical texts, but one wants to reject them in favor of a properly ordered sequence where chronology and aesthetic pattern coincide. To the sentimental King, life order must dominate over text order.

The specific situation in which the King enunciates his theory of narration is the giving of evidence during the trial of the Knave of Hearts. It is significant that a theory of narrative (and of interpretation) arises in this context, for the trial, and justice in general, are key themes in both nonsense literature and its high-literary relative, the absurd. Justice is man's attempt to systematize human affairs, to superimpose teleology upon causality. It is an archexample of the fictionalizing of experience. And the mechanism of justice, the trial, is curiously analogous to the literary text. Its proceedings are structured so as to get at 'the facts' (the *fabula*) while at the same time the lawyers try to reveal those facts in such a way as to lead inexorably to their own interpretations (*sjužets*). It is as if there were two authors competing for control over the same story line—which is fundamentally dialogic, even aphoristic, until the judgment takes over.

In *Alice in Wonderland* the theme of justice is particularly important. It is tied to the conflict between selfhood and death discussed earlier, because, of course, fate or doom is one pattern that life itself imposes. And again, the Mouse is the occasion for this theme. Alice keeps forgetting that mice meet their fate at the claws of cats and dogs and so offends the Mouse through her insensitive chatter about her cat Dinah and a pet terrier. Dinah is "'such a capital one for catching mice—oh, I beg your pardon!' cried Alice again, for this time the Mouse was bristling all over, and she felt certain it must be really offended. 'We won't talk about her any more if you'd rather not'" (p.

33). The topic of death inevitably causes a change of subject in *Wonderland,* but in this case Alice is unable to choose a happier one. The Mouse—all mice, all mortals—are doomed.

The Mouse decides to account for his aversion to cats and dogs by telling Alice a tale. But because Alice is more interested in his tail than his plaint, she perceives the story he tells her as a protoconcrete poem in the shape of a tail. So intent is she on this piece of anatomy that she completely misses what the Mouse's tale is about: a run-in that he once had with a cur named Fury who, out of boredom, decided to take the Mouse to court. (Notice that the boredom here is the same motivation that landed Alice in Wonderland in the first place; boredom is a dangerous state!) The Mouse protests to Fury that without a judge and jury the prosecution would be meaningless. " 'I'll be judge, I'll be jury,' said cunning old Fury: 'I'll try the whole cause, and condemn you to death' " (p. 40). The dog is here collapsing justice into fate, as symbolized by his name. The horror that the Mouse quite justifiably feels is not only at the prospect of death but at the nullification of any possibility of meaning in the face of it. Death makes a mockery of justice. If Alice learns anything by the end of her dream, it is the importance of rebelling against this fact.

But at the time that Alice encounters the Mouse, she is nowhere near learning this lesson. The Mouse accuses her of not listening to his poem and she, still fixated on his tail, replies, " 'I beg your pardon, . . . you had got to the fifth bend, I think?' 'I had *not!*' cried the Mouse sharply and very angrily," since not only had he not been involved with "bends" but he had reached the climax of the tale and tail. The typographic rendering of the poem-tail shows a steady reduction in the size of the type face up to the last word, "death," and that word, thematically, is the paradigmatic end of the story. Alice has not recognized the finitude of the narration just as she is oblivious to death itself.

But, on the other hand, if the Mouse's tale is in fact autobiographical, then it *is* unfinished, for clearly if the Mouse is still alive to tell his tale he must at least temporarily have escaped his fate. But he never narrates his escape. Alice's indifference, her proud desire to undo knots (riddles—which she mistakes for the Mouse's *negation,* "not"), ends the story at "death." It is the lack of empathy and 'human' concern that turns the triumph of narrative over contingency into a defeat. And Alice goes right on to repeat her error

with the birds, to whom she again brags of her cat Dinah's eagerness to "eat a little bird as soon as look at it!" (p. 41). It is no accident that Carroll makes the vicious Red Queen of *Through the Looking-Glass* a reincarnation of Alice's black kitten. Her analogue in *Wonderland,* the Queen of Hearts, wants to condemn her own son to death for allegedly stealing some tarts. Nature in the form of cats and mothers is a cutthroat world in which fate conquers justice. The benign mother Alice of her sister's daydream presumably has the lessons of Wonderland to thank for her loving understanding of her own children.

For by the end of *Wonderland,* Alice's reaction to injustice is quite different. She observes the various abuses in the trial of the Knave of Hearts with growing indignation and eventually eliminates the cards—'kills' them in fact—for their blatant defiance of the procedures and principles of law. The trial reads like something out of Kafka. The Knave is implicated in a crime by the nursery rhyme in which a Knave of Hearts steals some tarts baked by the Queen. Like many litigious victims, the Queen is intent on a verdict of guilty at any cost and appears to have biased the judge, the King of Hearts. Thus, the fact that the tarts are present in the courtroom does not deter him from prosecuting the crime. Moreover, the tarts are even termed evidence. The entire trial demonstrates the failure of facts to amount to evidence in the absence of a valid hypothesis. Alice's total ignorance of the circumstances of the theft, for example, is first taken as "important" by the King until the White Rabbit suggests that he meant "unimportant." "'Unimportant, of course, I meant,' the King hastily said, and went on to himself in an undertone, 'important—unimportant—unimportant—important—' as if he were trying which word sounded best." A set of verses is next entered as evidence even though they are neither in the Knave's handwriting nor signed by him. When the poor Knave points this out to the King, the King decides that the Knave has imitated someone else's handwriting, and "'You *must* have meant some mischief, or else you'd have signed your name like an honest man'" (p. 125). The Knave's unfortunate name and the hearsay evidence of the nursery rhyme are the only 'facts' against him. Without any rules of evidence, anything is relevant—or irrelevant—and the relation between truth and judgment is destroyed.

However, the King's reading of the verses, a triumph of hermeneutic skill, reveals what was apparent from the start, that the tarts are present, not

Fig 8
Sir John Tenniel, "Trial of the Knave of Hearts," from Lewis Carroll, *Alice in Wonderland*

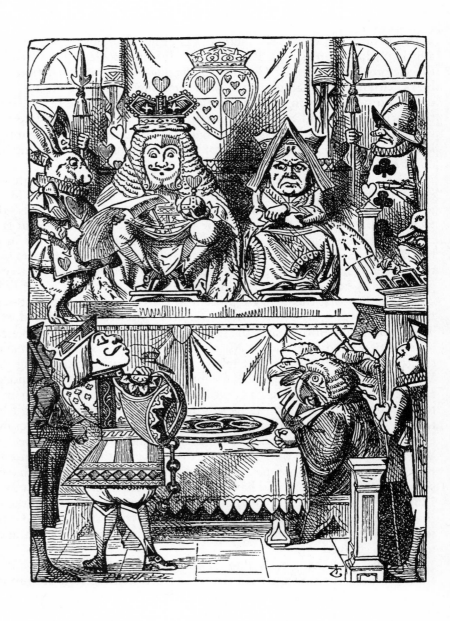

stolen at all. This reading is possible only because the verses are utterly vague, full of pronouns and other shifters that are unrestricted by the text in which they appear. They are demonstrations of the vast homonymic potential of any utterance. It is only the King's determination to have them apply to the crime at hand that makes them do so. And seemingly, this minimal referentiality of a text is all that it takes for justice and meaning to triumph over fate.

Though the Queen tries to overturn the outcome with a typical, unjust reversal—"Sentence first—verdict afterwards"—Alice stops her by waking up. Alice has destroyed injustice, and, unlike the Mouse, she does frame her run-in with the Furies by the act of waking up—thus rendering it a story rather than autobiography. It is a story because it is not life, because it can be experienced as an ending without undoing the perceiver.

But the story itself ends in absolute chaos and not teleological closure. The closure is all in the frame narrative. The Mouse's tale, in contrast, is closed as a narrative and as a life sequence, but its autobiographical frame is incomplete. It lacks the retreat from the horror that distinguishes a story from life, and for that reason it is a case in which justice and narrative teleology fail to overcome fate. In every detail *Wonderland* insists upon the distinction between telling a life and living one. And the contrast between fate and justice is a crucial facet of this position.

The importance of this opposition is stressed in Tenniel's illustration of the trial (fig. 8). Carroll chooses this out of all the drawings as his frontispiece, and a striking work it is. Formally balanced, the etching is divided horizontally into two halves, with only the White Rabbit on the extreme left extending his foot from the upper sphere into the lower. I cannot help but see the organization of this picture as a parodic suggestion of heaven and hell at the Last Judgment: the bifurcation of the scene into two distinct realms, one with the (holy) family enthroned on high, the other with the sinner before the bar of justice, with an angelic spirit (a time-conscious go-between) mediating between the two realms. A relation is surely being implied between human justice and the divine, the one ending in a shaped episode, the other in a meaning to life. But the banal descent of the Christian design into the world of nonsense makes the meaningful life seem problematic at best.

The trial is perhaps the most dramatic exploration of how system and evidence interact. Moreover, justice—and history and religion—are treated

in *Wonderland* as so many fictions that we use to organize reality, fictions that always fail as perfect fits, just as language—the ultimate nonsense fiction—is definitionally nonhomologous with reality. But just as an unmitigated acceptance of linguistic slippage leads to Humpty Dumpty's private meanings, an unmitigated belief in the failure of justice, history, and religion is shown to be insupportable; madness, social death would be the outcome. Sanity and social interchange are dependent upon the maintenance of a paradoxical world view in which reality and language (or any system) both are and are not mutually implicative. In such a view, the real madness is consistency, and nonsense has as its primary function the promotion of inconsistency. As Carroll claims, the portmanteau word (a fusion of homonymity and synonymity, a complete suspension between two words, two meanings) is the product of a perfectly balanced mind (Carroll, p. 754).

Illustration

It is a figure called Illustration, by the which the forme of things is so set foorth in words, that it seemeth rather to be seene with the eies, then heard with the eares.

John Marbeck

Illustration cooperates with nonsense in dramatizing the inevitable contradictions that exist in sense. In doing so, it functions very much like the metaphor. Since the beginning of this book, I have been arguing for the importance of metaphor in theoretical thinking, on the grounds that the metaphor both opens new possibilities and reveals the limits of our cognitive systems. To clarify the function of illustration, I would now like to look once more at the metaphor, that mere "color of rhetoric."

The metaphor, like nonsense, wreaks havoc with philosophical consistency. As A. C. Baier has stated, "what one philosopher will class as senseless, for example, 'Virtue is green'—another will class as false, and the literary critic may well find the same words, in a suitably enriching context, illuminating and apt."[45] In his entry on nonsense in the *Encyclopedia of Philosophy,* Baier places the metaphor/image in the middle of his typology of sense-deviations. He takes as the "paradigm of sense the utterance 'The water is now boiling' spoken when the water is in fact boiling, to an audience ignorant of and interested in that fact," and enumerates (pp. 520–21) the following main departures from the standard:

1. the same words spoken when the water is *not* boiling: nonsense as obvious falsehood;
2. the same words spoken when no one knows or cares about the water: contextual or semantic nonsense;
3. "The water is now toiling" spoken under almost any circumstances: category error or semisentence;
4. grammatical jumbles (e.g., 'boiling the now water is'): nonsense strings;
5. vocabulary nonsense, as in the coinages of "The Jabberwocky";
6. gibberish (e.g., "grillangborpfemstaw"), which nevertheless is consistent with the phonological system of the language of its speakers.

Baier classes the first two levels as token nonsense, because though this particular utterance of those words is nonsensical, other circumstances would make them sensible. Levels 4–6, in contrast, are type nonsense, for their failure to render sense is not a function of any particular utterance but of the words and syntax themselves. But what of the semisentence, level 3? "Some of the difficulty in specifying the nonsensical character of the semisentences of level 3 may arise from the attempt to find rules or gener-

alizations for sentence-types, when all that may be possible at this level is a characterization of utterance tokens. The stubborn fact is that in propitious circumstances (verbal context or nonverbal context) tokens of these semisentence types may be not nonsense but figures of speech, and figures of fully successful speech" (p. 521).

But the metaphor/image not only creates a confusion between formal and contextual sense. It makes the relationship of meaningfulness and truth paradoxical. If we want to characterize the senselessness of "virtue is green" as lying in the fact that it presupposes a false sentence, "virtue is the sort of thing that has color," we run into trouble:

> The difficulty is this, that logical relations are usually defined in terms of truth relations but truth relations hold only between statements which can be true or false. What, then, can be this logical relation of presupposition which can hold between the meaningless and the false? It seems that we cannot consistently hold all the following five theses, each of which some philosophers have wanted to hold:
> (1) Everything which has logical relations with the meaningful is itself meaningful.
> (2) Logical relations can be defined in terms of truth relations.
> (3) "Virtue is green" is a piece of nonsense.
> (4) "Virtue is not the sort of thing which can have color" is true.
> (5) There is a logical relation between "Virtue is green" and "Virtue is not the sort of thing which can have color."
> At least one of these theses must be abandoned, and different philosophers abandon different ones. The issues involved here essentially concern the demarcation of the field within which logical relations hold, within which sense can be spoken, in such a way as to allow us still to talk sense about those relations themselves. [P. 521]

The metaphor inevitably leads to a paradox, not only in terms of what it means but in terms of how we understand meaning. If the metaphor creates a logical relation between the nonsensical and the true, then it stands as the yoker of chance and system, of self-contained reflexiveness and unambiguous reference. And as the essential poetic figure, it helps to explain the closeness of nonsense to verbal art in general.

The metaphor is the paradigmatic case, I believe, of those evidentiary devices mentioned earlier. Its connection with illustration in particular is part of the official ideology of rhetoric that we have inherited. Sprat and the Royal Society condoned the tropes and figures as originally necessary "to represent *Truth*, cloth'd with Bodies; and to bring *Knowledg* back again to our very senses, from whence it was at first deriv'd to our understandings" (Sprat, p. 112). Rhetoric was seen as the means of presenting knowledge vividly, so as to be experienced in its truth rather than merely referred to. Thus, Howell notes that Bacon called rhetoric "the illustration of tradition" (Wilbur Samuel Howell, p. 371), and that the ancient figure of *enargeia*, vivid description, was understood as verbal illustration, a "painting with words" (p. 121). Galen held that science as a whole is based on *enargeia*, "the appeal to common notions so clear as to be universally accepted," and yet this same figure was at times taken as the essential device of poetry. Pictorial illustration in fact was used in scientific treatises before it entered historical and literary texts.[46]

The verb "illustrate" itself seems to have been used to refer to verbal elucidation before it was transferred to the pictorial supplementation of verbal texts. Some of its early contexts are suggestive: "1538 Coverdale *New Test.* Prol., Thou shalt see that one translation declareth, openeth, and illustrateth another"; or "1691 Norris *Pract. Disc.* 77 When Revelation had illustrated the obscure Text of Reason" *(OED)*. These usages indicate the rootedness of illustration in interpretation and intertextuality. One text through its clarity gives access to another, and Revelation, pure vision, is the ultimate illustration of texts, in this case the text of the world, of life. The noun "illustration" was also used of words before pictures, at one time being the name of a figure of speech like *enargeia*, "by the which the forme of things is so set foorth in words, that it seemeth rather to be seene with the eies, then heard with the eares" *(OED)*.

The difference between an object seen with the eyes or heard with the ears is the difference between an object shown or described. Heidegger writes that "showing is revealing something precisely as it is; it is to delineate its structure so clearly that the structure is finally *seen*, not merely indicated or described" (Casey, "Truth in Art," p. 360). This distinction parallels Peirce's icon/symbol contrast or Goodman's exemplification *versus* denotation;[47] it is

the entire motivation for the "speaking picture" metaphor for poetry. The fit between picture and pictured is so much more extensive than between word and referent that the picture is often confused with the world it pictures. Susan Stewart's statement cited earlier regarding some illustrated texts of Edward Lear is a case in point. "In these examples of nonsense botany, the natural world is made to conform to the discourse" (Stewart, p. 98). To object that it is rather a visual text that is being made to conform to verbal discourse seems supersubtle.

Much as Goodman warns us against assuming that a picture of a unicorn implies the existence of a unicorn (P. 22), pictures do rearrange the world. They add to the stock of things seen the set of things pictured, and since the two overlap and inform each other, they make the line between object-world and mental world rather thin. It is always a shock to find that photographs can look very unlike their subjects, and this in fact was one of Lewis Carroll's favorite nonsense themes. In "A Photographer's Day Out" the failure of his camera to capture the elements of reality is instrumental in the failure of his courtship of the "fair" Amelia, who is herself described as a photographic image (Carroll, p. 1090). The fall of positivism, as Todorov argues, has highlighted "the fragility of the limit between matter and mind,"[48] making problematic the themes of I and thou—perception and desire. Nonsense and the fantastic both play on the homology of picture and reality, the expectation that pictures are like what they picture, the resulting disappointment and shock when they are not, and the terror when pictures actually become reality (the topos of the moving eyes of portraits; or Dorian Grey's portrait which itself degenerates when its subject is frozen in the "picture of his youth").

While maintaining this quasi-magical relation to reality, pictures also emphasize the failure of language to achieve such presence, especially when word and picture represent the same subject. David Bland writes that when illustrators began to depict objects three-dimensionally, there arose the "problem (which is as much the problem of the illustrator to-day) . . . [of how] to reconcile the flatness of the text with the depth of the picture" (p. 65). The physical properties of the printed text are foregrounded by illustrations; this rectangular white surface covered with black marks is revealed as utterly unlike the represented world. Moreover, those black and white pages are meaningless divisions in a continuous span of meaning. If we tend to

overlook this fact, illustrations remind us of it, with their limitation to the page and their discrete edges. They divide the text up arbitrarily into a number of scenes which is potentially endless, just as one could always keep finding more examples or adding more pages to a book.

Illustrations need not be discontinuous, of course. In the earliest illustrated manuscripts, scenes followed each other in a cycle matching the continuity of the papyrus or parchment roll. But later the picture was fitted into a decorative pattern, and later still the scribe left a place for it in the text. "Lastly each scene becomes isolated though still not an entity but rather a unit from a cycle" (Bland, p. 25). With the modern typographical codex, illustrations turn the structured totality of a literary work into a collection of pages—arbitrary, comparable units, a list.

Appropriately, illustrated books have gravitated toward subjects structured as lists: the emblem book, for example, or catalogs of costumes, anatomical parts, animals, and so on. The verbal captions try to fill in the spaces, but in their discreteness illustrations become similar to aphorisms, to wildly multiplied examples, to reality itself. Like Leger's 'cubist' film, *Ballet Méchanique,* they fill a temporal medium with isolated fragments which tend to exhaust the viewer.[49] As such, they open the book to "the nonsense of the list—the possibility that one can make a vertical [or horizontal] arrangement of anything. . . . The antihierarchical and anticausal nature of the list is especially apparent in the printed list, for while the list has a top and bottom, a higher and a lower, there is no subordination in this" (Stewart, pp. 135–36). Illustrations reveal the central contrast between the teleological wholeness of the verbal text and the mere additive structure of its material vehicle, the book, and this is the same opposition between life and art, story and frame, that we saw in *Alice in Wonderland.* Moreover, the exhaustion they threaten is the inverse of the boredom created by Alice's book without pictures or conversations—an overdetermined monologic system. Boredom and exhaustion are the emotional extremes exploited by nonsense.

To circumvent exhaustion, which, of course, is the result of illustration gone wrong, illustration has stressed the beginnings and endings of texts, the points at which framing devices isolate the work from the realm of normal language reference, enclosing and shaping it. Thus, initials have long been an invitation to illustration, a point of convergence of typography and picture. Beyond merely ornate first letters are "historiated initials," which contain

pictures. "This type of initial appeared first in about the eighth century and it continued side by side with the more popular decorated initial right down to Victorian times, when it was relegated to children's books" (Bland, p. 57). The historiated initial blends typography into picture and through this semiotic repleteness marks the opening of a new semantic space.

Not only initials, but title pages have typically been illustrated, often with banners and other decorations rather than with scenes from the book. The frontispiece is a special case, frequently one of the illustrations from the body of the book moved up to the beginning for emphasis. In this way the mere sequence of plates is given a teleology, epitomized in a single framing plate. The engraving of the trial of the Knave of Hearts is elevated to this stature in *Alice in Wonderland,* Carroll stressing the importance of this scene as the culmination of disruptions that lead to Alice's violent (and mature) assumption of control by waking up. Similarly, the drawing of the White Knight is repeated as the frontispiece of *Through the Looking-Glass* to focus our attention on this gentle bumbler who, like Carroll himself, takes Alice up to the point of her transformation into a woman.

This emphasis on beginnings and endings is perhaps the most apparent in baroque book design, which was often based on an analogy between book and building, both needing an entrance and a 'back door.' The book contained an "engraved architectural title page by which the reader was led as it were into the text through a triumphal arch. This formula was soon to be used for all sorts of books however unsuitable, and by degrees other architectural ornaments found their way into the pages. . . . the illustrators gave free rein to their exuberance in a way that *was not possible to the builders themselves in their handling of real materials*" (p. 144, my emphasis). Illustrations thus associate the physical structure of the book with another kind of space, the building, which is literally an enclosed world cut off from that of nature. Moreover, whereas that architectural space is still limited by the physical laws of the material world, the book is not. Illustrations accordingly lend the book the closure, form, and materiality of a building, and then dematerialize it by defying the physical laws of material reality. They both shape and deny shape, refer and deny real reference.

The illustrated text is a *Gesamtkunstwerk,* a mixture of artistic media epitomized in Wagnerian opera. The *Gesamtkunstwerk* is a gesture toward semiotic repleteness, combining several kinds of sign types and having them

comment on each other. Yet in the case of illustration, this seeming realization of the speaking picture is as much a failure—a mere case of *cum pictura poesis,* as Wimsatt[50] puts it—since the connection of the two semiotic mechanisms is so uneasy. Nonsense writers and other tamperers with sense have capitalized upon the disjunction. Magritte's "Key to Dreams" (fig. 9), for example, shows a number of mislabeled pictures (or misillustrated nouns). The label and picture do not fuse into a metaphor defying the separateness of their media, nor do the various cases of mislabeling coalesce into a unitary meaning. Words and pictures here stubbornly maintain their independence, mocking the fusion sought for in illustration, and the one proper match, "the valise" (with Magritte's signature present as another possible label), seems as arbitrary a collocation as the rest.

Breton's photographic illustrations to *Nadja* function similarly (fig. 10). If the "light of the image" results from the disjointedness of the two terms that give rise to it, the experience of Breton's photos in *Nadja* should be a marvel of luminosity. And if the wild affects recorded in this 'romance' did arise in part from the drab, mundane cafes and statuary shown in the photographs, surreal-

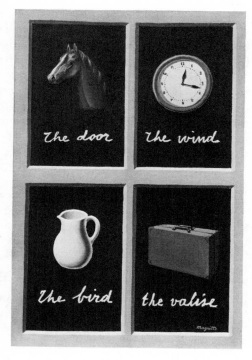

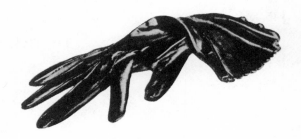

ism must indeed be a powerful state of mind. Here are evidentiary devices whose thesis has ceased to exist, pictures which no longer illustrate. Breton himself points to the failure of the illustrations, blaming it on the difference between his feelings now and at the time when he saw those scenes with Nadja. In preparing the book he had decided to go "back to look at several of the places to which this narrative happens to lead; I wanted in fact—with some of the people and some of the objects—to provide a photographic image of them taken at the special angle from which I myself had looked at them. On this occasion, I realized that most of the places more or less resisted my venture, so that, as I see it, the illustrated part of *Nadja* is quite inadequate."[51]

But Breton goes on to connect this failure with the discontinuities of the book as a medium:

The sudden intervals between words in even a printed sentence, the line which as we speak, we draw beneath a certain number of propositions whose total is out of the question, the complete elision of events which, from one day to the next or to another, quite upsets the data of a problem we thought we could solve, the vague emotional coefficient applied to and removed from the remotest ideas we dream of producing, as well as our most concrete recollections, as time goes by—all these function so that I no longer have the heart to consider anything but the interval separating these last lines from those which . . . would seem to have come to an end a few pages back. [P. 148]

The intervals between words, the interval of the deductive "line" between surreal proposition and conclusion, the intervals in memory that obliterate the data—the evidence—in problem solving, and the disappearance of the affect from ideas and concrete memories are all symbolized in those lifeless, disconnected illustrations.

One of the most perfect exploitations of this illustrational discreteness occurs in the nonsense texts of Edward Gorey. With his graphic genius and bizarre sense of humor, Gorey is certainly the foremost nonsense artist of our day, and his works, like those of Carroll, can teach us a good deal about the norms and assumptions of nonsense.

"The Willowdale Handcar,"[52] for example, is a picaresque adventure of three people who, like Alice, are bored. They wander down to the railroad tracks, spy a handcar, and decide to go on a trip. The sequence of plates and

147

narrative captions that ensues is re-markable for its lack of cohesion. Event after event occurs, but they do not add up to a coherent plot. This is the picaresque gone wild, with only the topos of the handcar ride to create continuity. The events—Titus W. Blotter heading into the Great Trackless Swamp, the discovery of Nellie tied to the railroad tracks, the newspaper fragment informing the travelers of the fall of Wobbling Rock on a family having a picnic, and so on—are all suggestive, narra-tively numinous, one might say. They are the staples of melodramatic plots, but here, undeveloped and strung together, they result in non-sense. As in *Wonderland* they are all connected with death or danger and yet back away from them into a kind of logical and contingent amnesia. The unintegrated episodes 'cul-minate' with the three adventurers perched on their handcar about to enter a tunnel, with the caption "At sunset they entered a tunnel in the Iron Hills and did not come out the other end" (fig. 11). The travelers merely fail to reappear. On the next page we find an uncaptioned back plate with an empty railway tressle and a cannonball in midair. The journey of exploration, like all such journeys and its archetype, life, ends in the failure to reappear. But typi-

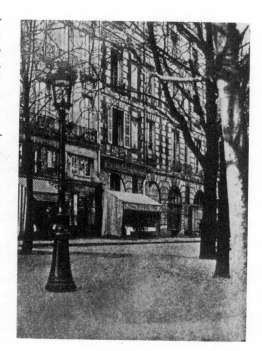

cally for nonsense, this failure is never experienced or even directly acknowledged.

The disjointed plot sequence in "The Willowdale Handcar" is supported and in a sense justified by the illustrations. These function like postcards, and in fact one of the early acts of the trio is to write "postcards to everybody, telling them what they were doing and didn't know exactly when they would be back." The switch from the narrator's summary of the messages ("telling them what they were doing") to the indirect discourse version of one of them ("[they] didn't know exactly when they would be back") is, I think, significant. It indicates an ambivalence in the point of view of the plates themselves. All but one show the three travelers observing the scenes described in the caption, and yet the pictures are not presented from their vantage point. In several cases the travelers are tiny specks or even fragments in the pictured scene. Whose visual experience, then, are we observing?

The one illustration that does not contain the travelers shows the fall of Wobbling Rock (fig. 12), which they read about in a newspaper but do not witness. It is thus a completely 'objective' scene and not a part of their visual experience. But it is deliberately paralleled to all those other scenes that they 'actually' see. The rock is shown just at the point where it has lost its balance and begins to lean toward the slope of the hill beneath it. Caught at that moment of imminent fall it is the type of every other event in the book—a moment full of an unrealized narrative potential. In this way it fulfils the classicist notion of how action can be represented in the static medium of visual art—by being caught at the crucial moment when all the past and future of the act are implied. What happens in "The Willowdale Handcar," however, is that the elements of the narrative have been turned into just such painterly moments—a series of disjoint but enormously suggestive instants. The narrative itself has been made into illustrations. In a way, the picaresque always threatens to degenerate into this numinous randomness, and this connection between the narrative series and the illustration series is perhaps another reason why nonsense so often uses illustrations.

The overleaf of the title page (fig. 13) provides an interesting amplification of this idea. It contains an assemblage of elements alluded to but omitted from the text proper: a picnicking family with a little boy staring upward, presumably at Wobbling Rock in its approach; the birds and plants of the Great Trackless Swamp; vinegar bottles from a defunct vinegar works the

Fig. 11.
Edward Gorey, from "The Willowdale
Handcar," *Amphigorey.* Reprinted by
permission of Candida Donadio &
Associates, Inc. Copyright ©1972 by
Edward Gorey

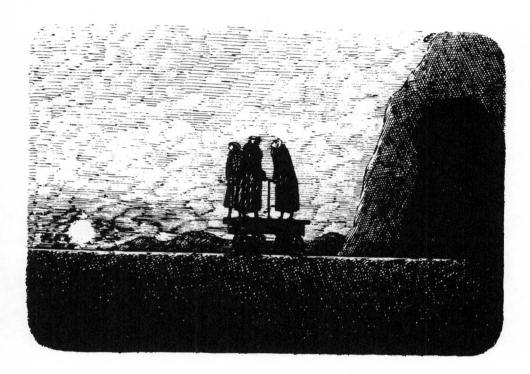

*At sunset they entered a tunnel in the Iron Hills
and did not come out the other end.*

150

Fig 12.
Edward Gorey, from "The Willowdale
Handcar," *Amphigorey.* Reprinted by
permission of Candida Donadio &
Associates, Inc. Copyright ©1972 by
Edward Gorey

*An undated fragment of the 'Willowdale Triangle'
they found caught in a tie informed them that
Wobbling Rock had finally fallen on a family
having a picnic.*

trio visit; a telephone pole containing glass insulators like those in the seven-thousand-item collection at Edna's cousins, the Zeph Claggs; the children from the orphanage to which they have taken an abandoned baby; and Wobbling Rock lodged in the ground where it fell (or else a cannonball from the collection on the courthouse lawn at Hiccupboro). At the bottom of the plate we see a skull—that of Titus W. Blotter, I imagine—impaled on a stick rising from the Great Trackless Swamp, suggesting the dangers, no doubt, of getting 'off the track' from an existential or narrative point of view. These omitted elements are related metonymically to the ones actually included in the narrative; they supply causes, effects, and sources where these are omitted from the plot line.

This relation is most apparent in the central vignette of the page, whose words provide a premature end of the story. "Afterwards a gold ring embellished with leaves, grapes, etc. was found; inside were engraved IRON HILLS and the letters D.M.G., which last stood for the words 'Don't move, Gertrude.'" Not that this text makes coherent what before was a disjointed sequence—on the contrary, it suffers from the "surplus of signification" typical of nonsense (Stewart, p. 93). But it points to many kinds of closure. First, the gold ring that was found is like the frames of the vignettes themselves, fragments left over and enclosed, cut off from each other and from the background. (The narrative illustrations, in contrast, are unframed.) The background to the vignettes is a childish picture of the heavens with a different phase of the moon at each corner. Though this background forms a continuous, quasi-naturalistic space, the phases of the moon suggest a conglobing of time. And the juxtaposition of pictorial vignettes around the textual conclusion reinforces this simultaneity. The page resembles an assemblage in a photo album.

The Iron Hills mentioned in the vignette text are the location of the tunnel into which the travelers disappear, and the contrast of their iron to the gold ring is important. The Iron Hills like the iron tracks beneath the handcar are part of the continuous story line. The gold ring and all the ringed vignettes are hypostases from it. They are like cross sections of the tunnel rather than the side view presented in the last illustration. There is no ominous action presented in them, but merely scenes, even composed portraits—the orphans posing presumably before a camera, the vinegar bottles grouped on a table. The final words engraved on the ring, "Don't move, Gertrude," though

152

there is no Gertrude anywhere in the story, reinforce this stasis. They are the kind of order a photographer gives to his subject to avoid a blurred image. One stops the action in an image, just as the end of a story must be a stoppage of action, and just as any cross section of a narrative track or tunnel must be a static moment.

The artificiality of such pure stoppage is made manifest in the phrasing, "the letters D.M.G., which last stood for the words 'Don't move, Gertrude.'" These stood "last," at the end (even though the page of vignettes precedes the beginning of the story). But they also "last stood" for these words in their sequence of meaning shifts: at last hearing they stood for "Don't move, Gertrude," but presumably they may stand for something else at some other time. These initials are frozen in a meaning, like the scenes in the vignettes or any illustrative fragment. They are removed from their context of being and placed elsewhere, frozen into a single moment of signification. This isolation of meaning is a staple technique of nonsense.

I do not mean to imply, by the way, that Gorey (or even Carroll), is overtly analyzing semantic slippage or the interaction between static image and temporal narrative in the illustrated text. It is rather that nonsense cannot help but imply these issues since it exemplifies them. In the act of disrupting sense it reveals its preconditions by showing the nonsensical outcome of pursuing any single element of the dialectics of meaning, and often by equating such monomania with danger and death it becomes a rather subtle propaganda for eclecticism, balance, and breadth of vision. The various problems *and* gains in integrating pictures and words are thus a natural playground for nonsense.

In fact, to see nonsense as merely a conscious exploration of semantic issues is to treat it as allegory, and the temptation to do so is, I think, definitional for the genre. Where nonsense focuses on the gaps in consciousness, logic, perception, and so forth, allegory uses such gaps to force us to a higher unity of meaning. Gestaltist creatures that we are, we inevitably search a nonsense structure for clues to such a unity. William Empson clearly felt this temptation in regard to the Alice books: "whether you call the result allegory or pure nonsense, it depends on ideas about progress and industrialization, and there is room for exegesis on the matter."[53] And Robbe-Grillet claimed that "non-sense, a-causality, and the void irresistibly attract higher worlds and supernatures. . . . Kafka's narratives would thus be no more than

allegories."[54] Patrick Leigh Fermor obliterates almost the entire canon of nonsense with his instructions for allegorical interpretation:

Pure nonsense is as rare among the arts as an equatorial snowdrop. . . . The wild scenes that run riot in wall-paintings, capitals, and stained glass are lunacy only to the uninitiate: pagan survival, the apocryphal gospels, faulty translation, demon-lore and the bestiary, in collusion with the Thebaid and the torments of anchorites, solve every riddle. Familiar broodings hatched out the eggshells of Bosch, identifiable furnaces stocked his rocketing and backfiring journeys and lit up the apocalyptic scenes; and the same impulses, reinforced by Spanish tyranny and the spectacle of folly, unloosed the skeleton onslaughts of Breughel; all his allegories and proverbs and parables, even the teeming amphibian chaos, have their explanations.[55]

The choice that is offered here between pure nonsense and allegory is a version of all those misleading either/or's that nonsense delights in. If we accept pure randomness we risk appearing as bewildered ignoramuses; if we insist on finding the allegorical system behind it all we become dreary pedants, V. S. Pritchett's "laborious bores of criticism."[56] The double threat of exhaustion and boredom continually stalks the reader of nonsense.

Moreover, allegory is a near neighbor, at least technically, not only of nonsense literature but of illustration. We have already noted that an illustration breaks the perceptual field of a page, disjoining itself from typography particularly when it uses the devices of perspective. In many kinds of illustration, however, the referential subject itself undergoes a similar isolation from its context. Barbara Herrnstein Smith contrasts a scientific illustration and a painting on these grounds:

the illustration of the laurel oak, appearing starkly on the white page of a textbook, surrounded by nothing but printed words, is, in effect, a non-contextual, ahistorical visual structure. As such, however, the illustration can also be distinguished from the representation of an oak tree in a painting. A painting of an oak tree is also a fictive visual structure, but the artist's depiction, unlike the illustrator's, is designed to evoke in the spectator a more or less vivid *impression* of the tree's substantiality, particularity, and historical identity. [Pp. 52–53]

The illustration's separation of the represented object from its spatial-

temporal particularity is matched in allegory, where any temptation to take
the object as an instance rather than a type must be eliminated.

The tendency to treat objects as if they could be independent of spatial-
temporal contexts is, as we have seen, one of the meaning poles that results
in nonsense. It is associated both with a certain kind of scientific thinking and
certain schools of art, as Rudolf Arnheim points out:

Only within a man-made world of fiction, conceived in such a way as to
eliminate interaction—for example, in a textbook illustration, formula, or
descriptive text—can the scientist show the forces emanating from the set-
ting as those inherent in the object. And in a child's drawing the trees can
be a splendid green, quite independent of any influence by the yellow sun
shining forth somewhere else in the picture. A view of consummated con-
stancy created by the absence of interaction is characteristic for certain
styles of art, some early, some late, whose interest is in the invariable ob-
ject as such. It is characteristic also for the absolutist approach to science.[57]

Allegory in particular requires this physical decontextualization. Its in-
sistence on the integrity and identity of objects through their lack of con-
textual modification at the same time obliterates those objects by forcing
them to mean what they are not, to symbolize concepts. Thus, what natu-
ralistically resembles a skeleton ultimately signifies death in Dürer's allegory.
This turning of icons into symbols is the cause of Lessing's criticism of
allegorical painting; he claimed that it violated the art of painting by turning
it into "an arbitrary method of writing."[58] The painting is thus detached
from its dependence on reality—the isolated objects help to signal this
detachment—and leans exclusively toward the side of the self-enclosed
mental world.

The superclear, decontextualized image is typically found in emblem
books, Comenius' *Visible World* (*Orbis sensualium pictus,* the prototype of
illustrated textbooks for children), and allegorical painting proper. Unlike
nonsense, such art is programmatically aimed at eliminating doubt, confu-
sion, and the disorder of the sense world.[59] William Blake, an ideologue of
allegory, insisted that "Sin and destruction of order are the same," and
"Him, who humanizes all that is within and around himself, adore."[60] How
is it that allegorical art can use the same disjunctive potential in illustration
that nonsense does, and yet come out with such different results?

156

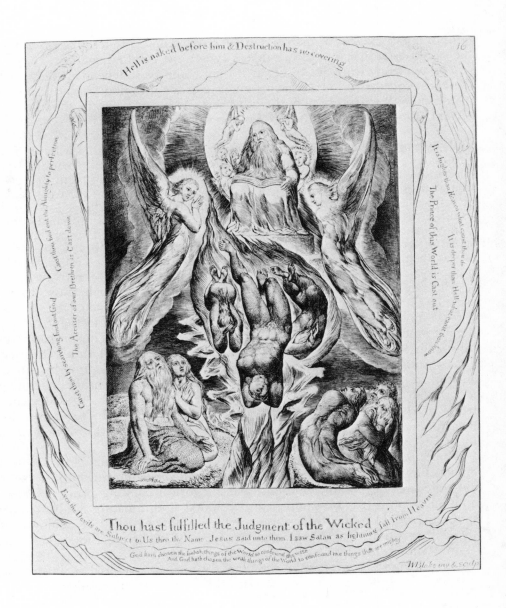

Blake's account of the stages of perception in the passage to wisdom is instructive here. In order to attain this state, one must first pass from the undifferentiated world of solipsistic innocence to the painfully divided world of experience. This state of irreconcilable contraries is, in Blake's *Job,* a brush with the absurd—the nonsensical applied to the life world. Here identity itself becomes split, so that a protagonist in the state of experience becomes what Angus Fletcher calls an allegorical *daemon* (from the word "to divide"): experience "implies an endless series of divisions of all important aspects of the world into separate elements for study and control" (p. 59).

The visual equivalent of this mental division is the disjunctive allegorical plane. Because "reality is imagined in diagrammatic form, it necessarily presents objects in isolation from their normal surroundings" (Fletcher, pp. 99–100). To effect this isolation, Blake stressed the importance of the outline (fig. 14). "The great and golden rule of art, as well as of life, is this: That the more distinct, sharp, and wiry the bounding line, the more perfect the work of art.... The want of this determinate and bounding form evidences the want of idea in the author's mind.... Leave out this line, and you leave out life itself; all is chaos again, and the line of the almighty must be drawn out upon it before man or beast can exist."[61] But the isolation of objects and the fragmentation of the visual field, like "experience" itself, are the result of a mode of perception that one must get beyond. The surface of allegory is only a seeming fragmentatiton that is healed in the unity of vision that follows, an ideational unity that transcends the picture itself.

Thus, overtly the allegorical illustration presents itself as nonsense, a riddle to be solved, whereas nonsense presents inconsistency, impossibility, and division for themselves, without providing mechanisms to dispel them. Enough clues are provided, however, to tempt us to dispel them, for as I have been arguing, nonsense rests on the need for keeping both opposing possibilities in play. As a result, it insists on the salutary effect of the red herring. It seems to me quite reasonable, then, that both nonsense and allegory treat each other as components of their own greater structures, the contradictions of nonsense being a prelude to the higher order of allegory, the allegorical mania for closure and seamless meaning being one of the extremes creating nonsense. It is no accident that Edward Gorey named a collection of his nonsense works *Amphigorey,* stressing the duality of non-

sense through *amphi* and through the pun on "Gorey," "gory," and "allegory."

This gesture both toward and away from allegory is typical of the liminal state of illustration. It reflects this liminality as well in its preoccupation with scenes of transformation, the pivoting between two systems of meaning or states of being. Ovid's *Metamorphoses* has a consistent history of illustration, as has *Aesop's Fables* with its humanized animals, and emblems too are very frequently built around a transformation. The selective illustrations of the Bible often focused on scenes of transformation; Bland says that Cranach illustrated "the earlier part of the Old Testament and the Book of Revelations—for some reason the other parts of the German Bible of that date were usually left unillustrated" (p. 150). Though illustration has certainly had other areas of concentration—erotica, to mention just one—the association between drawing and the fantastic, metamorphosis, and areas where the suspension between two modes of meaning[62] is crucial is remarkable, and even in our day this thematics continues. Apollinaire wrote and illustrated bestiaries and emblem books, and Max Ernst produced collage books with hawkmen and other metamorphic types. Surrealism in general, whether in illustrated texts or pure painting or literature, is programmatically concerned with this pivot between two worlds, as Breton's manifesto title, *Connected Vessels,* suggests.

Illustration thus has a special connection to deviant modes of verbal meaning, and this connection is particularly appropriate to modernist concerns. Whether we look at the surrealist pivot between two worlds of consciousness or the failure of transformation in Eliot's *Waste Land* ("Those are pearls that were his eyes," the forlorn echo of a time when the sea change was still possible), the issue of change and discontinuity is everywhere with us. Modernist art constantly presents us with a duality, both of whose terms must somehow be kept in play, and one of the prime symbols of this precarious balancing is the illustrated text, or, as we shall soon see, the metaphoric image.

Pictorial Nonsense

Horace used the case of the metamorphic mixed creature in painting to establish a standard of verisimilitude for both painting and literature. In what sounds strikingly like a description of a surrealist canvas he warns:

Suppose a painter chose to place a human head
upon a horse's neck, to lay feathers of all colors
on organs gathered from all over, to make his figure
a black, disgusting fish below, on top a lovely girl.
Given a private view, my friends, how couldn't you laugh?
Believe me, Pisos, this painting and a kind of poem
are very similar, one like an image in a sick man's dream,
a fever image whose head and foot can't possibly belong
upon the same physique.[63]

Thus, for the classicist, the conglomerate being is a violation of the known and should be avoided.

Horace's advice became part of a universal theory of decorum by the late sixteenth century requiring that painters and poets be educated so as to escape incongruity or 'factual error.'[64] Dryden thus claims that "to avoid absurdities and incongruities, is the same law established for both arts. The painter is not to paint a cloud at the bottom of a picture, but in the uppermost parts; nor the poet to place what is proper to the end or the middle, in the beginning of a poem" (Dryden, p. 322). In such a view, paintings, whether illustrations or not, could be taken as nonsensical if they presented images that are inconsistent with the known objects and physical laws of the extra–artistic world.

But pictorial nonsense in not merely a matter of composite creatures and misplaced clouds. The metamorphic subject verges on nonsense because it strains the medium of painting and at the same time conforms to the classical directive about what painting *should* represent. If painting at its best should capture a significant action, it must catch it at its crucial moment, the moment that contains the past and future within it. But in this case the moment is a transformation, a becoming which in itself is never visible. Thus, either the picture plane must be split into two moments so that its physical unity contradicts its representational disunity (as in Bernard Salomon's illustrations to the *Métamorphose d'Ovide figurée* of 1557); or the figure must be presented halfway through his change—Tiresias part woman and part man,

159

for example. Such mixed figures are signs of a past and future rather than significant moments of being in themselves. For despite the fact that they purportedly show us how a nonobservable moment would appear if observed, they actually symbolize the whole process in which that moment arbitrarily figures. In themselves, composite figures are inevitably taken as fictive, fantastic, or even nonsensical, for they not only violate what we know to be the case but they reveal contradictions in the conventional understanding of visual representation. This chapter will reveal, I hope, that the tension between process and stasis is one of the most important bases for visual nonsense.

Before we proceed to that issue, however, there is a more general one that we must address. The very possibility of pictorial nonsense is controversial for some theorists, and the fact that there is no genre of nonsense painting comparable to the category of nonsense literature is significant. The problem, as with the status of figurative language, is the relation of painting to truth-telling. Plato and his Renaissance followers believed that the painted image was a lie, an illusion, a deception.[65] However, most post-Renaissance theorists have discarded this position, claiming instead that a painting is neither true nor false but, as Sol Worth put it, nonpropositional. It cannot assert; it is not to be taken as a picture of the world but as a construct, a hypothetical way of structuring it.[66]

This claim, innocent in itself, leads to a rather sweeping impoverishment of the signifying power of pictures, for Worth goes on to argue that pictures cannot express negation, metastatement, self-contradiction, and many other aspects of meaning that are possible in language. His position is related to the belief that pictures must be completed by titles or more extensive texts in order to be understandable at all. Dr. Johnson, for one, claimed that painting can illustrate but not inform (Wimsatt, p. 40). We have only to look at Edward Gorey's "The West Wing" (fig. 15) to see the problems in meaning that arise when unaccompanied pictures are presented as if they were a story sequence; and even with the continuous action of the motion picture, silent films often resorted to captions. However, this need for semantic completion does not follow from the nonpropositional nature of pictures; a titled painting or an illustrated text is no more propositional than a simple image. A work of verbal art is equally nonpropositional, although related, as Baier's treatment of metaphor shows (pp. 520–21), to true-false statements.

161

Worth's response to this argument would be that this nonpropositional quality applies to all pictures, not just to works of art, whereas there would certainly be linguistic messages—untitled, decontextualized, and so forth—that would be propositions. But if I found a scrap of paper with the words "the water is now boiling" written upon it, would I feel that I understood what it said in anything but a potential, lexical sense; would I immediately look around for some referential water? Even an isolated case of "All men are mortal" might prompt some questions about the status of the statement—a reference to syllogistic logic? to the life of Socrates? to the issue of tautology? Or on the other hand, if I, a latter-day Procne, were to receive a tapestry representing a rape and the excision of the victim's tongue, that victim strongly resembling my absent sister, would I comment on the workmanship or the gory subject matter, or would I become concerned about my existent, actual sister?

There is no message in any medium that asserts without some help from the external context, nor does any message ever come to us free of the contamination of other media and contexts. It may be that pictures require more help from the outside

than verbal messages, or at least that this is the case with paintings produced in the iconographic tradition. But I do not accept Worth's claim that pictures cannot express negation, nonpresence, metastatement, or self-contradiction. The various conventions of the grotesque or the dream-vision are signals that we are seeing the phantasmagoric, the nonphysically existent; and visual parodies (Tenniel's ones of Pre-Raphaelite conventions, for instance) involve complicated metastatements.

Or maybe metathoughts would be the proper term here, since Worth's position might in fact be that pictures are incapable of the various operations mentioned because they are not words. But how do we test this hypothesis if not by paraphrase, and if my paraphrase contains negations, metastatements and so on, how can they be declared not part of the painting? One would not object that the statements generated by a verbal text are not part of its meaning, so why should one do so of a painting?

Involved in the semantics of every painting are the norms of the object world—what actually exists and in what kind of spatial, temporal, and social relationships it does so. Painting enters the nonsense continuum—Baier's six levels—at number 3, the figurative, since the earlier kinds of token nonsense—contrary-to-fact statements and contextual nonsense—do not apply. They do not normally apply to literature either, except when a novel or epic represents embedded speech that contradicts the facts of the actual communication situations of the artist, the work, or the perceiver, because its reference to them is only potential. When painting does represent violations of context—as with Manet's naked woman picnicking with her fully clad companions, or Dali's enormous clocks suspended in midair—they seem closer to the tropism of the third verbal nonsense type in which some confused relation is established between the true and the nonsensical.

Though it might be possible to find some pictorial correspondence to each of the remaining three levels of verbal nonsense, to do so would involve equating the structure of painting to that of language. For levels 4 to 6 are, respectively, disruptions of syntax, vocabulary, and both, and it is not clear to me that dividing pictorial nonsense into, say, disruptions of extra-artistic space relations, objects, and both, for example, would be especially enlightening. (Would abstract impressionism correspond to gibberish [level 6]? Would a phantasmagoric vision correspond to vocabulary nonsense [level 5]? And in either case would we call them nonsense?) Though either of these

constitutes a deviation from normal sense-making in the visual arts, not every deviation deserves the title of nonsense.

True pictorial nonsense should involve the same driving of system to contradiction that we observed in literary nonsense. If a painter can use traditional representational norms to produce a picture that contradicts what we know to exist, he would be a nonsense painter, and not a mere flirt with the fantastic. But the power of even the fantastic lies in its proposed violation of our understanding of the world. Representational norms are taken to produce pictures homologous with the appearance of the real world, and if they do not, we experience a disruption of both representational and actual categories. If there were no such disruption, no such implicit proposition that what is *pictured* is *picturable,* visible, there would be no shock in seeing any painterly violation. Surrealism, dream visions, and even allegories would lose much of their power. By deliberately remaining faithful to realist norms through perspective, light direction and modeling, and yet at the same time defying what we know to be the case in reality, such art uses the normative to depict the contrary-to-fact, thus placing us in the logical quandary typical of nonsense.

But whereas surrealism juxtaposes the realistic to the chimerical, it does not prove their interdependence. This interdependence is achieved by only the rarest masters of pictorial nonsense. For me, the Lewis Carroll of the visual arts, the genius of visual contradiction, is M. C. Escher. An enthusiast of the Alice books,[67] Escher demonstrates the incompleteness of the fit between the Renaissance conventions of representation and the laws of the reality represented, between two-dimensional drawing and three-dimensional reality. He makes us feel that our faith that things do in fact look as they are represented in postmedieval paintings is misplaced, and even that our normal understanding of visual appearances is faulty. In this sense, he does very much what nonsense writers do. "Common sense . . . becomes, when juxtaposed through nonsense with alternative conceptions of order, an only partial reality, an ideology" (Stewart, pp. 49–50). This relativizing of the commonsense view occurs not only because impossible realities are represented, but because they appear as if they were utterly possible, in fact, inevitable. This systemic quality of Escher's work changes it from the wishful thinking of the fantastic or the surreal to a criticism of our very perceptual conventions. "The suggestion of three dimensions in flat-picture representa-

tion can be taken to such lengths that worlds which could not even exist in three-dimensional terms can be suggested on a flat surface. The picture appears as the projection of a three-dimensional object on a flat surface, yet it is a figure that could not possibly exist in space" (Ernst, p. 20). "Drawing is deception. On the one hand Escher has tried to reveal this deception in various prints; and on the other hand he has perfected it and turned it into superillusion, conjuring up with it impossible things, and this with such suppleness, logic, and clarity that the impossible makes perfect sense" (Ernst, p. 34). Just as in the Alice books, Escher's nonsense keeps the authority of both the representational system and the represented world in play. It also balances the proof of their fit (in the realism of individual details in prints) against their discrepancy (in the figure created out of the synthesis of parts). This semantic dialectic is the very essence of nonsense, and in Escher's case it focuses on the tension between process and stasis—the classical boundary between the verbal and the visual arts.

Almost all of Escher's pictorial genres are structured around this peculiar balancing act. Aside from some early landscapes, he produced metamorphoses, moebius strips (fig. 16), interpenetrations of worlds, cycles, approaches to infinity, impossible perspectives, and abstract mathematical solids (Ernst, p. 21). The latter he peoples with fairly naturalistic lizards and dragons, elements of the real or fantastic world which are here combined to reveal the laws of the ideal, the abstract, the nonreal. His interest in mathematical relations is closely connected with this merging of the real, the fantastic, and the ideal. Escher's periodic drawings, for example, have actually shown crystallographers and mathematicians new types of symmetry (fig. 17).[68] "The laws of mathematics are not merely human inventions or creations. They simply 'are'; they exist quite independently of the human intellect" (Escher, quoted in Ernst, p. 35). As such, they are both absolutely real and quite divorced from what we think of as everyday reality. They involve us in such 'truths' as infinity, which we can never experience, in fact, which would threaten the very exhaustion warned against in nonsense.

Infinity is one of the three paradoxes that Stewart finds in nonsense. "Play with infinity involves a transformation of [our expectation that events are] . . . characterized by distinguishable beginnings and endings. . . . The discreteness of events depends upon a temporal as well as a spatial sense of closure and each sense implicates, is *relative to,* the other" (Stewart, p. 116).

Fig. 16
M. C. Escher, "Cube with Magic Ribbons." © BEELDRECHT, Amsterdam/VAGA, New York; Collection Haags Gemeentemuseum, The Hague, 1982

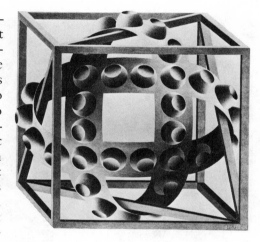

Some of the operations for the verbal play with infinity that Stewart isolates—nesting, circularity, serializing, and infinite causality—have direct visual equivalents in Escher's work. Moebius strips, which he so frequently draws, not only have no ending but make inside and outside indistinguishable. His periodic drawings are created out of a pattern that must, mathematically, recur at regular intervals up to infinity. His infinitely interpenetrating worlds—a hand holding a convex mirror that reflects the hand and its context—fuse the 'in front of' and the 'behind' nesting them in each other like the paradoxical framing in *Wonderland*. All of these are presented with a minute attention to detail that makes their realism unquestionable. It is this merging of conventional realism with mathematical realism that makes Escher's use of infinity nonsensical. This claim, I think, suggests an answer to Escher's puzzled question as to why the only other periodic artists, Moorish mosaicists, always made the elements of their patterns abstract rather than "concrete, recognizable figures, borrowed from nature, such as fishes, birds, reptiles or human beings. This is hardly believable because the recognizability of my plane-filling elements not only makes them more

166

fascinating, but this property is the very reason of my long and still con-
tinuing activity as a designer of periodic drawings" (MacGillavry, p. vii). As
long as the elements remain abstract, the periodic drawing makes no claims
on the commonsense world. But with natural objects fitting together into an
infinite pattern the mutual exclusion of the two realms creates a typical
nonsense paradox.

The second of Stewart's nonsense paradoxes is simultaneity (pp. 146–68).
It is paradoxical in that though we know that discrete events must be trans-
piring at the same time, we cannot focus on more than one; we cannot in fact
experience simultaneity. Escher's periodic drawings involve a kind of ver-
tigo of simultaneity that he obviously enjoyed. "The border line between
two adjacent shapes having a double function, the act of tracing such a line is
a complicated business. On either side of it, simultaneously, a rec-
ognizability takes shape. But the human eye and mind cannot be busy with
two things at the same moment and so there must be a quick and continuous
jumping from one side to the other" (MacGillavry, p. viii).

In "Relativity" (fig. 18) or "High and Low" (fig. 19), Escher uses multiple
vanishing points to confuse up and down and the other points of spatial
orientation. It is the animate figures' different orientation to the scene that
creates the different readings of the environments they inhabit. The relativity
of point of view is thus underscored, and Escher's genius lies in combining
discontinuous perspectives into a single, *seamless* spatial representation. He
thus creates a similar vertigo to that in polyperspectival literature, where a
person or event becomes emptied of determinate content to achieve shape
only through the minds of the various perceivers. But what Escher is able to
keep in play here is a naturalistic unity that accommodates the wild dis-
junctions. In cubism, the similar polyperspectivalism does not create the
same shock (fig. 20), nor do floor plans juxtaposed to elevations in blue-
prints. It is the engaging of reality, through the norms of perspective, chiaro-
scuro, and the rest, that makes us feel that we are looking at the real, and yet
a real that contradicts reality. Similarly in "High and Low," the eye "cannot
decide between two equally valid standpoints. It keeps on hesitating between
the scene above and the scene below; and yet in spite of this the print comes
over to us as a unity, a mysterious unity of two incompatible aspects of the
same scene expressed visually" (Ernst, p. 53).

Fig. 18.
M. C. Escher, "Relativity."
©BEELDRECHT, Amsterdam/VAGA,
New York; Collection Haags
Gemeentemuseum, The Hague, 1982

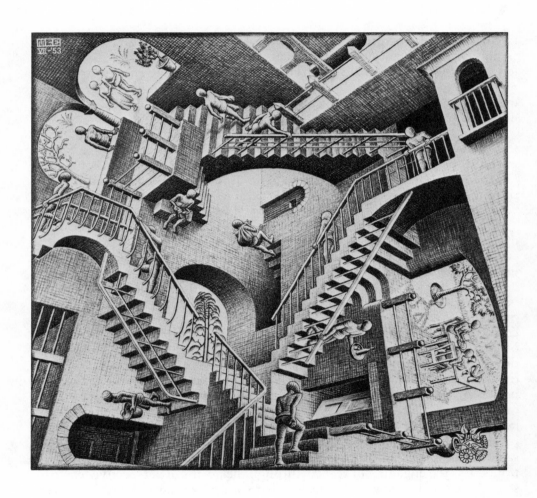

Fig. 19.
M. C. Escher, "High and Low."
©BEELDRECHT, Amsterdam/VAGA,
New York; Collection Haags
Gemeentemuseum, The Hague, 1982

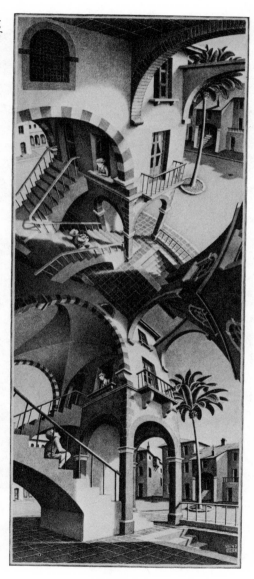

An extraordinarily interesting demonstration of this paradox of simultaneity occurs in Escher's cycles. In "Cycle" (1938; fig. 21), for example, "we see a quaint little fellow emerging, gay and carefree, from a doorway. He rushes down the steps, oblivious of the fact that he is about to disappear down below and become dissolved into a whimsical geometric design.... at the top left the pattern gradually changes to simpler, more settled shapes,... [which] go to make up a block that is used as building material or as the pattern of the tiled floor of the little walled courtyard" (Ernst, p. 39). Beside that courtyard we see the "quaint little fellow" emerging once more from the house.

But think of the assumptions implicit in this description. Why is it that we take the figure on the stairs as a single being in various stages of a motion rather than five figures all stopped at a single instant? And why, in contrast, do we take the elements of the pattern—flat little men, but otherwise identical to the "quaint fellow"—as separate figures frozen in a pattern? It is the norms of pictorial realism that allow us to see process in pictures; without them we see mere pattern.

This contrast between identity and multiplicity, between action and

Fig. 20
Pablo Picasso, "Les Demoiselles
d'Avignon." The Museum of Modern
Art, New York (Acquired through the
Lillie P. Bliss Bequest)

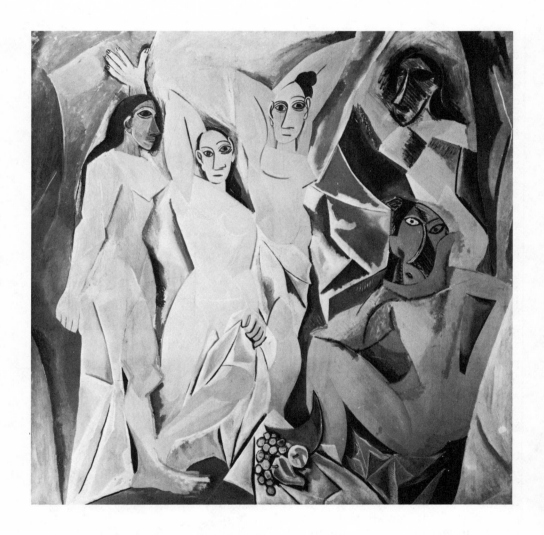

Fig. 21.
M. C. Escher, "Cycle." ©BEELDRECHT,
Amsterdam/VAGA, New York; Collection
Haags Gemeentemuseum, The Hague,
1982

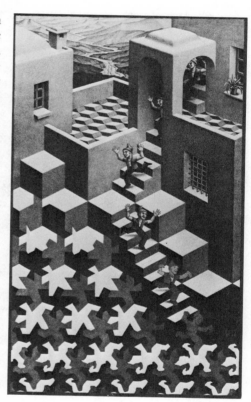

pattern, is brilliantly exploited in "Encounter" (1944; fig. 22), where figures in a periodic pattern step off a wall onto a circular platform. The white figure (who becomes singular and in motion as soon as he achieves three-dimensionality) walks clockwise around the circle; the black figure walks counterclockwise. They meet in the middle foreground and shake hands. The shift from stasis to motion resolves into stasis once again, but not this time because the figures return to the wall to merge with the pattern. In fact, they do not get back to the wall at all. They are frozen in their handshake. Were the action to continue, the black and white figures (phases of figures) would intersect, impossibly occupying the same physical space of the drawing, although not of "reality," since they would have crossed these points at different times. The encounter, the meeting of achromatic opposites, also merges the traditional stopped action of painting with the serial phases of action of narrative art; the infinite continuity of the circle is literally stopped in its tracks.

A final paradox, reflexivity, is rampant in Escher's work in the many mirror prints (e.g., "Magic Mirror," 1947) and in "Drawing Hands" (1948; fig. 23). Through all

172

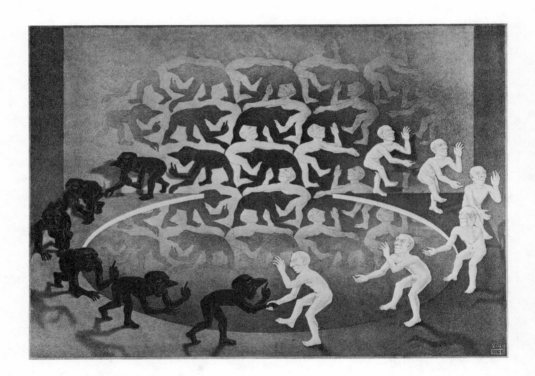

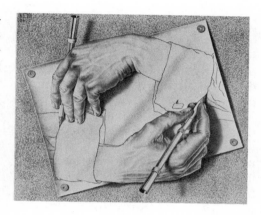

of these paradoxes—infinity, simultaneity, reflexivity—Escher achieves the nonsensical by making the impossible a logical outcome of the possible. This is not a simple violation of what we know to be the case, as in even the most radical surrealism. Instead, Escher is bound by the need, as Bruno Ernst puts it, to "show that absurdity, sur-reality, is based on reality" (p. 64). "Some things there are that are totally impossible, such as a squared circle. It is to this latter category that Escher's impossible worlds belong. They remain forever impossible and have their existence purely and simply within the bounds of the print" (Ernst, p. 66). When violations of sense in language go beyond the metaphor and the oxymoron to the contradiction in terms, one has reached the bound of nonsense, as we saw with the Red Queen earlier, and it is the engagement of this definitional paradoxicality, this mathematically absolute, real disjunction between the system of pictorial representation and the system of the represented world, that constitutes visual nonsense.

It would seem possible to use the Red Queen's three deviations from sense in order to distinguish nonsense from the surreal and the absurd. As we have seen, the contradiction in terms links two elements that are logically or physically incompatible, the square circle, for example, and in the process the impossibility of the combination is not obviated. In the variety of ways that we have encountered, nonsense operates with just such discontinuities. The oxymoron also links contradictories, but in such a way as to assert that they can coexist in reality, for example, "bittersweet." Absurd literature would correspond here, showing man suffering under the simultaneous imposition of contradictory expectations, the double bind. Finally, surrealism in painting and literature would be analogous to the metaphor, a nonnormative equation that becomes synthesized into a higher meaning, for the violent juxtapositions in surrealist painting and literary images are intended to give rise to surreal meanings. The surreal metaphor dispels disjunctions; the absurd oxymoron insists on the actuality of both factors clashing within reality; but the nonsense contradiction opens up new and frighteningly unstable bounds of sense, as extremes to which the very pursuit of sense and semiosis lead. The release and the warning implicit in the exploration of this limit—the hilarity and the monomania of the quest, if you will—are the very essence of nonsense art in literature or in painting.

The search for boundaries and the concomitant need to avoid them, to maintain a dialectic balance between extremes if communication is to be possible, are the drama of twentieth-century art as a whole. This search has necessitated an analysis of sense-making in both painting and literature and has resulted in a modern ideology in the arts that goes much beyond the realm of the aesthetic. The balancing of antithetical realities has, moreover, important implications for the theory of art, and these will be the subject of the next chapter.

Three

A Cubist Historiography

History cannot be more certain than
when he who creates the things also
narrates them.

Giambattisto Vico

The Interartistic Period

> The "should be" kills life, and every concept expresses a "should-be" of its object; that is why thought can never arrive at a real definition of life, and why, perhaps, the philosophy of art is so much more adequate to tragedy than it is to the epic.
>
> Georg Lukács

Nowhere does the interartistic comparison seem more justified—and less understood—than in the historical periodization of the arts. Indeed, much of the current impetus for the technical examination of the arts originates in the need to create groupings, concepts—a history of the arts as a totality rather than as separate lines of development. As a result, purely stylistic terms for painting–literature relations—cubist, surrealist, abstractionist—undergo an unspoken metamorphosis into characterizations of a time span, with the claim that such characterizations are more precise, more descriptive, than mere chronological slices like "modern" or "twentieth century." But the switch from the supposedly neutral time span to the stylistic era is fraught with difficulties. As Matthew Arnold put it, "To ascertain the master-current in the literature of an epoch, and to discern this from all minor currents, is one of the critic's highest functions; in discharging it he shows how far he possesses the most indispensable quality of his office—justness of spirit."[1]

"Justness of spirit"—how unlikely a characterization of the critic who would call the "master-current" of our century *cubist!* Yet what could be more natural than (confirming an intellectual domino theory) to argue from dominant style in one art to two and then to all the arts of an era? It is this very sense of naturalness that we should examine, however, for the inter-artistic comparison can afford fascinating insights into the epistemology of artistic study—how we understand the arts and claim whatever justness of spirit that we, as modern critics, dare. As a heuristic exercise then, let us take the case of cubism and propose the bold hypothesis that it is the master current of our age in painting and literature and—why not?—criticism itself, and then let us examine the implications of such a move.

Here we must tread with caution, however, for the act of naming a style is burdened with presuppositions. Even limited to painting, cubism is a construct created by a particular view of cultural developments. Heinrich Wölfflin, one of the great initiators of periodization through interartistic analogy, went so far as to say that "to *explain* a style . . . can mean nothing other than to place it in its general historical context and to verify that it speaks in harmony with the other organs of its age."[2] If such is the case—and it may well be—then the threads of technical style and period norms that we seek to separate may be not only tangled but indistinguishable, identical. With this danger in mind, the best we can do is to proceed commonsensi-

cally, asking first what cubism in literature might be, and only then what value the term has as a characterization of the art of our century.

Little by little, "cubist writing" is gaining critical currency. A canon of cubist writers is already taking shape with Gertrude Stein, William Carlos Williams, Guillaume Apollinaire, and Max Jacob as the more or less established figures, and new candidates—Ezra Pound, Wallace Stevens, E. E. Cummings, André Gide, and Alain Robbe-Grillet—emerging day by day. This distinguished list in itself is enough to suggest why literary cubism seems such a powerful concept. We have here not only the leading lights of the American and French avant-garde, but major mainstream writers as well. The very fragility of the distinction between avant-garde and mainstream in the light of the cubist analogy is a further sign of its power. The respectability and undoubted importance of cubist painters carries some weight too in our willingness to entertain cubist writing as a central aspect of modern literature. But most significant of all is the heterogeneity of these writers. If a single style can link Gertrude Stein to Wallace Stevens or Pound to Robbe-Grillet, then we are indeed contemplating a conceptual tool of a high order and one capable of characterizing what is most typical of twentieth-century writing.

What makes a writer cubist, however, varies from critic to critic, and many of the exponents of literary cubism suffer from an impressionism that is embarrassing to read. But still it is worthwhile to sift through the various works on the subject to find what emerge as the traits of literary cubism.

The first and most obvious argument is the actual contact between certain writers and the cubist painters. Jacob and Apollinaire lived in the same tenement as Picasso and Gris—the famous Bateau-Lavoir in Montmartre. They were all friends, all in Gertrude Stein's circle of intimates, all poor, all foreign, all on the outside of French bourgeois life.[3] Stein's first published writings were literary portraits of Picasso and Matisse accompanied by reproductions of their paintings, and her "Portrait of Mabel Dodge" was printed in connection with the Armory Show, which brought cubism to the attention of the American public for the first time.[4] Thus, insofar as the world knew of her at all then, they knew of her as a cubist writer, although at the time that was hardly a term of praise. Williams frequented Stieglitz's Gallery 291, where he met Picabia, Demuth, and most of the cubist and avant-garde painters in America, and he repeatedly mentions the seminal

influence of painters on his work. The most profound contacts in Pound's early life were the sculptor Henri Gaudier and the painter-writer Wyndham Lewis, and though neither would have submitted to the appellation "cubist," their work was obviously related to that movement. Pound, at the end of *Canto* I, acknowledges an equal debt to Lewis and Picasso:

Barred lights, great flares, new form, Picasso or Lewis.
If for a year man write to paint, and not to music.

From these writers and artists, of course, the tentacles of influence extend to virtually any writer in the twentieth century—to Eliot, to the imagists and vorticists, to the futurists and the concrete poets, to Joyce. The canonic cubists were a sociable lot, and if mere contact were proof of the cubist core of modernism, the special isolation of the artist from society and the consequent rise of coteries and movements in the early decades of the century would be sufficient explanation.

But, of course, contact is only the beginning of the argument. From there most critics move to stylistic parallelism. They almost never make explicit the basis of a given comparison—why perspective is parallel to point of view, for example—but there appears to be a common understanding about what cubist writing might be. And this is all the more interesting since art historians disagree about cubist painting, and because cubist painting itself contains technically distinct, even opposite, phases. We must thus keep in mind the fact that cubist painting is a generalization, a construct perhaps as questionable as its purported literary echo. For at best, "Style is the unity of a whole that consists in a lot of concrete and disparate elements"; it merely "brings a community of problems, methods, and solutions."[5]

The cubist analogy involves both the matching of technical elements of painting with those in writing (haphazard at best without a systematic view of the two arts) and the comparison of ideologies, of aesthetic presuppositions. Proponents of the cubist analogy usually begin with cubism's disruption of the Renaissance norms of linear perspective, chiaroscuro, and other means of suggesting three-dimensionality on a two-dimensional medium. The flatness of the picture plane is stressed in the noniconic patches in Cézanne, in the geometric faceting of analytic cubism, and in the pastings and totally two-dimensional 'bodies' found in synthetic cubism. The integrity of objects is violated, the laws of gravity and directionality of light

defied, and the premise that the canvas presents one atemporal moment of vision by a perceiver standing in a fixed position is exploded by the multiple views of a single object simultaneously present on the picture plane. The size and position of objects are not dependent upon their distance from the viewer, but upon their conceptual or formal importance. Thus, objects are broken up and reassembled according to a conceptual logic that functions after the fact of the physical laws of appearance.

This will do, perhaps, as an initial characterization of cubist painting. Out of it come a whole host of analogies with modern literature. Multiple perspective finds its parallel in the experimentation with point of view in the novel and some poetry, an experimentation that itself reflects the relativism of modern philosophy. Thus, Claudio Guillén compares Nietzsche's merging of perspective and evaluation with cubist perspective: "The active subject is able to control and exploit a variety of points of view on a single object as well as the contrasts they imply. By having 'several eyes,' by combining various points of view—almost like a Cubist painter—he contributes to the endless richness of being."[6] Guillén goes on to apply his comparison to Wallace Stevens (in, for example, "Thirteen Ways of Looking at a Blackbird"), as do Gerald Kamber to Max Jacob, Elly Jaffé-Freem to Robbe-Grillet, and I to Stein.[7]

The analysis or fragmentation of the cubist object proceeds from this polyperspectivalism. Sypher (p. 297) compares the destruction of outline, concreteness, and solidity in the paintings to Gide's destruction of causality and motivation in *l'acte gratuite*. Dykstra (p. 76) parallels Williams's breaking of sentence and image with the cubists and Kandinsky, in describing the thoroughgoing fragmentation of sense impressions, speakers, narrative, logic, and viewpoint in Williams's *Kora in Hell*. The same splitting has been elaborately discussed in connection with Jacob, Robbe-Grillet, and Stein (Kamber, p. 23; Jaffé-Freem, pp. 1–2; Steiner, pp. 141, 156). Perhaps one of the most interesting extensions of this idea is Hugh Kenner's description of Pound's translation technique: "lay out . . . the elements all on one plane, each sharp, each bright, each of comparable importance; disregard their syntactic liaisons; make a selection and arrange them anew, as the cubists arranged visual elements so that one cannot say what is theme, what is detail: . . . Not, good Lord, a translation: a poem made out of words from another poem."[8]

The ability to treat the object in this way implies a distance, an absence of sentimentality or even of emotion toward it. The lack of affect behind this "analytic" stance is frequently discovered in cubist writers as well. It is one reason why the imagists and vorticists were anxious not to be identified with cubism (Kenner, pp. 234–38), despite their fundamental similarities to it.

The emotional distance of the artist is connected to the fact that the work of art signifies not reality, but the process of perceiving and conceiving of it. Thus, cubist art is definitionally self-reflexive. It calls attention to focus and the figure-ground opposition by making intervening spaces comparable to objects. This faceting of analytic cubism turns all elements of the represented world into equivalent units. Dykstra (p. 66) finds Williams doing something similar when he uses concrete, animate terms to depict invisible atmospheric conditions ("plastering," "puckering," "counter-pulling"). Similarly, Jaffé-Freem describes Robbe-Grillet's geometrized, formalized objects, which, removed from any context of utility or importance to a character, become like lexical entries—the ideal forms of banal everyday objects. She quotes Spinoza to the effect that in a geometrical universe "there is no tragedy, because there is no history" (Jaffé-Freem, p. 32). And Gertrude Stein, too, who claims to have learnt her sense of composition by studying Cézanne, deliberately divided the sentences in her early writing into comparable units which could be repeated and combined in ever new relations (Steiner, p. 152). She wanted to spread her climax throughout the work, making every sentence an equivalent, self-enclosed moment. As a result of such thinking, Williams can argue that a good poem should be able to be read backward, stanza by stanza (Dykstra, p. 63), and that he, like Stieglitz, was freeing the object from metaphor and seeing "it as it actually existed, within its own experiential framework" (Dykstra, p. 106).

The units in cubist painting, whether in the analytic or synthetic phases, were made deliberately ambiguous in their reference, as if to show the semiotic nature of painting where even what reference there is is never direct and simple. The techniques of passage and collage were enlisted here, respectively making edges of objects appear and disappear, and clouding the distinction between the elements of the art world and those of the object-world beyond it. The literary methods of punning, contradiction, parody, and word play create a similar state of ambiguity in modern writing, both in terms of the multiple reference of words and the multiple levels of

reference—to the world, the text, or language in general. All the writers termed "cubist" saturate their work with such ambiguities—as indeed do almost any writers of the last hundred years or so (and ultimately all writers, if one concurs with William Empson). It is the amount of this play that strikes most critics as unusual. Typical of such responses is the following depiction of one of Williams's poems: "'The pot of flowers,' like all the poems in *Spring and All*, is filled with multivalent signs, juxtaposed images and shifting syntax; its language is dense, multidirectional, cubist."[9]

From this polysemy in the two arts, Sypher (p. 267) is led to compare Joyce with Picasso and to find in their use of ambiguity and simultaneity a connection to the existentialist subject, conceived as a set of coexistent contradictions. Sypher calls this phenomenon "montage," thus employing a further component of the cubist analogy: the comparison to cinema. Joyce, Stein, Robbe-Grillet, Eliot, and many others are commonly termed cinematic writers for their use of montage and continuous mental flow. Stein herself claimed that her writing was like a strip of film, each sentence minimally different from the one before it and the one after, and existing in a continuous present (Steiner, pp. 51–52). The use of the interior monologue and the disruption of temporal continuity in plot structure were tied to the movie metaphor and the spatial disruption of cubist painting. In such cubist-futurist works as Duchamp's "Nude Descending a Staircase," the analysis of action into a sequence of nearly identical still moments is immediately apparent. Given the essential temporality of writing and the spatiality of painting, the complication of space relations in cubist painting could quite persuasively be approximated by a complication in temporal relations in cubist writing (Steiner, p. 141).

The depiction of direct perception, the immediate flux of experience, is, of course, the opposite of the conceptual treatment of the subject described earlier as essential to cubist painting. Indeed, many cubist writers were rather ambivalent about whether theirs was a perceptual or a conceptual art. Stein began conceptually and switched purposely to a "visual writing" aimed at presenting the flux of sensation. Guillén calls Robbe-Grillet "one of the first important writers who has tried to divorce seeing from knowing" (p. 355). It is perhaps not so much the side a writer chooses that makes him cubist, as the fact that he sees this opposition *as* a choice, as an issue for him to confront in his stylistic experimentation.

In all these aspects of cubist ideology and technique, the most central feature is the peculiar tension that is set up and maintained between the representational and nonrepresentational features of the medium. Painter after painter insisted on the new balance he was creating between two-dimensional canvas and three-dimensional world. And writer after writer—no matter how hermetically his work was cut off from the "average reader"—vowed his hatred of abstraction. Pound, Williams, and the imagists all stressed the need for concrete subjects realized and referred to concretely,[10] and Stein termed abstract art "pornographic" (Steiner, p. 204). The work of art is most essentially both a sign of the thing-world and a part of the thing-world. It thus points to itself and to the world. And the cubist work insists on our awareness of this double relation. Thus, it is both self-referential—irritatingly so at times—and profoundly concerned with the object world. This dynamics, worked out in any of the areas we have examined so far, is fundamental to cubist art. Moreover, it has come to be equated with modernism as a whole. Jan Mukařovský develops this idea extensively in "Dialectic Contradictions in Modern Art,"[11] and it lies behind most treatments of the "problematic" nature of modernism.

Such, we might say, is the enthusiast's view of the concept of cubist literature. The skeptic's response is all too easy to imagine. Though some works of all these cubist writers have some traits in common, they do not all share the same traits: there are only glancing contacts among them, and not essential similarities. Such contacts could be plotted among works of any and all periods, but certainly all art is not cubist. Second, for the art historian there are precise technical differences between a cubist and a vorticist or futurist painting, but do these distinctions have any meaning for literature, where the definitional characteristics have become so generalized as to include all three movements? If not, why not call the modern arts "futurist" or "vorticist" or "dadaist"? The cubist tag seems arbitrary and overgeneralized. And even if we do accept it in its current formulation, is there not something wrong with a concept that puts Eliot and Stein in the same boat, or Robbe-Grillet and Williams, or Gide and Ezra Pound? Do not such 'powerful' concepts run the risk of being empty? And the parting shot: is it not suspicious that the most general definition of cubist art sounds so much like the most general definition of art as a whole in modern theories like semiotics, structuralism, or even the New Criticism? Is this coincidence not just a bit

too handy—for what distance can a theory have from its material if the two form such a good fit?

The literary scholar by now will be suffering the ennui (an unexpected ennui, I hope) of *déja vu*. For this discussion reproduces with surprising fidelity the arguments surrounding the critical crux of periodization—the baroque.[12] Toward the turn of this century, art historians enunciated a stylistic syndrome for the architecture of the years immediately following the Renaissance, which they termed "the baroque." The chief voices in this approach, Heinrich Wölfflin and Oskar Walzel,[13] argued that the distinction between Renaissance and baroque architecture would have relevance in distinguishing the literature of those periods. Thus, Ariosto would be a Renaissance poet while Tasso or Shakespeare would be baroque, because each belongs on one side of the following architectural oppositions: rule-governed/formless, static/dynamic, symmetrical/asymmetrical, medium-determined/medium-defying ("linear"/"painterly"), graceful/dignified, playful/pompous, and so on (Wölfflin, pp. 23–38, 84).

From this suggestion grew the troubled giant of the baroque, a term for all the arts in any medium produced between the Renaissance and the neoclassical period (whatever *they* are). Again we have a visual art category extended first to literature and then to a period. Again we have anomalies: is the baroque Shakespeare not rather playful in comparison with the Renaissance Spenser? And again scholars spin their wheels trying to explain why such an obviously error-riddled, misleading concept has made us all its slaves.

For slaves we are. After a closely argued, densely documented disproof of virtually every claim of coherence within the baroque copia, René Wellek concludes:

If I seem to end on a negative note, unconvinced that we can define baroque either in terms of stylistic devices or a peculiar world view or even a peculiar relationship of style and belief, I would not like to be understood as [denying the utility of the term]. . . . baroque has fulfilled and is still fulfilling an important function. It has put the problem of periodisation and of a pervasive style very squarely; it has pointed to the analogies between the literatures of the different countries and between the several arts. It is still the one convenient term which refers to the style which came after the Renaissance but preceded actual neoclassicism. For a history of English literature the concept seems especially important since there the very exis-

tence of such a style has been obscured by the extension given to the term Elizabethan and by the narrow limits of the one competing traditional term: "metaphysical." As Roy Daniels has said, the century is "no longer drawn apart like a pack of tapered cards." . . . Baroque has provided an esthetic term which has helped us to understand the literature of the time and which will help us to break the dependence of most literary history from periodisations derived from political and social history. . . . it is a term which prepares for synthesis, draws our minds away from the mere accumulation of observations and facts, and paves the way for a future history of literature as a fine art. [Wellek, pp. 113–14]

In other words, "baroque" is useful as a heuristic device. Tautological as this reasoning may seem—"comical," one reviewer termed it (quoted in Wellek, p. 127)—it is a commonsense rendition of the thinking necessarily involved in periodization. We need concepts in order to write history, even though those concepts may be so inadequate to the phenomena they cover as to 'falsify' or hide their 'true' nature. But in the mere formulation of this objection, the fallacy of talking about the 'true nature of things' exclusive of our concepts of them is obvious. We appear to be caught.

The alternatives inevitably lead to more upsetting contradictions. To see the work as an utterly unique entity, as Croce insisted, is to atomize art and ultimately to prevent us from knowing that anything *is* a work of art. I fancy that the interpretive and evaluative blunders of the poor students immortalized in I. A. Richards's *Practical Criticism*[14] are not so much the result of their faulty education in analysis as of Richards's treatment of the poems as things complete in themselves, appreciable independently of their cultural and historical contexts.

Another alternative is to believe that a period need be nothing more than a temporal span, part of a "noninterpretive chronology," as Guillén (p. 469) calls it. But this is to be fooled by terms like the "Quattrocento" or the "nineteenth century." Guillén (p. 469) values them because they supposedly stress "the confrontation, within such chronological units, of a plurality of durations, movements, systems, schools, institutions, and other temporal processes." But what gives them any value is their identity, the conceptual hierarchy they impose upon the multiplicity of phenomena they encompass. In using such terms we inevitably have a concept in mind. This is why the "nineteenth century" begins in 1789 for some theorists, or with the work of

Blake. A truly "noninterpretive chronology" is a useless chronology. Though what passes for historicism in this country is usually just such a blind slicing of the literary pie, we have this willful blindness to thank for the current state of the academic curriculum.

What is left at the opposite extreme (aside from the amusing oscillation between pure time span and stylistic concept in Warnke) is a lingering faith in the absolute unity of a period. The sources of such faith are often outdated conceptual models, such as the Hegelian Zeitgeist, a common spirit pervading every aspect of culture at a given time; Goethian or romantic organicism, which sees the arts as a holistic unity with individual genuses and species connected in an ever changing whole; the Viconian myth at the back of history, "an ideal eternal history traversed in time by the histories of all nations" as a result of which "imagination is nothing but extended or compounded memory."[15]

We are too embarrassed by the contexts of these ideas to embrace them as such. And so a mystical stubbornness arises, as in Mario Praz[16] or Wylie Sypher, insisting that there *must* be a unity among the imaginative products of people at a given time, but not a unity whose necessity one should question. Wellek's commonsense justification that we need period concepts in order to think about art at all seems too open an admission of our intellectual vulnerability to satisfy those 'convinced' of the interartistic basis of periodization and its truth for art.

But the coincidences surrounding the baroque and cubism do not stop at the issues they have raised for theorists. You will recall that one of the most striking achievements of modernism was the elevation of baroque poetry from the status of a literary sport to an essential component of the canon. In performing this feat, Eliot and others explicitly compared their own art to the Metaphysicals', and erected the myth of the unified sensibility, symbolized by the prescientific conceit, as the goal to which the modern aspired.[17] Conflicting terms or realities did not disappear in such art: they were instead housed in the same place, entertained simultaneously, enjoyed in a mood that gloried in their diversity.

The parallel with cubism is obvious. Thus, when Ernest Gilman describes the "curious perspective"—the devices for representational distortion that so fascinated the baroque age—he might almost be describing cubism. He claims that whereas Renaissance linear perspective expresses "confidence in the certainty of human knowledge," the baroque period is characterized by

"a more complex and ambiguous relationship between the knower and the knowable."[18] "The curious perspective undermines the viewer's authority by dislocating him from the 'centric point' and obliging him to see the work of art from multiple 'perspectives' before he grasps it fully" (Gilman, p. 50). It destroys any absolute notion of the real, and for writers in particular "the curious perspective offers a model for manipulating language—a visual construct that reflects their confirmations and suspicions of their own medium, the two yoked by wit together" (Gilman, p. 66). In many respects, this 'eccentric' view of language uncannily echoes what we might now call the cubist discussion of nonsense in the previous section of this book.

These similarities between cubism and the baroque immediately raise certain questions. Why is it that the baroque and now cubism are the only major period concepts based on the transference of terms from the visual arts to literature? And why is it that they have created so much more scholarly controversy than noninterartistically generated period terms like "romantic," "Renaissance," "medieval," or "neoclassical," which receive tolerant lip service, a resignation to the fact that rough as they are, they perform a useful function?[19] In trying to answer these questions, we might turn to the very basis of the comparison of literature to the visual arts: the assumption of the direct connection of art to reality that we have been discussing since the beginning of this argument. The analogy to the visual arts necessarily introduces the relation of literature to reality, and hence the problem of knowledge itself, into the period concept. In the case of cubism, this epistemological thrust involves the knowledge of history and its conceptualization as well. Cubism in both painting and literature is self-consciously critical and historicist, and thus, as a period term, it, like the art it subsumes, is self-referential.

The obvious—and most notorious—expression of this historicism is in the avant-garde's polemics with the past. André Breton in his dadaist days wrote Tristan Tsara that "to kill art is what seems most urgent to me."[20] The vorticists used their journal *Blast* to "BLAST years 1837 to 1900" (Materer, p. 30); "the Vorticists dreamed of building a new world, but they were forced to squander their energy demolishing the old" (Materer, p. 44). Italian futurism is sometimes called "*antipassatismo,* the down-with-the-past movement."[21] Gertrude Stein equated the stylistic innovation of the continuous present with the sensibility of the modern, one completely disjoint from the sense of tradition and temporal continuity of earlier days (Steiner,

p. 53). There was barely a writer living in the early years of the century who did not see his activity as a criticism, a demolition, or a dismissal of the past, at least of the immediate past. This is all the more striking in contrast to the spirit of historical revival that pervades the romantic and Victorian eras.

But beyond this breaking with the past, modern manifestos and the very thematics of modernist art constitute a historiographic ideology. It is in this respect that the analogy with cubist painting becomes so important. For the vision of art history that cubism received was a steady progress since the Renaissance toward more and more 'accurate,' 'real' renderings of the visual world (the quotation marks are a modern qualification). Guillén (pp. 18–19) argues that the belief in progress was one of the romantic supports for the holistic notion of literature, and elsewhere he describes the relationship among vision, knowledge, painting and "the metaphor of perspective in its progress from optics to philosophy, from Alhazen and Roger Bacon to Ortega and Bertrand Russell" (Guillén, p. 287). But no one puts more pregnantly the connection among science, progress, and painting than Thomas S. Kuhn:

For many centuries, both in antiquity and again in early modern Europe, painting was regarded as *the* cumulative discipline. During those years the artist's goal was assumed to be representation. Critics and historians, like Pliny and Vasari, then regarded with veneration the series of inventions from foreshortening through chiaroscuro that had made possible succes- sively more perfect representations of nature. But those are also the years, particularly during the Renaissance, when little cleavage was felt between the sciences and the arts. . . . even after that steady exchange had ceased, the term "art" continued to apply as much to technology and the crafts, which were also seen as progressive, as to painting and sculpture. Only when the latter unequivocally renounced representation as their goal and began to learn again from primitive models did the cleavage we now take for granted assume anything like its present depth.[22]

Kuhn goes on to argue against the use of progress as a model for the history of science as well.

The renunciation of representation as a goal—or as *the* goal—of painting and the return to primitive models are central aspects of cubism. It is not that cubism could utterly disregard older painting; indeed many people claim that

cubism is indebted "probably, to nearly all known styles" (Sypher, p. xxiii). But it marks the end of the continuity of artistic goal since the Renaissance. It reifies that history, lifting bodily a piece of this and a piece of that work from the sequence of discoveries, rather than cooperating in that goal, logically extending the realist capacities of painting. As such, cubism can be seen as the inauguration of what Kuhn terms a new paradigm[23]—a universally recognized achievement that for a time provides model problems and solutions to a community of practitioners (Kuhn, p. x).

The revolution that cubism announced not only broke with the past but with the very image of scientific progress that formed its ideology. New developments in the arts were not to be seen as logically founded upon each other, not constituting a developing plot whose complication and denouement lay somewhere in the future. Instead, modern art was a multiplicity of explorations based on a common set of problems. Williams asks in his *Autobiography*, "What were we [writers] seeking? No one knew consistently enough to formulate a 'movement.' We were restless and constrained, closely allied with the painters."[24] And Gertrude Stein presents the nonnarrative, nonlogical unfolding of artistic activity in this century in the metaphor of the social life of her salon: "my life in Paris . . . was based upon the rue de Fleurus and the Saturday evenings and it was like a kaleidoscope slowly turning"; "It was an endless variety. And everyone came and no one made any difference."[25]

I make this claim about the modernist view of history despite the popular metaphor of modernist art as an avant-garde, the beginning of a steady march forward. The nineteenth-century coiner of that term himself, Gabriel-Désiré Laverdant, wrote that "to know whether art worthily fulfills its proper mission as initiator, whether the artist is truly of the avant-garde, one must know where Humanity is going, know what the destiny of the human race is" (quoted in Poggioli, p. 9). But there is no knowledge that seemed less accessible to the artists of this century. Over and over, we find the plot of the arrested quest, the progress stopped in its tracks with nothing but a historical patchwork to behold or represent.

Out of this vision, a more or less conscious analogy emerges between the mind, the artwork, and the artistic period. In "Tradition and the Individual Talent" Eliot pictures the artist's mind as the receptacle of the past, shaping and evaluating it according to his own needs.[26] The ekphrastic moment is

thus important not only as an explanation of the relation between art's stasis and the constantly shifting reality it represents, but of the mind and reality, too, for "time is a storm in which we are all lost."

The still photograph was a crucial model as well. "Williams conceived of the imagination as a condition analogous to the undetermined moments between waking and sleeping, when the mind breaks up, rearranges, and then fixes the images which it has collected—the picture units of experience—as if they were photo-montages on the film of memory. These picture units have the same power as photographs or paintings to suspend a moment of intense action forever.... The non-sequential visual unit thus fixed and projected on the mind retains its qualities of movement. It rather than time becomes the field of action" (Dykstra, pp. 53–54). The mind, the imagist poem, the cubist collage, the photograph, and the historical period all wrest action from time and cage it in the tensions of a structure.

This reification of time is essential to imagist and vorticist doctrine. It grows out of Fenollosa's teaching that "The eye sees noun and verb as one, things in motion, motion in things."[27] The image presents its intellectual and emotional complex "in an instant of time"[28] and the vortex is a "system of energy." The case of the vortex is especially revealing, since it refers not only to the work of art but to an author, a time period, or a nation. Thus, Timothy Materer follows Gaudier's usage in claiming that "the meaning of the Vortex is the entire history of [Pound's, Eliot's, and Lewis's] careers" (Materer, p. 225). And all these systemic histories are analogous to the principles they exemplify, for "vortex" was also taken to mean "vortext," a foreword *(Vorwort)*, pretext, or statement of first principles (Materer, p. 24). Accordingly, Hugh Kenner imagines an art history based on vorticist tenets: "So written, art history is neither a catalogue nor a chronicle of passive craftsmen flopping from derivation to derivation at some Zeitgeist's behest. The ambition to write it so was not peculiar to Gaudier. Ernest Fenollosa in the summer of 1906 had unfolded 'a universal scheme or logic of art' which 'as easily subsumes all forms of Asiatic and of savage art and the efforts of children as it does accepted European schools'" (Kenner, p. 239). This universal scheme or logic of art is at the same time a history: temporal sequence is transformed into a Steinian kaleidoscope.

As a result of such thinking, numerous modernist writers take up the task of history-writing, for example, Williams in *In the American Grain* or Stein in

the appropriately entitled *Geographical History of America*. And more still use the gap between the continuity of the past and the stasis of the present as the pathos of the modern situation. Eliot's *Waste Land* is a rubble heap of memory in which the artistic past shows up the squalidness of the present. Joyce, more positively disposed to the modern, tries to encompass all of cultural experience in fleeing that nightmare of history that Stephen so bitterly condemns. Pound writes a lifelong poem in the *Cantos* juxtaposing elements of every time and civilization. And he translates past art, leaving it somehow intact in the process. Kenner contrasts this to Picasso's purported destruction or violation of the sources he incorporates in his paintings—"Which is perhaps to say that Picasso ceased being a cubist, whereas Pound's work, say from *Lustra* to the last Cantos, is the longest working-out in any art of premises like those of cubism" (Kenner, p. 142). The cubist interaction with the past makes a simultaneity of it, a system whose elements are altered not in substance but in context. Cubism thus tells us to think of history in a new way, not as a plotted narrative moving toward a resolution, but as a cubist painting whose elements maintain their heterogeneity—objects, people; things, signs; the banal, the dramatic; the contemporaneous, the anachronous—in an aestheticized structure of interrelations.

The notion is particularly clear in contrast to the neoromanticism of Harold Bloom's poetic historiography. Bloom isolates artistic history from any other realm of culture, making it a private drama between each poet and his precursors. Paraphrasing Nietzsche, he says that "The genius is *strong,* his age is *weak,*"[29] and that "Poems arise not so much in response to a present time, . . . but in response to other poems" (Bloom, p. 99). Poetic history is thus poetic influence, and the history of influence for Bloom is a history of misreading (Bloom, p. 30). In no sense does the poet perform the reification, rearrangement, and concomitant preservation of the past that we have seen in Fenollosa, Pound, and the rest, but he distorts and disregards past works so as "to clear imaginative space" for himself (Bloom, p. 5). "The history of fruitful poetic influence, which is to say the main tradition of Western poetry since the Renaissance, is a history of anxiety and self-saving caricature, of distortion, of perverse, wilful revisionism without which modern poetry as such could not exist" (Bloom, p. 30).

Bloom depicts the poet's activity as a romantic quest. "To search for where you already are is the most benighted of quests, and the most

fated. . . . no quest ends, if its context is Unconditioned Mind, the cosmos of the greatest post-Miltonic poets" (Bloom, p. 13). All romantic quests "are quests to beget one's self, to become one's own Great Original. We journey to abstract ourselves by fabrication" (Bloom, p. 64). The way to pursue this quest is to write poems whose meanings seem to replace the poems by which they are influenced. As a result, the critic's activity is very close to that of the poet's. He is himself on a quest, to learn "to read any poem as its poet's deliberate misinterpretation, *as a poet,* of a precursor poem or of poetry in general" (Bloom, p. 43). Thus, "Criticism is the art of knowing the hidden roads that go from poem to poem" (Bloom, p. 70). Criticism is historicism, but a historicism that is perilously close to psychoanalysis.

The beauty with which this theory is enunciated, and the obvious support it appears to offer Derridean theories of meaning (and even Peirce's idea of unlimited semiosis, the infinite regress of signs generated by the act of interpretation) should not blind us to the fact that Bloom's historical ideology is not in keeping with the moderns. It places the poet's and the critic's acts squarely within a temporal progress that is goal-oriented. It denies the interconnection among poets as animated by any set of problems other than the artist's individual survival. It insists that the artist seeks only to obliterate the past rather than to elevate it into a work of art. And most significantly, it denies the homology between the artist, the artwork, the period, the nation, and art theory that a cubist historiography establishes in the vortex, in Poundian translation, in Stein's geographical history, and so on.

Thus, "cubist literature" and even "the cubist period" are terms with a special conceptual power. They not only necessitate a technical comparison of the arts—as all interartistic analogies do—but they also demand an aestheticizing of history and a historicizing of art. Because of the long-standing mutual implicature of painting, perception, and knowledge, they teach us to see artistic history in connection with the problem of knowledge. And they give us a new view of history and a new justification for the act of periodization. In doing so, cubist historiography stands for the same criticism of Saussure's split between synchrony and diachrony as the early structuralists mounted: "Pure synchronism now proves to be an illusion. Every synchronic system has its past and its future as inseparable structural elements of the system. . . . The concept of a synchronic literary system does not coincide with the naively envisaged concept of a chronological epoch, since the

former embraces not only works of art which are close to each other in time but also works which are drawn into the orbit of the system from foreign literatures or previous epochs. An indifferent cataloguing of coexisting phenomena is not sufficient; what is important is their hierarchical significance for the given epoch."[30]

The structuralists trace the inspiration for this new vision of time and period to cubism itself. As Elmar Holenstein writes, "Saussure's dichotomy relies on the rigid conception of time in classical physics. The present dwindles to an unextended thread. Jakobson's time conception, on the other hand, is inspired by cubist and futurist art and literature. He seeks to adapt their dynamic experience of time, which overflows the present moment, to linguistic findings."[31] Thus, the structuralist conception of the historical period might be considered the first critical statement of a cubist historiography.

Whether we like it or not, cubist painting, literature, and thinking are essential to what we call "the modern." The twenty-year experiment of Picasso, Braque, Gris, and their followers and epigones did not stop with the end of cubist painting proper but has transcended those works to form the dominant aesthetic (and perhaps intellectual) ideology of our day. (I recently heard some abstract expressionists on a television broadcast describing their art as essentially cubist.) To answer the skeptic conjured up earlier in this chapter, it is cubism and not vorticism, futurism, or dadaism that governs the age, because none of these combined the impetus from the visual arts with figures of the stature of Picasso, Braque, and Gris (and Cézanne), and none dramatized with cubism's precision the meaning of the break with the past as a reevaluation of knowledge, history, and representation.

As for the obvious objection that not all modern works contain all or even most traits designated "cubist," Wellek offers an especially helpful answer. A period concept, he says, "cannot be defined as a class concept in logic can be.... a work of art is not an instance of a class, but is itself a part of the concept of a period which it makes up together with other works. It thus modifies the concept of the whole. We shall never define... [any period term] exhaustively, because a period is a time section dominated by some system of... norms" (Wellek, pp. 92–93). Unlike Lukács's life-killing "should be" of our epigraph, in this concept of the whole the work helps to compose the system but is not totally defined by it. If it were, it would be

extraneous, as any particular circle is to the geometrician. The work stays itself but contributes to the building of a composite notion of an age. And thus, cubism is a direct contradiction of Lukács's notion that "the philosophy of art is so much more adequate to tragedy than it is to the epic." Thought *can* arrive at a definition of life if that definition is as dialogic, polyperspectival, and subject to change as Wellek's notion.

We might notice how similar this idea is to the concept of history we have seen in Pound, Eliot, and the vorticists, and how closely—once again—it coincides with an essential aspect of the baroque. One of Wölfflin's (p. 43) contrasts between the Renaissance and baroque is that the details of baroque buildings do not replicate the proportions of the wholes in which they function, whereas Renaissance details are models of the whole. The period—the artwork of the historian—is in the modern conception also a whole whose parts compose it but are not absolutely determined by it. Thus, Stein and Gide or Pound and Robbe-Grillet are not mechanically identified through their participation in cubism. Insofar as their art coincides more or less with those traits designated "cubist," they will be deemed more or less central to that system of norms. And the existence of that system permits their relations to be found in the first place and presented in a coherent way consistent with the relations sought among other artists. The period concept creates an identity for texts, as texts create the identity of the period concept.

We need period concepts, if I may repeat myself, in order not only to write history but to know what a work is—for it is nothing in isolation from all norms, values, and other relational concepts. But on the other hand, those period concepts are inevitably fluid, inevitably affected by the changes undergone by the works that comprise it. And these changes are the addition not only of new works as they are written but of new interpretations of existent works generated by the changing state of our aesthetic and extra-aesthetic norms and by the new individuals whose interpretations constantly enter the structure of culture. One should not mutter that our period terms are imprecise, nor be embarrassed at the 'inaccuracies' of past critical judgments. Instead one should marvel that period concepts ever do catch on, among artists *or* critics, and try to learn the basis and the meaning for that choice of norms.

In such a conception we necessarily seesaw back and forth, looking to works to discover a period concept and to a period concept to interpret

works. The very meaning of a critic's concretization of a text, as Felix
Vodička argues, is to compel such "a confrontation between the properties
of the work and the period's literary requirements."[32] Circular as this thinking
might appear, it is inevitable and essential to criticism, and far from signaling
the sad fate of the literary historian, Vodička finds it the source of his creativ-
ity and his social utility:

Literary movements of the past, created as abstractions from particular
concrete works, are detached from them as fictions that exist in the reading
public's awareness as simplified schemes. In reality a literary period is a
structure made rich by the dynamic tension of its components, so that a
current conception is only one of many ways of concretizing it. . . . in
studying the reception of older principles of artistic creation in the present,
we are not concerned with the scholarly description of the literary periods
of the past but the way in which their appearance changes in the perspective
of current literary activity and evaluation. [Vodička, p. 131]

As a result, it is also inevitable that a cultural theory will be influenced by
the art of the period in which it arises.

When asked what inspired the new conception of language and linguistics
in the Moscow and Prague Circles, Jakobson regularly cites as most impor-
tant the avant-garde trends in painting, poetry, and music immediately pre-
ceding the First World War. . . . What fascinated the literary scholars of
Moscow and Prague in the work of these artists were . . . the inquiry into
the relations among different tenses, which appear extremely dynamic,
flexible, and even reversible . . . and also the stress on invariance in multi-
plicity and the relations between wholes and parts. [Thus, Jakobson cites]
Braque's credo, "I do not believe in things, I believe only in their re-
lationship." . . . [Particularly fascinating was] the semiotic orientation of
these schools of art, especially cubism with its experimental destruction and
explorative transformation of the relations connecting *signans, signatum,* and
denotatum. [As Jakobson wrote,] "The mode in which the *signatum* stands
relatively to the *signans,* on the one hand, and to the *denotatum,* on the
other, had never been laid bare so plainly, nor the semantic problems of art
brought forward so provocatively as in cubist pictures, which delay rec-
ognition of the transformed and obscured object or even reduce it to zero.
In order to enliven the inward and outward relationships of the visual

signs, one had, as Picasso said, 'to break, to make one's revolution and start at zero.'" [Holenstein, pp. 23–24]

A theory, like an artistic period, is a construct constantly influenced by the new phenomena it covers. And when these phenomena, as in the case of cubism, themselves contain both an artistic and a historiographic theory—in fact, collapse the two, the influence is irresistible. Thus, the skeptic who finds the fit between structuralist-semiotic art theory and cubist art a bit too convenient is assuming an entirely unfounded independence between conceptualizations and their objects, as an examination of the relations between Russian formalism and Russian futurism or poststructuralism and surrealism would, I think, reveal.

Hayden White has written that the value of history lies in its ability to transform unfamiliar events into familiar ones through the structure of a plot. Events become familiar "not in their details, but in their functions as elements of a familiar kind of configuration. . . . They are familiarized not only because the reader now has more information about [them], but also because he has been shown how the data conform to an icon of a comprehensible finished process, a plot-structure with which he is familiar as a part of his cultural endowment."[33] We experience this "'fictionalization' of history as an 'explanation' for the same reason that we experience great fiction as an illumination of a world that we inhabit along with the author. In both we recognize the forms by which consciousness both constitutes and colonizes the world it seeks to inhabit comfortably" (White, p. 61).

If what I have said about cubism is valid, the value of a cubist historiography is that it creates a special kind of plot—one perhaps not found among the Fryean archetypes that White relies on. The plot of cubist history and historiography is neither a quest nor a picaresque wandering. It is a kaleidoscopic play: a constant reevaluation of the relations between concepts and particulars, the creation of unity out of elements whose heterogeneity is not masked but preserved, a contemplation of meaning itself in the constantly changing contemporary structures that we form out of elements of the past. The cubist work, cubism as a period, and a period conceived of cubistically are all scrutinies of the process of knowledge itself.

Res Poetica

There is no clearer working out of a cubist ideology than concrete poetry. In fact, the very prevalence of the concrete motif in twentieth-century artistic theory reflects the new possibility of considering the work a thing in itself, not merely a sign of a more important reality beyond it. The cubist tension between thing and sign, however, was sometimes forgotten in the excitement over this object force of art: concreteness was not understood as one side of an essential opposition, but as an ultimate goal in itself. Thus, T. E. Hulme called for a poetry of "small, dry things"; Archibald MacLeish claimed that "A poem should not mean / But be"; Pound demanded a visual poetry modelled on Chinese ideographic writing in which "we do not seem to be juggling mental counters, but to be watching *things* work out their fate."[34]

The poetry immediately resulting from these notions, divergent as it was from Victorian literature, was still more a sign than a thing—a poetry that referred to things, rather than a thing-poetry. The only literal interpretation of "physical poetry," as John Crowe Ransom disparagingly termed this trend,[35] came later in the century—with concrete poetry. And it was the concrete poets' awareness of linguistic and semiotic theory that helped them discover what a concrete art, rather than mere concrete reference, entails. As one of its founders, Augusto de Campos, wrote after a discussion of Sapir, Cassirer, Langer, and von Humboldt, the "concrete poem is an object in and by itself, not an interpreter of exterior objects and/or more or less subjective feelings. its material: word (sound, visual form, semantic charge). its problem: a problem of functions-relations of this material."[36] Paradoxically, this sophistication in semiotic theory often led, as in this quotation, to a near denial of the semiotic status of the concrete art work.

For, of course, semiotically, 'concrete art' is a contradiction in terms. Paintings and poems by definition are signs rather than things, except in the sense that ultimately a sign is a thing; a poem that is literally a tree or a rose is not a poem but that tree or rose. Even Gertrude Stein's famous formula, "A rose is a rose is a rose," which serves as an archetype of concrete thinking, however much it may insist on the thingness of each token of the word "rose" and the nonfigurative quality of its reference, remains finally a formula. Insofar as a poem is art, it cannot be totally concrete and we are thus in the presence of an extreme instance of Derridean *differance*.

Concrete poets often signal this problem, as in Henri Chopin's "il manque toujours l'y" (fig. 24), reprinted as "le dernier poème concret." Here the "y" is missing from its place as the penultimate letter of the alphabet in the sequence of letter rows; it is also missing from the recapitulation of the alphabet in the legend or title at the bottom. But just after the title we find the missing row of *y*s, outside the poem proper, with the ambiguous phrase "quelle importance" (affirmative exclamation or skeptical question?). At the same time, the *y* is *present* as unfilled space—the blanks in the typography in the body of the poem, laterally inverted on the right, and in fragments on the left. Since *y* is also the adverb "there" and the pronoun for all but possessive prepositional phrases, it is a vehicle of indexical specificity, this indexical gesture relating to both extratextual and textual space. The pun here on the notion of presence—a blank that stands for location, "thereness," and indexicality to both text and world—indicates the inevitable compromise in the concrete project, where all presence is mitigated by the sign function. Thus, despite its ironic inversions, we might describe this "last concrete poem" as a rather wistful statement about art.

Nevertheless, within this necessary limitation, concrete poets have discovered numerous ways in which to increase the apparently nonsemiotic properties of their work at the expense of the semiotic ones, and what this usually involves is the maximizing of iconic properties at the expense of symbolic ones. We recall that Morris's definition of the icon gave its sign vehicle some of the characteristics of its designatum, so that in some respects the represented object was not just represented but present; the icon has its sign vehicle as one of its denotata.[37] In all the recent controversy over the meaning of iconicity, no matter how often it is claimed that all resemblance is a function of convention, the difference between conventional resemblance and conventionally arbitrary association always involves an appeal to shared properties (including relations).[38] A 'thing-poetry' thus comes to be in large part an iconic poetry, and the poet and theoretician Max Bense has made this point explicitly in discussions of concrete poetry and Peirce's semiotic triangle.[39]

The second feature of the concrete poem (in all but its acoustic variety) is its approximation to painting. It is the most literal realization of the painting-literature analogy that I know. The reason for the stress on the visual properties of the poem is not only that painting is traditionally seen as

an iconic art, but also that it over-comes some of the barriers that stand between words and things. Words are devoid of presence largely be-cause they are 'transparent,' that is, the visual appearance of their material vehicles is irrelevant to their signifi-cation. They signal what is physically absent and train us to ignore what is physically present—type. As Leon-ardo argued, poems are "pictures for the blind," and unlike objects in our experience, which appeal to the whole gamut of the senses, they make an appeal to the ear alone. In order for words to become things, they need the palpability and materi-ality of things. And since painting is an art with ample materiality of this sort, the concrete poet makes the boundary between poem and paint-ing as indistinct as possible. The father of the movement, Eugen Gomringer, thus argues that as an object the visual poem is "memor-able and imprints itself upon the mind as a picture."[40]

Concrete poetry has gone a long way toward becoming Simonides' "speaking picture." And in doing so it has overcome some of the major barriers that modern theoreticians have discovered between the two arts. The concretist movement, in fact, is a further development of the line from Lessing to Jakobson and

```
aaaaaaaaaaaaaaaaaaaaaaaaaaaaaaaaaaaa aaaaaaaaaaaaaaaaaaaaaa aaaaaaa
bbbbbbbbbbbbbbbbbbbbbbbbbbbbbbbbbbbbbbbbbbbbbbbbbbbbbbbbbbbbbbb
ccccccccccccccccccccccccc cccccccccccccccccc cccccccccccccccccccc
ddddddddddddddddddddddddd dddddddddddddddddddddddddd
eeeeeeeee eeeeeeeeeeeeeeeeeeeeee eeeeeeee eeeee eeeeeeeeeeeeeee
fffffffffff fffffffffffffffffffffffffff fffffffffffffffff ffffffffffffff
gggggg gggggggggggggggggggg gggggggggg gggggggggg
hhhhhh hhhhhhhhhhhhhhhhhhhh hhhhhhhh hhhhhhhhhh
iiiiiiiiii iiiiiiiiiiiiiiiiiiiiiiiiiiiiiiii iiiiiiiii iiiiiiiiiiiiiiiii
jjjjjjjjj jjjjjjjjjjjjjjjjjjjjjjjjjjjjjjjjj jjjjjjj jjjjjjjjjjjjjjjjj
kkkkk kkkkkkkkkkkkkkkkkkkkkkkkkk kk kkkkkkkkkkkk
llllllll llllllllllllllllllllllllllllllllll llllllllllllllllllll
mmmmmmmmmmmmmmmmmmmmmmmm mmmmmmmmmmm
nnnnnnnnnnnnnnnnnnnnnnnnnnnnnnnnnn nnnnnnnnnnnnnn
ooooo ooooooooo ooooooooooooooooooo ooooooooooooooo
oooo ooooooooooo oooooooooooooooooooo ooooooooooooooo
ppp ppppppppppppp pppppppppppppppppppp pppppppppppp
qqqqqqqqqqqqqqqqqq qqqqqqqqqqqqqqqqqq qqqqqqqqqq
rrrrrrrrrrrrrrrrrrrrrrr rrrrrrrrrrrrrr rrrrrrrrrr
sssssssssssssssss ssssssssssssssssssss ssssss
tttttttttttttttttttttt tttttttt tttttttttttttttttt ttttttttt
UUUUUUUUUUUUUU UUU UUUUUUUUU uuuuu
vvvvvvvvvvvvvvvvvvvv vvv vvvvvvvvvvvvvv vvvvv
wwwwwwwwwwwwwwww ww wwwwwwwwww www
xxxxxxxxxxxxxxxxxxxxxxx x xxxxxxxxxxxxxxxxx xxxx
zzzzzzzzzzzzzzzzzzzzzzzzzz zzzzzzzzzzzzzzzzzzzzzzzzz zzzzz

       ABCDEFGHIJKLMNOPQRSTUVWXZ
          il manque toujours l'y
yyyyyyyyyyyyyyyyyyyyyyyyyyyyyyyyyyyyyyyyyyyyyyyyyyyyyyyyyyy
quelle                          importance
```

Fig. 25.
Eugen Gomringer, "wind," from Milton Klonsky, ed., *Speaking Pictures*

Arnheim, and so I shall review their argument briefly. Lessing, you will recall, claimed that the proper subject matter of painting is objects juxtaposed in space, that is, bodies, while that of poetry is things succeeding each other in time, that is, actions. Lessing's reasoning is purely dependent on his understanding of art as iconic. He states that the necessity for each of these subject matters is, on the one hand, the inherent spatiality of the painting medium, and on the other, the innate temporality of the literary medium, and the need for what he called a "suitable" relation between medium and subject matter.[41] "Suitable," it seems certain, can mean only "iconic." Thus to insure iconicity in the two arts, they must have different subjects.

Philosophers and linguists in our century have modified Lessing's position somewhat by comparing the arts not in terms of media but modes of perception. Husserl has argued that a temporal object must be processed by retention and protention in such a way as to be held in the mind, at its completion, as a simultaneous synthesis.[42] And reciprocally, psychologists have shown that visual perception is not an instantaneous feat but a similar fusing of temporally successive perceptions into a synthesis. Thus, both temporal and spatial art involve sequence and simultaneity in their concretions.

And yet, certain crucial differences still remain. First, Arnheim has pointed out that the ordering of the processing is predetermined in poetry, whereas it is free in painting.[43] That is, the poem demands to be read from beginning to end, from upper left to lower right, and if individual readers choose to ignore this, they thereby ignore part of the inherent structure of the work of art. A painting, on the other hand, though it may have a focus of interest and a spatial arrangement that indicate a hierarchy of importance among its elements, does not dictate the order in which the viewer is to process these elements. Indeed, physiological trackings of eye movements prove that individuals process pictures idiosyncratically within certain constraints.[44]

Roman Jakobson has identified a second difference, that the simultaneous synthesis at the culmination of painting perception is accompanied by the physical presence of the picture to which it corresponds, whereas the poem has disappeared by the time the synthesis is complete.[45] This claim is based on Jakobson's identification of the poem with its auditory rather than its visual manifestation, since the typography is, of course, present at the end of the perception of the poem. Moreover, he appears to assume that what is

Fig. 26.
Ian Hamilton Finlay, "wave rock," from
Emmett Williams, ed., *Anthology of
Concrete Poetry*

physically present in a painting does
in fact correspond to a mental con-
cretization, in a way different from
the correspondence between the
typographical form and mental con-
cretization of a poem. These assump-
tions are both debatable, I think, but
Jakobson and Arnheim's observa-
tions isolate the major barriers now
understood to exist between painting
and poem.

Concrete poetry, however, has
properties which sweep these obsta-
cles aside. In the first place, it is a
poetry programmatically aimed at
rendering perceptual sequence a
sphere of free play. By focusing at-
tention on typography spread across
space without regard to the upper-
left-to-lower-right convention (see
Gomringer's "wind," fig. 25) or
sometimes by playing directly on this
assumption (see Finlay's "wave
rock," fig. 26, in which the arbitrary
conventional left-to-right reading is
motivated as an imitation of the di-
rection of waves washing toward a
shore), the reader becomes a viewer
who can begin anywhere and pass
through a large number of perceptual
sequences which he in fact invents.
There are any number of theoretical
statements to this effect, for example,
this one by the German concretist,
Ferdinand Kriwet: the form of my
SEHTEXTE "is 'open; its beginning and

202

Fig. 27.
Carlfriedrich Claus , "Poetic Syntax in Relation to Prose," from Emmett Williams, ed., *Anthology of Concrete Poetry*

end are both fictitious. Their development is nowhere definite,' with the result that the 'reading activity' of the viewer must 'complete the text anew in each case and thus leave it always open.' Reading becomes analogous with the 'independent' performances of a piece of contemporary music, for the 'process of reading' is of equal importance with 'that which is read' which becomes 'no longer exclusively essential'" (Solt, p. 20). The strict correspondence between script and performance meets its nemesis in concrete poetry, with the result that the process of concretization is as much a matter of individual freedom as in painting.

And to Jakobson's objection that the physical correlate of the painting concretization still remains present at the time of that concretization, whereas the poetic one has vanished, concrete poetry has a number of rejoinders. First, insofar as the poem may be utterly unpronounceable, its whole existence may in fact lie in its visual, typographical representation, just as a painting's supposedly does (see Claus, "Poetic Syntax in Relation to Prose," fig. 27). Second, even if words are involved, many concrete poems—and all programmatic ones except for the acoustic variety—are printed so that the meaning inheres largely in the typographic arrangement (see Kolář's "brancusi," fig. 28). This fact is the source of the frequently repeated claim that "all definitions of concrete poetry can be reduced to the same formula: form = content/content = form" (Solt, p. 13). As a result, the configuration that gives rise to meaning *is* still present when the poetic concretization is complete, just as in a painting.

If the objection remains that print and paint, though both visual, are nevertheless innately different, the former having a preexistent ordering of elements and a set of sound referents to which it refers, we can hold up Klee's alphabetic sketches as examples of paintings using typography, or any number of concrete poems in which not a single letter appears (see Augusto de Campos's "eye for eye," fig. 29). What the barrier between the two arts is at such a point would be hard to identify. And it is precisely here that theoreticians try to discredit concrete poetry as being nonpoetry, since it disregards not only the auditory quality of verbal art but words as such.[46] Yet the pressures upon poetry to do just this are enormous. As we have seen, the entire tendency of western art to achieve presence in the text, hence iconicity, hence the visual, has forced poetry to try to overcome the symbolic properties of language and to stress its iconic and indexical ones. If this

Fig. 28.
Jiří Kolář, "brancusi," from Emmett
Williams, ed., *Anthology of Concrete
Poetry*

is the dead end of verbal art, then it is a dead end to which poetry has aspired for centuries. It *is* a dead end, moreover, because of its neglect of one side of the tension essential to the literary icon—its semiotic, mediated nature.

It is important to keep in mind, however, that the poetic exploitation of typography in and of itself does not create concreteness. And here the example of Mallarmé is instructive. His *Coup de dès* is frequently. mentioned as a crucial step toward the development of concrete poetry, and yet his explanation of what he was doing with language in this revolutionary experiment could not be further from the concrete enterprise. "Why should we perform the miracle," he asks in "Crise de vers," "by which a natural object is almost made to disappear beneath the magic waving wand of the written work, if not to divorce that object from the direct and the palpable, and so conjure up the pure idea?"[47] And he goes on to glorify this nullifying of the concrete world in a famous passage: in the typographic poem "Everything will be hesitation, disposition of parts, their alternations and relationships —all this contributing to the rhythmic totality, which will be the very silence of the poem, in its blank spaces, as that silence is translated by

Fig. 29.
Augusto de Campos, "eye for eye,"
from Emmett Williams, ed., *Anthology
of Concrete Poetry*

the black mystery

is here

here is

the black mystery

each structural element in its own way . . . in silence the mystery of nothing-ness—the idea—breaks in upon man" (Bruns, p. 229). In other words, the orchestrated arrangement of type focuses attention on the very nonconcreteness of language, its inevitable divorce from the thing-world and its appeal to the idea.

But where Mallarmé, along with Hegel and others, glorifies the efficacy of writing in "founding and purifying . . . the ground of interiority within the subject," Derrida dramatizes the dangers of this abstracting process in the yearning for presence: "What writing itself, in its nonphonetic moment, betrays," he says, "is life. It menaces at once the breath, the spirit, and history as the spirit's relationship with itself. It is their end, their finitude, their paralysis. Cutting breath short, sterilizing or immobilizing spiritual creation in the repetition of the letter . . . it is the principle of death and of difference in the becoming of being."[48] The very properties of language which for the concretist promise an object-poetry are fraught with danger, threatening by the repeatability of the letter and the nondenotation of normal poetic reference to leap into the realm of pure ideas.

The danger is something that concrete poetry has met head-on. It has hailed Mallarmé as its most important predecessor, stressing, however, those aspects of his art that play into their program and ignoring the rest. In the "Pilot Plan for Concrete Poetry," for example, the Brazilian Noigandres group name Mallarmé as their first forerunner, finding the crucial innovation in his "'subdivisions prismatiques de l'idée'; space ('blancs') and typographical devices as substantive elements of composition" (de Campos, de Campos, and Pignatari, p. 56). When concretists represent what might be taken as a Mallarméan silence, however, what they in fact achieve is a reification of silence itself, an inversion of the very absence marking the conventional attempt to make a poetry of presence. We saw something of this in "il manque toujours l'y," where despite the title and the missing *y* in the alphabetic sequence, the *y* was present in the form of typographic absence—spacing. Similarly, Eugen Gomringer's title, "words are shadows," does not stress a Derridean *differance,* but the extreme concreteness of language, manifested in its ability to cast shadows, to take up space. As Liselotte Gumpel presents Gomringer's idea here, "the significance of 'shadow' . . . was also made explicit: words break silence, then invoke a new silence: in between they cast the shadow of their black type on paper. Grouping these words

Fig. 31.
Eugen Gomringer, "words are shadows" (translated by Jerome Rothenberg), from Milton Klonsky, ed., *Speaking Pictures*

constitutes engaging in 'games' (spiele), though not 'trifling games' (spielereien). He who plays with the word plays with projections, with structures, with activity" (Gumpel, pp. 39–40; see Gomringer, "the black mystery is here," fig. 30, and "words are shadows," fig. 31).

Another exploitation of what is normally linguistic or typographic silence is Hiro Kamimura's reification of the distinctive feature. In "Water and Ice" (fig. 32), he takes a minimal graphemic pair differentiated by the presence or absence of a single stroke, and uses a pattern of the + stroke ideogram, ice, to form a diamond of ice floating in a larger square of water. The water is represented not by its ideogram, however, but by blank space dotted with the distinctive feature which would be *absent* in the water ideogram. This stroke, distributed across the watery blank, might represent random ice crystals floating down into the water as well, in which case the water would be signified by a blank, the absence of the ideogram altogether. In either case, an elaborate game is being carried on here with the normally transparent elements of writing. The abstract distinctive feature, rendered visible in writing, is further rendered meaningful in and of itself —as either an ice crystal or, more

words are shadows
shadows become words

words are games
games become words

are shadows words
do words become games

are games words
do words become shadows

are words shadows
do games become words

are words games
do shadows become words

subtly, a sign of the very ideogram, water, from which it is absent. And at the same time, the patterning of ideogram, blank, and distinctive feature produces a picture with strongly iconic properties. This is truly a case where the differential elements "carry" the meaning, in a way that even Saussure did not anticipate.

Thus, concretists deliberately turn the most nonconcrete aspects of language to their purposes. The normal determinacy of the reading sequence is loosed, as we have seen, in order to open the literary text to the eyes as if it were an object rather than a linguistic sequence. Through the free play of perception that results, the concretists overcome the alleged stasis of the word, which, like Keats's Grecian urn or Eliot's Chinese jar, freezes objects in an unchanging or ideal configuration, rather than allowing them the dynamism of existing objects.[49]

In fact, concrete poetry stresses a theory of language as a dynamic interplay of signs and things rather than a stable system of names. The conventional view of the *signifiant-signifié* relation—for example, Saussure's or Derrida's—insists on the abstraction of the signifier and hence print as an infinitely repeatable, ideal entity: "Is it not evident that no signifier, whatever its substance and form, has a 'unique and singular reality?' A signifier is from the very beginning the possibility of its own repetition, of its own image or resemblance. It is the condition of its ideality, what identifies it as a signifier and makes it function as such, relating it to a signified which, for the same reasons, could never be a 'unique and singular reality.' From the moment that the sign appears, that is to say from the very beginning, there is no chance of encountering anywhere the purity of 'reality,' 'unicity,' 'singularity'" (Derrida, *Of Grammatology*, p. 91). But others, like Sergej Karcevskij, claim just the opposite: that the referent of each token of a sign is slightly different because of differences in the time of the utterance, at least, and that no two tokens are ever identical. Is this not what Gerhardt Rühm is getting at in his poem, "jetzt" (fig. 33)? Here each token of the work "now" marks a unique moment of time, the time of the reading of the word "now," and each token is physically different from the others both in its typographic rendering and its disposition in space. Repetitive as the word-tokens may be, the strongly indexical functioning of the poem insists upon the specificity, uniqueness, and presence of its meaning. We are confronted with a concrete reference that constantly changes and a signifier that denies its own static

repeatability. As Karcevskij would say, "the *signifiant* (sound form) and the *signifié* (function) slide continually on the 'slope of reality.' . . . It is thanks to the asymmetric dualism of the structure of its signs that a linguistic system can evolve."[50]

Indeed, the realization that the nonrepeatability of signifier–signified pairs is responsible for language change and an essential function of poetic discourse is everywhere visible in the concretists' theories. Their poems, moreover, are often enactments of this process of linguistic evolution. Like Karcevskij, they stress homonymity as a fundamental mechanism of this change. Öyvind Fahlström says in his "Manifesto for Concrete Poetry," "Homonyms provide great possibilities. Zeugma-binding also belongs here: to connect words, meanings and fragments, for example, poetry is poetry is poetry, where the middle poetry is both end and beginning" (Solt, pp. 76–77). And Augusto de Campos explains Décio Pignatari's poem "hombre-hembra-hambre" (fig. 35) as follows: "To say *man-woman-hunger* would be sufficient from the point of view of content, but the force field of the assemblage would be lacking. Here it is necessary to remember with regard to the conceptual perception of the poem, that the process of vowel or

木 = water
氷 = ice

Jetzt

Jet

Jetzt

jetzt

jetzt

Fig. 33.
Gerhardt Rühm, "jetzt," from Emmett
Williams, ed., *Anthology of Concrete
Poetry*

jetzt

Jetzt

jetzt

tzt

jetzt

jetzt

Jetzt

consonant shifts, frequently linked to reduplication, has profound roots in language.''[51]

This aspect of language development was exploited amusingly in Lewis Carroll's game of "Doublets."[52] Here the object was to change one word into another by generating a string of intervening words, each differing from the one before in one letter only. The result would be a speech chain of minimal graphemic pairs establishing typographical rather than semantic or even phonological relations. The puzzles were posed, however, as semantic problems: "Drive PIG into STY" or "Make WHEAT into BREAD" (Carroll, p. 1279), but the problem is solved by finding a typographical passageway through language, a new basis for paradigms. There are any number of concrete poems employing just this technique, for example, Décio Pignatari's "hombre-hembra-hambre" (fig. 34) and his "beba coca cola" (fig. 35), where a kind of folk etymology is in operation, the word developing a motivated relationship with others spelled similarly. But where Carroll's rules specified that all intermediate links have to be words, concrete poets often violate this requirement, allowing the letter itself to carry the force of linguistic transformation (see Emmett Williams's "sense sound," fig. 36).[53] And metamorphosis in general, even in the Ovidian sense, is a recurrent theme of concrete poetry (see Paul de Vree's "eros," fig. 37).

This switching of the graphic artwork into a game is a frequent ploy of concrete poetry. Finlay's witty "Homage to Seurat" (fig. 38) transforms a pointilliste painting into a join-the-dots game, leaving a picture frame of Seurat-like points to stress the contrast. Not only is this contrast funny—the brilliant illusionist technique reduced to a children's pastime—but it constitutes a rather interesting comment on Seurat. The pleasure of playing join-the-dots is to see a figure emerge, in fact to create it, out of a bunch of unintelligible dots, to find pattern in chaos. This is precisely the wonder of pointilliste painting itself, for part of the pleasure of looking at it comes from comparing close-up with more distant views. The active participation of the viewer, the processual nature of visual perception, and the resulting gamelike status of art are all implied by Finlay's poem. It comments on the painter, and at the same time it humbly exposes the modestness of its own visual achievement (mere outlines of sailboats, if we join the dots).

Another concretist procedure is the teasing implementation of representational techniques from painting. Who can look at Timm Ulrich's

Fig. 34.
Décio Pignatari, "hombre-hembra-
hambre," from Emmett Williams, ed.,
Anthology of Concrete Poetry

h o m b r e h o m b r e h o m b r e

h a m b r e h e m b r a

 h a m b r e

h e m b r a h e m b r a h a m b r e

Fig. 35.
Décio Pignatari, "beba coca cola,"
from Emmett Williams, ed., *Anthology
of Concrete Poetry*

"Zusammenfassung" (fig. 39) without seeing it as a pair of planes slanted toward the viewer? And yet at the same time we know that it is flat typewriting on paper. The texture created by the different letters used and by the typing of one word over another also suggests depth, as do the blackened (shaded?) edges of the planes, set, we seem to know, on a collision course to achieve the "Zusammenfassung" of the title. But most important in creating this illusion of depth are the diagonals, which betoken both dynamic motion and foreshortening, recession away from the picture plane. These are meager gestures which become a kind of minimalist theory of illusionism. In a similar vein, students have sworn to me that after 'reading' "jetzt" long enough they experienced the poem as a scene of deep space where they, traveling farther and farther inward, were bombarded by random "jetzt"s floating past, a kind of meteor shower of present moments. Regardless of whether one shares this perception, the tendency to see these poems as not only paintings but, in this case, motion pictures is a testimony to their visual power.

Concretists also make use of visual paradoxes in order to achieve this dynamism. Dom Sylvestre Houédard, for example, presents a

beba coca cola
babe cola
beba coca
babe cola caco
caco
cola
 cloaca

Fig. 36.
Emmett Williams, "sense sound," from Emmett Williams, ed., *Anthology of Concrete Poetry*

Fig. 37.
Paul de Vree, "eros," from Eugene Wildman, ed., *Anthology of Concretism*

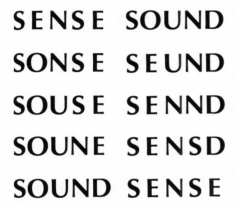

play with perspective in "trip trap" that is reminiscent of gestalt double images. Like Escher's impossible perspectives or his famous tuning fork, Houédard's poem makes us switch back and forth between two contradictory realities occupying the same space. Though the integration of visual and verbal text here is weak, the poem demonstrates the crucial connection between nonsense and the pursuit of the concrete in art. For just as logicians verge on nonsense in pursuing a language of pure and unambiguous reference, the concretist verges on it in pursuing an art with a purely object status.

In these ways and several others, the dynamism of the word and letter and of the reality they refer to are stressed in concrete poetry, the poem itself becoming almost as vital and thinglike as objects in the world. Just like Kandinsky, concrete poets reverse the very application of the terms *abstract/concrete,* conceiving of "*disengagement from* the extant reality as a concomitant *engagement* in an esthetic reality of one's own making. Once shaped, this esthetic domain constitute[s] a counter-reality fully 'Concrete' within its own denominations" (Gumpel, pp. 45–46). Instead of gaining concreteness as a feeble shadow of an imitated reality outside it, concrete art neglects the mirror function in order to become a thing. Thus, Ian Hamilton Finlay can place his poems in nature, and have art-thing stand beside nature-thing as reciprocally as ever sign can coexist with object. And Gaudí, one of the undiscovered precursors of concrete poetry, can depict the evangelists on the facades of Sagrada Familia not by statues but by their names, which have perhaps more concrete reality as synecdoches of these archetypal writers than any imagined visualization of their mere bodies would ever have.

One of the earliest proponents of a concrete art, Hans Arp, made a statement that embodies the optimism of the approach as an attempt to create presence in the work of art:

concrete art aims to transform the world. it aims to make existence more bearable. it aims to save man from the most dangerous folly: vanity. it aims to simplify man's life. it aims to identify him with nature. reason uproots man and causes him to lead a tragic existence. concrete art is an elemental, natural, healthy art, which causes the stars of peace, love and poetry to grow in the head and the heart. where concrete art enters, melancholy departs, dragging with it its gray suitcases full of black sighs.[54]

Fig. 38.
Ian Hamilton Finlay, "Homage to
Seurat," from Milton Klonsky, ed.,
Speaking Pictures

Whatever one might think of this art—happy in its play with the tension between thing and sign or wistful in its realization that the tension cannot be released, that art can never fully become thing—concrete poetry serves to dramatize the entire striving behind the interartistic comparison. It is the enactment of a critical idea, a metaphor that appears to be as old as human thinking about art itself. I see the meaning of this comparison as an attempt to personify the work, to make it simultaneously a presence visible, continuous with our experience in the extra-artistic world, and a voice, words, that are real in a very different sense.

No doubt, for later times or conflicting frames of reference the interartistic comparison will mean something quite different and will be evaluated differently vis-à-vis the rest of twentieth-century art. But this is as it should be. The picture that I have presented features its presuppositions as much as its findings—so much so in fact that I am forced to put aside a detailed history of the painting-literature connections in this century to some future work. The present essay explores the issues and assumptions that will inform such a history and lays the groundwork, I hope, for a new way of thinking about "the discipline of literary study." For what is most characteristic of modern literature may very well be what exceeds that discipline, integrating verbal art in a system that includes the visual arts, criticism, and philosophy. Ultimately, of course, this system is as broad as culture itself, but the relation between literature, painting, and art theory forms the very core, I believe, of the artistic activity of our day.

Fig. 39.
Timm Ulrich, "Zusammenfassung,"
from Katalog *Visuelle Poesie,*
Westfälischer Kunstverein, Münster,
1969

The Franklin's contribution to the pilgrim's dispute over who should have mastery in marriage is to recall an old "Breton lay" depicting the marital experiment of Dorigen and Arveragus. They have pledged their troth with the understanding that the husband, Arveragus, will never have mastery over his wife, nor show any jealousy toward her; Dorigen in return promises that her husband will never have cause to do so. This is an ideal marriage of equals, in utter contrast to the alternative literary ideal of courtly love. Moreover, the two have agreed to be ruled by their mutual pledge and to have absolute faith in "trouthe," here the conjunction of truth, one's word, and the marriage vow. This triple conflation suggests that the Franklin is telling a highly language-oriented tale concerned with the relation between reality and literary convention and between deeds and promises.

The young pair live blissfully for some time "In Armorik, that called is Briteyne," until Arveragus is forced away on business. He travels to "Engelond, that cleped was eek Briteyne," thus exchanging one place for another of the same name. The discrepancy between the two "Briteynes" drives Dorigen to despair: "Desir of his presence hire so destreyneth / That al this wyde world she sette at noght." That is, her response to Averagus's absence is to disdain the world, a serious mistake for one pledged to value truth, one of whose essential terms, as the story goes on to show us, is the external world.

Dorigen's friends find her despair unhealthy and comfort her with some success, for "By proces, as ye knowen everichoon, / Men may so longe graven in a stoon / Til som figure therinne emprented be. / So longe han they conforted hire, til she / Receyved hath, by hope and by resoun, / The emprentyng of hire consolacioun." Like good matter, she has received the imprint of comfort carved in her, like a figure in a stone, and so she consents to go out of doors for springtime entertainment, to return once more to the world.

But no sooner does she do so than she notices huge rocks by the seacoast. To her they signify danger to her husband, and terrified, she calls upon God to destroy them. In her plea she argues that the rocks "semen rather a foul confusion / Of werk than any fair creacion." Disregarding the idea that God makes nothing without a reason, she finds the rocks a "werk unresonable" in that they threaten to kill the very creatures, men, that God has made "lyk to thyn owene merk." Thus, despite the fact that Dorigen, rocklike, has re-

ceived the imprint of friendly consolation that returns her to the world, she fails to see God's mark upon *His* rocks, the consolation of the world itself, and so is driven once more into despair.

Her friends' next tactic is to take Dorigen to a garden "Which May hadde peynted with his softe shoures." The figurative act of nature's painting here has a special significance, for the Franklin has promised that there will be no "colours of rethoryk" in his story. Yet here we not only find one, but it is a "colour" about painting itself. The painter here is nature in the person of May, a figure in conformity with the Franklin's averment that "Colours ne knowe I none, withouten drede, / But swiche colours as growen in the mede"; in other words, we have here a literary figure depicting nature's figuration, which is hence placed in parallel to man's. The other colors that the Franklin claims to know are "swiche as men dye or peynte." But "Colours of rethoryk been to me queynte." That is, man is an alternative painter to nature, as long as he keeps to the visual and avoids the verbal. The painter—and the friend and the sculptor—are acceptable colorists, since they stamp the figure of consolation upon their creations, as God stamps his likeness on man (and nature—the rocks). But figures of speech have no such marks. They are tricky ("queynte" = strange, curious, ornamented, neat, artful, sly, graceful!), because often they do not reflect in their externality the hand of their creator. To put it in semiotic terms, "icons," or signs which resemble what they designate, are safe; they reinforce the chain of resemblances that ultimately leads to the arch-signifier and -signified, God. But "symbols," purely conventional signs, contain no such resemblances, and when they are used figuratively in poetry or rhetoric, they promise resemblance (or other kinds of motivation) but do not deliver it. The link between words, world, and speaker is not direct or even present in poetic language.

But if we look back at the words depicting two of the approved forms of "painting," consolation and sculpture, a curious ambiguity is evident. The Franklin says that "Men may so longe graven in a stoon / Til som figure thereinne emprented be." But "figure" signifies "figure of speech" in the Clerk's "Prologue" and "an imaginary form, a phantasm" in *The House of Fame (OED)*. Literary figuration and illusion are thus implicitly present in this image of consolatory engraving, and the coincidence of stone and coastal rocks—creative potential versus brute matter—is likewise not an accident.

Perhaps it is through figures of speech that "marks" are placed on creations. After all, the act of consoling is itself expressed here through a simile.

A further suggestion that the issue of figuration is not treated innocently by the Franklin is apparent in his dealings with the Host. The latter had entreated the Clerk: "Youre termes, youre colours, and youre figures, / Keep hem in stoor til so be that ye endite / Heigh style, as whan that men to kynges write. / Speketh so pleyn at this tyme, we yow preye, / That we may understonde what ye seye" (Clerk's "Prologue"). The Clerk had agreed, but then proceeded to narrate the highly wrought tale of Griselde in which figures abound and the moral calls for a wife to be totally subservient to her husband. Chaucer's "Envoy" exhorts women not to suffer their husbands' cruelty as Griselde had, but the Host foolishly gushes: "By Goddes bones, / Me were levere than a barel ale / My wyf at hoom had herd this legende ones!" Can it be an accident that the Franklin praises the Squire's ornate tale of male betrayal in love in similar words? "I have a sone, and by the Trinitee, / I hadde levere than twenty pound worth lond, / . . . He were a man of swich discrecioun / As that ye been!" The host impatiently cuts him off and demands a tale, to which the Franklin sarcastically answers, "I prey to God that it may plesen yow; / Thanne woot I wel that it is good ynow." The Host does not recognize figures of speech when he hears them. In several manuscripts, the "Franklin's Tale" actually follows the Clerk's, the two connected by a spurious link in which the Host complains bitterly about his shrewish wife. A connection is thus repeatedly implied between the demand for taming wives to subservience and taming words to univocity.

To return to the tale, it happens that not only had May painted this consolatory garden, but "craft of mannes hand so curiously / Arrayed hadde this gardyn, trewely, / That nevere was ther gardyn of swich prys, / But if it were the verray paradys." A joint work of nature and man, the garden rivals *the* garden, Eden. But that perfect garden, we know, was ruined by man's acts. Using the gardener's art to perfect nature has some of the danger of eating the apple or building the Tower of Babel. As with rhetorical figures, there is a suggestion here of the perils involved in man's taking on God's creative powers, and the direction of the plot presently bears his warning out.

For in the garden a young knight called Aurelius is dancing. He has loved Dorigen in the courtly fashion, all unbeknown to her, for the past two

years. And like the garden, Aurelius is the most perfect man "sith that the world bigan." Emboldened by the Maytime festivities, he swears "by God that this world made" that he loves Dorigen. But she answers him disdainfully, also swearing in the Creator's name, that she will become his love only when he removes all the rocks from the Brittany coast. Dorigen and her friends continue their revels as Aurelius crawls off in despair, like the deflated figure of speech that ends the episode: "the brighte sonne loste his hewe; / For th'orisonte hath reft the sonne his lyght,— / This is as muche to seye as it was nyght!" Aurelius thus becomes identified with a figure of speech and with a real color—the gold *(aurum)* of the sun. He is himself a "color of rhetoric" and presents as much of a danger to the stability of the "trouthe" between the married pair as figurative language always does to direct reference.

In an interesting symmetry, Dorigen has invoked God, and then in ironic fashion a person, in order to remove the rocks; and so does Aurelius. He calls upon Apollo (again a reference to the sun and hence gold), and suffers for two years awaiting an answer, attended only by his brother who is, significantly, a clerk. When no help seems forthcoming from Apollo, the brother remembers a more human source of magic, a clerk that he had met in France. Of course, in Christian Britain, magic has no place: "hooly chirches feith in oure bileve / Ne suffreth noon illusioun us to greve." But in its literary namesake, "Britaigne," "with an appearance a clerk may make, / To mannes sighte, that alle the rokkes blake / Of Britaigne weren yvoyded everichon." Here the connection between magician, illusion, and learning (the "clerk") again reminds us of the frame story of the Garden of Eden and the concomitant dangers of knowledge and figurative language. This is perhaps also a dig at the Clerk, with his false claims to plain speech and his depiction of female servility in marriage.

Arveragus had long since returned home by the time Aurelius and his brother finally located an obliging magician whose "magyk natureel" could be bought for a thousand pounds of gold. Aurelius at first scoffs at such a small fee: "Fy on a thousand pound! / This wyde world... / I wolde it yeve, if I were lord of it." Like Dorigen, Aurelius disdains the world, and through a contrary-to-fact conditional that stresses the disjunction between words and world. The Franklin notes that the sun is a sickly brass color rather than gold when Aurelius presents the rockless seacoast to Dorigen and demands

his reward. She returns home to think it over, and unearths every conceivable literary precedent to her predicament. These unanimously dictate suicide as the only honorable way out. But Arveragus, upon hearing of the situation, insists that Dorigen keep her word. It is the literal rather than the literary solution that must prevail. Unhappy, but no longer desperate, Dorigen offers herself to Aurelius. But he, hearing of the mutual trust of the husband and wife and their truthfulness, relents and releases Dorigen from her word. And the magician in turn releases Aurelius from *his* word because of his magnanimity; thus, Aurelius need not give up his gold. The imprint of mercy and consolation has been transferred from one character to the next, all as a result of Averagus's insistence on the need to keep one's word. But we should note that the plot finds its resolution in the utter failure of promises to materialize into acts. The generosity that the Franklin so stresses in his final question, "Which was the mooste fre," is specifically the quality that *releases* one from his word.

What the tale sets up, then, is a complex of factors relating truth—and particularly the truth that holds for words in their correspondence to reality—to figuration, and to the creative power of God, of nature, and of man as painter and gardener and magician and friend. The creator leaves his mark on his creation, and knowing how to read that mark keeps one in touch with truth. If Dorigen had known how to read the rocks, she would have found them imprinted with God's mercy, and so would not have been led to deny nature through her wild pledge. Since a word should be stamped with its bearer's likeness too, when Dorigen made her promise based on the belief that it could not be fulfilled ("It is agayns the proces of nature," she says) she was divorcing her word from reality and from herself; thus loosed into the void, her words could only create mischief.

But unfortunately, words always have this danger, as is symbolized by the *causa efficiens* of the tale's action, the homonymity of "Briteyne," which refers to different countries and here functions to indicate absence, temporal displacement, discrepancy in reference. Just so, the colors of the meadow and the colors of paint are safe to know, but the colors of rhetoric are too complicated and tricky to keep under control—all this despite the Franklin's very competent mastery of figuration throughout the story. And so again the possibility arises that the story is an intentional falsification of its claim to plain speech, proving instead that *only* through figuration is truth possible.

Just as the situation is solved by the husband's actually exercising mastery, influence, through his insistence on the truth, telling the truth can be accomplished only through a masterful control over what signifies it, words. And this control is not a diminishing of language to literalness (or of women to subservience), but a full liberation of its virtuosity in the name of truth. The tale, innocently recapitulating a "Breton lay" from another country, time, and language, makes all its ostensible claims ambiguous and thus foregrounds the essential polysemy of artistic language.

Notes

Preface

1. The phrase is not, of course, original to Chaucer, but appears in Geoffroi de Vinsauf's *De coloribus rhetoricis* and in other medieval rhetoricians. It is the peculiar manipulation of this figure that I find so fascinating in Chaucer.

2. Rudolf Arnheim, "Visual Aspects of Concrete Poetry," *Yearbook of Comparative Criticism* 7 (1976):109.

3. Svetlana Alpers and Paul Alpers, "Ut Pictura Noesis? Criticism in Literary Studies and Art History," *New Literary History* 3 (spring 1972), 457–58.

4. Rudolf Arnheim, "The Unity of the Arts: Time, Space, and Distance," *Yearbook of Comparative and General Literature* 25 (1976):7.

One
Thoughts That Fit Like Air

1. Abrams, *The Mirror and the Lamp* (New York: Oxford University Press, 1953), p. vi.

2. Black, *Models and Metaphors* (Ithaca, N.Y.: Cornell University Press, 1962), p. 25.

3. Black, "How Do Pictures Represent?" in *Art, Perception, and Reality,* ed. E. H. Gombrich, Julian Hochberg, and Max Black (Baltimore: Johns Hopkins University Press, 1972).

4. Charles S. Peirce, *Collected Papers* 2 (Cambridge, Mass.: Harvard University Press, 1932): 158. An icon is a sign that resembles what it represents. I discuss this concept in detail on pp. 19–22.

5. W. H. Leatherdale discusses Keynes's categories of negative, positive, and neutral analogy in *The Role of Analogy, Model, and Metaphor in Science* (Amsterdam: North-Holland, 1974), p. 41.

6. Alistair Fowler, "Periodization and Interart Analogues," *New Literary History* 3 (spring 1972): 503.

7. René Wellek, "The Parallelism between Literature and the Arts," *English Institute Annual* (New York: Columbia University Press, 1941), p. 33.

8. See Wellek's summary of the issues in "The Concept of Baroque in Literary Scholarship," *Concepts of Criticism* (New Haven, Conn.: Yale University Press, 1963).

9. See the discussion of Peirce's semiotics, pp. 19–22. For Derrida, see *Of Grammatology* (Baltimore: Johns Hopkins University Press, 1974) and "Differance," *Speech and Phenomena and Other Essays on Husserl's Theory of Signs* (Evanston, Ill.: Northwestern University Press, 1973).

10. Leonardo da Vinci, *Treatise on Painting,* vol. 1, trans. and annotated by A.

Philip McMahon (Princeton, N.J.: Princeton University Press, 1956), p. 18. Leonardo's views here are discussed in Niklaus Rudolf Schweizer, *The Ut Pictura Poesis Controversy in Eighteenth-Century England and Germany* (Bern and Frankfurt: Herbert Lang & Peter Lang, 1972), pp. 29–30.

11. Mukařovský, "Between Literature and the Visual Arts," *The Word and Verbal Art,* ed. and trans. John Burbank and Peter Steiner (New Haven, Conn.: Yale University Press, 1977), p.213.

12. See Ernest Gilman, *The Curious Perspective* (New Haven, Conn.: Yale University Press, 1978).

13. Horace, "Ars Poetica," ll. 1–9, *Horace's Satires and Epistles,* trans. Jacob Fuchs (New York: W. W. Norton, 1977), p. 85.

14. Nelson Goodman, *The Languages of Art* (Indianapolis and New York: Indiana University Press, 1968), p. 22.

15. Jakobson, "The Poetry of Grammar and the Grammar of Poetry," *Lingua* 21 (1968): 606.

16. Hagstrum, *The Sister Arts: The Tradition of Literary Pictorialism and English Poetry from Dryden to Gray* (Chicago: University of Chicago Press, 1958), p. 7.

17. W. K. Wimsatt, "Laokoön: An Oracle Reconsidered," *Day of the Leopards* (New Haven, Conn.: Yale University Press, 1976), p. 41.

18. Rensselaer W. Lee, *Ut Pictura Poesis: The Humanistic Theory of Painting* (New York: W. W. Norton, 1967), p. 4.

19. See Chap. 4 of my *Exact Resemblance to Exact Resemblance: The Literary Portraiture of Gertrude Stein* (New Haven, Conn.: Yale University Press, 1978) for a discussion of the relation between Stein's *écriture-objet* and the cubists' *tableau-objet.*

20. John Hughes, "Descriptions in poetry, the reasons why they please," *Lay Monastery,* 39 (Feb. 12, 1713), in *The Gleaner,* ed. Nathan Drake, I, vii (London, 1811), pp. 45–46.

21. A number of critics have denied that the *ut pictura poesis* proponents were in fact making such magical claims for the identity of the arts, describing the comparison instead much more as a matter of decorum and convention. Hagstrum, for example, argues that a "pictorial" description was one that was "paintable." That is, it would make reference to visual details, the relations among which would be amenable to graphic representation; such a description would not involve temporal sequence or motion, nor be purely conceptual, and it might, but need not, directly 'copy' paintings or schools of painting (Hagstrum, pp. xxi–xxii). Such a depiction, cautious as it is, glosses over many crucial questions. In what ways can a piece of writing copy a painting or school of painting? How can a writer eliminate temporal sequence from literature? And most crucially, what is the hidden motivation for such a peculiar set of restrictions—if not to make some claim for visuality or vivid-

ness in poetry? The seventeenth- and eighteenth-century *ut pictura poesis* arguments are full of such question-begging.

22. Joseph Frank, "Spatial Form in Modern Literature," *The Widening Gyre* (New Brunswick, N.J.: Rutgers University Press, 1963), p. 8.

23. Lessing, *Laokoön, Selected Prose Works of G. E. Lessing,* ed. Edward Bell, trans. E. C. Beasley and Helen Zimmern (London: G. Bell, 1879), p. 91.

24. Goethe, *Dichtung und Wahrheit,* vol. 8, trans. Minna S. Smith (London: G. Bell, 1908), part 2, p. 282.

25. Wimsatt, "In Search of Verbal Mimesis," *Day of the Leopards,* p. 57.

26. Laude, "On the Analysis of Poems and Paintings," *New Literary History* 3 (spring 1972): 471.

27. Guillaume Apollinaire, "Pure Painting" (from *Cubist Painters*), in *The Modern Tradition,* ed. Richard Ellmann and Charles Feidelson (Oxford and New York: Oxford University Press, 1965), p. 114.

28. "The Art of Painting," by C. A. Du Fresnoy, trans. and with introduction, "A Parallel between Painting and Poetry," by John Dryden (1695), in *The Works of John Dryden,* ed. Walter Scott (London, 1808) 17:312.

29. In "Mimesis: The Translator as Painter," *English Translation Theory, 1650–1800* (Amsterdam and Assen: Van Gorcum, 1975), T. R. Steiner outlines the translator's problems in terms strikingly similar to those of the interartistic parallel.

30. Jakobson, "Visual and Auditory Signs," *Selected Writings,* vol 2: *Words and Language* (The Hague: Mouton, 1971), p. 335.

31. This is the central theme, for example, of John Crowe Ransom's *The World's Body* (Baton Rouge, La.: Louisiana State University Press, 1938).

32. See, for example, Jakobson, "The Quest for the Essence of Language," *Diogenes* 51 (1965): 21–37, and *Shakespeare's Verbal Art in "Th'Expense of Spirit"* (The Hague: Mouton, 1970).

33. Jakobson, "Linguistics and Poetics," *Style in Language,* ed. Thomas A. Sebeok (Cambridge, Mass.: M.I.T. Press, 1960), p. 358.

34. Morris, "Esthetics and the Theory of Signs," *Journal of Unified Science* 8 (1938): 134.

35. For a comparison of these two approaches, see P. Steiner, "Jan Mukařovský and Charles Morris: Two Pioneers of the Semiotics of Art," *Semiotica* 19, 3/4 (1977): 321–34.

36. See my "Case for Unclear Thinking: The New Critics versus Charles Morris," *Critical Inquiry* 6 (winter 1979): 257–70.

37. Ray L. Birdwhistell, *Introduction to Kinesics* (Louisville, Ky.: University of Kentucky Press, 1952).

38. Schweizer (pp. 39–40) claims that since *all* artistic signs are artificial, the

natural-artificial distinction is irrelevant to a differentiation of the two arts and that only the space–time opposition separates them. But to deny that paintings have the capacity to resemble physical objects is just as one-sided as to deny their spatiality on the grounds of their sequential processing by the viewer. Both claims involve a willful disregard for the material properties of the medium. If paintings do contain natural signs, however limited this property may be, their spatiality is a function of this property. And for Lessing, the significance of the simultaneity of painting is its "suitability," its imitative potential, to the world of objects.

39. See W. Steiner, *Exact Resemblance,* chap. 4.

40. See W. Steiner, "The Case for Unclear Thinking."

41. Casey, "Truth in Art," *Man and World* 3 (November 1970): 358; "Meaning in Art," in *New Essays in Phenomenology,* ed. James Edie (Chicago: Quadrangle, 1960). See also Casey's "Expression and Communication in Art," *Journal of Aesthetics and Art Criticism* 30 (winter 1971): 197–208.

42. Benjamin Lee Whorf, *Language, Thought, and Reality* (Cambridge, Mass.: M.I.T. Press, 1956); Edward Sapir, *Language* (Oxford and New York: Oxford University Press, 1921).

43. Jurij Lotman, *The Structure of the Artistic Text,* trans. Ronald Vroon (Ann Arbor, Mich.: Michigan Slavic Materials, 1977), chap. 1.

44. Roland Barthes, in *Eléments de sémiologie* (Paris: Seuil, 1964), goes so far as to subsume semiotics under linguistics in his introduction.

45. *The Structurist* 12 (1972–73): 38.

46. Goodman, *The Languages of Art,* p. 14.

47. Worth, "Pictures Can't Say Ain't," *Vs.* 12, 3 (1975): 104.

48. Jakobson, "On Realism in Art," trans. K. Magassy, in *Readings in Russian Poetics,* ed. L. Matejka and K. Pomorska (Cambridge, Mass.: M.I.T. Press, 1971), pp. 38–46.

49. Schapiro, *Words and Pictures: On the Literal and the Symbolic in the Illustration of a Text* (The Hague: Mouton, 1973), p. 47.

50. Schapiro, "On Some Problems in the Semiotics of Visual Art: Field and Vehicle in Image-Signs," *Semiotica* 1 (1970): 236.

51. James Joyce, *Ulysses* (New York: Vintage, 1966), p. 37.

52. Interestingly, like the medieval theologian, C. K. Ogden and I. A. Richards argue that perception is the interpretation of visual signs; see *The Meaning of Meaning* (New York: Harcourt, Brace, 1938).

53. Rudolf Arnheim, "The Unity of the Arts: Time, Space, and Distance," *Yearbook of Comparative and General Literature* 25 (1976): 8–9. For a study of eye-tracking in the perception of pictures, see David Noton and Lawrence Stark, "Eye Movements and Visual Perception," *Scientific American* 224 (June 1971): 35–43.

54. Peter Steiner and Wendy Steiner, "The Axes of Poetic Language," in *Language, Literature, and Meaning,* vol 1: *Problems of Literary Theory,* ed. John Odmark (Amsterdam: John Benjamins, 1979), pp. 35–70.

55. Edmund Husserl, *Zur Phänomenologie des inneren Zeitbewußtsein* (1893–1917) in *Husserliana,* ed. H. L. van Breda, (The Hague: M. Nijhoff, 1966), 10:28.

56. Saint Augustine, *Confessions,* trans. Edward B. Pusey (New York: Cardinal, 1951), book 11, 236–37.

57. Roman Jakobson, "Zeichen und System der Sprache," *Selected Writings* 2:272–73.

58. How sequence can be dissolved in "a slowly rising crescendo" (Frank, p. 15) is also difficult to see.

59. Frank (p. 60) admits as much: Sutton's "major argument is that, since reading is a time-art, the achievement of spatial form is really a physical impossibility. I could not agree more. But this has not stopped modern writers from working out techniques to achieve the impossible—as much as possible."

60. See Elemér Hankiss, "Semantic Oscillation," *The Sign in Music and Literature,* ed. Wendy Steiner (Austin: University of Texas Press, 1981) for an attempt to schematize various plot structures.

61. W. J. T. Mitchell, "Spatial Form in Literature," *Critical Inquiry* 6 (spring 1980): 539–67, has recently tried to revive Frank's idea and in fact to extend it to all of literature. He points out that we cannot conceive of time except through space and that "all our temporal language is contaminated with spatial imagery" (p. 542). Struck by the extent of this verbal contamination, Mitchell suggests that we should examine the causes rather than vainly struggle to regain a conceptual purity that probably has never existed. This would be one area of investigation in a new discipline called *iconology,* whose goal would be the elucidation of the painting–literature analogy. Sharing this goal, I feel obliged to stress what Mitchell acknowledges only in passing—that "neither linear nor spatial phenomena in literary forms are *literally* spatial" (p. 560). There is a difference between the structure of a literary text and its alleged spatiality, and only by keeping these distinct can one hope to understand such complicated problems as concrete poetry, for example, offers. Mitchell's article is important, however, in stressing the presence of the simultaneous synthesis in every kind of art.

62. Roman Jakobson, "On the Relation between Visual and Auditory Signs," *Selected Writings* 2:344.

63. James Bunn, "Circle and Sequence in the Conjectural Lyric," *New Literary History* 3 (spring 1972): 514.

64. J. E. Morpurgo, Introduction to *Keats* (London: Penguin, 1953), p. 19.

65. Roman Ingarden, *The Literary Work of Art,* trans. G. G. Grabowicz

(Evanston, Ill.: Northwestern University Press, 1973), pp. 122–23.

66. E. E. Cummings, *One Hundred Selected Poems* (New York: Grove, 1923), p. 80.

67. Genette, *Mimologiques: Voyage en Cratylis* (Paris: Seuil, 1976).

68. Irving Babbitt, *The New Laokoön: An Essay on the Confusion of the Arts* (Boston and New York: Houghton Mifflin, 1910), p. 177.

69. Eisenstein, "Colour and Meaning," *Film Sense,* trans. Jay Leyda (London: Faber, 1948).

70. Vallier, "Malévich et le modèle linguistique en peinture," *Critique* 31 (March 1975): 291.

71. Veltruský, "Some Aspects of the Pictorial Sign," *Semiotics of Art,* ed. L. Matejka and I. R. Titunik (Cambridge, Mass.: M.I.T. Press, 1976), p. 248.

72. Jakobson, "The Poetry of Grammar and the Grammar of Poetry," *Lingua* 21 (1968): 606.

73. Elemér Hankiss plots such diagrams in "Semantic Oscillation."

74. See František Daneš, ed., *Papers on Functional Sentence Perspective* (The Hague: Mouton, 1974) for the general issues related to this concept.

75. The tedious arguments demonstrating that optical perspective is not quite identical to scientific optics, and hence that it is not an approximation of vision,seem to me beside the point. Renaissance perspective looks a great deal more like the way we see than medieval hierarchical perspective, and the corrections that would have to be made in it to match vision are not significant, compared with what would have to be done, for example, to a Gothic altarpiece. Even such a confirmed conventionalist as E. H. Gombrich has come to this position; see "Image and Code: Scope and Limits of Conventionalism in Pictorial Representation," in *Image and Code,* ed. Wendy Steiner (Ann Arbor, Mich.: Rackham Humanities Series, 1981).

76. Uspenskij, *A Poetics of Composition: The Structure of the Artistic Text and Typology of Compositional Form,* trans. Valentina Zavarin and Susan Wittig (Berkeley: University of California Press, 1973), p. 57.

77. Luce Marinetti Barbi, "Marinetti and Futurism," *Structuralist* 12 (1972–73): 52.

78. Richards, *Principles of Literary Criticism* (London: Kegan Paul, 1924), p. 84.

79. Arnheim, *Visual Thinking* (Berkeley: University of California Press, 1969), pp. 44–54.

80. Steinberg, "Other Criteria," *Other Criteria* (New York: Oxford University Press, 1972), p. 77.

81. This fact led Goethe to distinguish between them and what he considered the three literary universals. As Claudio Guillén explains, "Allegory, the ballad, the drama, the elegy, the epistle, the fable, the idyll, the ode, the novel, parody, the

romance, satire, and several others, Goethe thought, are merely *Dichtarten*—poetic kinds, species, or modes. They compose a miscellaneous group, as some of them seem to be named after their content, others after external aspects, and only a few according to their 'essential form.' . . . These kinds or modes should not be confused with the three basic 'natural forms,' . . . the epic (or narrative), the lyric, and the drama. . . . The genres, one might say, are contingent, because they are a function of historical change, and of the character and development of nations: only the archetypal inner forms are 'necessary' " (*Literature as System* [Princeton, N.J.: Princeton University Press, 1971], pp. 115–16).

82. Michel Foucault, *Les Mots et les choses* (Paris: Gallimard, 1966).

83. John Passmore, "History of Art and History of Literature: A Commentary," *New Literary History* 3 (spring 1972): 576.

84. See my "Language as Process: Sergej Karcevskij's Semiotics of Language," in *Sound, Sign, and Meaning,* ed. L. Matejka (Ann Arbor, Mich.: Michigan Slavic Materials, 1976) for the source of this conception of sign function. It is developed at greater length in chaps. 2 and 3 here.

85. Williams, *Paterson* (New York: New Directions, 1963), p. 170.

86. Riddel, *The Inverted Bell* (Baton Rouge, La.: Louisiana State University Press, 1974), p. 158. See also p. 162: Williams recalls "the poet to his 'virgin purpose, / the language' . . . and thus to a search for 'virtue' (perhaps, also, *virtu*). Virtue is the 'complex reward in all / languages, achieved slowly' . . . , an 'effort' ('*La Vertue / est toute dans l'effort*' goes the 'legend' baked into the 'Venerian scallop' ashtray), an effort which 'takes connivance / takes convoluted forms, takes time' 'Time' is the problematic, for time is the deprivation of vírtue. Like language, time is brought into question by 'thought.' Time is the measure of lost innocence. To rediscover language is to recall the original time of 'legend,' enwrapped in the 'sea-shell.'"

87. This is perhaps what causes Jerome Mazzaro to refer to the "androgynous" element of Williams's notion of creativity, *William Carlos Williams: The Later Poems* (Ithaca and London: Cornell University Press, 1973), p. 122.

88. Williams, *Imaginations,* ed. Webster Schott (New York: New Directions, 1970), p. 312.

89. Stuart Davis's "compositions, Williams' *I Wanted to Write a Poem* (1958) asserts, were doing 'graphically exactly what I was trying to do in words'" (Mazzaro, *Williams,* p. 42).

90. Williams, *Autobiography* (New York: Random House, 1951), p. 380.

91. For example, Joel Conarroe, "The Measured Dance: Williams' 'Pictures from Brueghel,'" *Journal of Modern Literature* 1 (May 1971): 572: "In finding words to fit the painting, Williams again makes no attempt to discover meaning or message. He does not interpret, but simply records, letting his eye move over the various details

(though the selection itself is a kind of interpretation), allowing the things to evoke their own resonance. He focuses, as is his wont, on the telling detail, the things one is likely to look at but not actually see, i.e., the broken hinge, the crucifix between the antlers of the stag, and the bush in the foreground, used to 'complete the picture.' As the emphasis on this last image suggests, it is the composition of the work that primarily concerns him."

92. Roger H. Marijnissen, *Bruegel* (New York: Putnam, 1971), p. 238.

93. F. Grossman, *Pieter Bruegel* (London: Phaidon, 1973), p. 47.

94. Erwin Panofsky, *Early Netherlandish Painting* (Cambridge, Mass.: Harvard University Press, 1953), pp. 33–34.

95. Fritz Novotný, *Die Monatsbilder Pieter Bruegels d. A.,* noted in Grossman, p. 49.

96. Robert Hughes, *The Complete Paintings of Bruegel* (London: Weidenfeld & Nicolson, 1969), p. 6: "In Bruegel, nature is dominant and man must survive in it as best he can. The blackened red silhouettes of *The Hunters in the Snow,* the numb peasants pollarding trees in the foreground of *Dark Day,* exist on not quite equal terms with clouds, rocks, snow, magpies, and thatched roofs. . . . At a time when most Italian artists (and Flemish, working *all'Italiana*) were painting monumental figures within a controlled and usually shallow, pictorial space, Bruegel widened the lens, raised the eyeline, thrust his perspective towards an engulfing horizon and dispensed with the grand manner. His people—ants on the far snow—are barely more than events within nature."

97. Coincidentally, a similar dispute has arisen about Williams's *Paterson,* which announces a correspondence between each of the first four books and one of the seasons, but seems not to follow through on it; see Conarroe, "The Measured Dance," p. 568; Louis Martz, "*Paterson:* A Plan for Action," *Journal of Modern Literature* 1 (May 1971): 513; and Riddel, *The Inverted Bell,* p. 140.

98. "The winter scene of the series most probably represents January, as its iconography agrees most fully with that of this month in representations of the *Labors of the Months* in the calendars of the illuminated books of the 15th and 16th centuries. . . . However, it is characteristic that while he retained motifs from these sources, he used them freely and occasionally altered them considerably," as, e.g., January is usually represented by a rabbit hunt rather than a fox hunt (Wolfgang Stechow, *Pieter Bruegel the Elder* [New York: Harry N. Abrams, 1970], p. 96).

99. Schapiro, "On Some Problems," pp. 235–36: "The [relative] sizes of things in a picture express a conception that requires no knowledge of a rule for its understanding. The association of style and a scale of value is already given in language: the words for superlatives of a human quality are often terms of size—greatest, highest, etc., even when applied to such intangibles as wisdom or love. . . . In the

perspective system the virtually largest figure may be an *accessory* one in the fore-
ground and the noblest personages may appear quite small. This is a reversal of the
normal etiquette of picture space in which the powerful individual is often repre-
sented as a large figure elevated above the smaller figures around him."

100. Several critics claim that Brueghel was mixing Italian landscape with the
Flemish in this painting.

101. Brueghel's name has become a term for 'wild confusion' in Czech *(brajgl)*,
for just such scenes of complex and uncentered detail.

102. See "The Pot of Flowers," for example, based on Charles Demuth's
"Tuberoses" in *Spring and All,* discussed in James E. Breslin, "William Carlos
Williams and Charles Demuth: Cross-Fertilization in the Arts," *Journal of Modern
Literature* 6 (April 1977): 248–63.

103. See the discussion of Uspenskij above on pp. 61–62; for Bakhtin, see Mikhail
Bakhtin, *Problems of Dostoevsky's Poetics* (Ann Arbor, Mich.: Ardis, 1973).

104. Huxley, *Essays New and Old* (New York: H. W. Wilson, 1932), pp. 65–66.

105. See Noton and Stark, "Eye Movements," p. 37, for a discussion of foci of
information in pictures.

106. Williams, *Collected Later Poems* (Norfolk, Conn.: New Directions, 1963), p.
5.

Two
Nonsense

1. Quoted in Edward Casey, "Truth in Art," *Man and World* 3 (November 1970):
355.

2. Heidegger, "Hölderlin and the Essence of Poetry," *Existence and Being,* trans.
Douglas Scott (Chicago: University of Chicago Press, 1949), p. 281, quoted in
Gerald L. Bruns, *Modern Poetry and the Idea of Language* (New Haven, Conn.: Yale
University Press, 1974), p. 216.

3. This notion is most influentially presented in Ferdinand de Saussure, *Course in
General Linguistics,* trans. Wade Baskin (New York: McGraw-Hill, 1966), pp. 67–70.

4. Breton, *Manifestoes of Surrealism* (Ann Arbor, Mich.: University of Michigan
Press, 1972), p. 37.

5. Susan Stewart, *Nonsense: Aspects of Intertextuality in Folklore and Literature* (Bal-
timore: Johns Hopkins University Press, 1979), p. 40: "The rules for conceiving
reality are constantly in process. Once other levels of living become readily in-
corporated into the everyday lifeworld, once they are taken for granted, they be-
come, so to speak, 'dead metaphors.' In this is the profound ring of Jacques

Ehrmann's point that 'the distinguishing characteristic of reality is that it is played.'"

6. The terms for the various classes of literature are inevitably unsatisfactory. The structuralist use of "poetry" for all verbal art but nonfiction has not yet overcome our sense of the formal limitations of poetry. And correspondingly, Barbara Herrnstein Smith's use of "fiction" (*On the Margins of Discourse* [Chicago: University of Chicago Press, 1978]) has not become current, for many critics balk at the thought of terming poetry "fiction." The modernist onslaught on the very categories of fiction and nonfiction has exacerbated the situation. I shall use "nonfiction prose" in opposition to "poetry" or "literary art" and hope for a day when such clumsiness will be unnecessary.

7. Eliot, "The Metaphysical Poets," *Selected Essays,* new ed. (New York: Harcourt, Brace, 1950). Robert W. Stallman, in "The New Critics," *Critiques and Essays in Criticism,* ed. R. W. Stallman (New York: Ronald Press, 1949), pp. 488 and 492, finds the belief in the dissociation of sensibility the common feature of the New Critics.

8. Ransom, *The World's Body* (Baton Rouge, La.: Lousiana State University Press, 1968).

9. See my article, "The Case for Unclear Thinking: Charles Morris Versus the New Critics," *Critical Inquiry* 6 (winter 1979): 257–69.

10. Brooks, *Modern Poetry and the Tradition* (Chapel Hill, N.C.: University of North Carolina Press, 1935), p. 52.

11. Thomas Sprat, *The History of the Royal-Society of London* (London, 1667), p. 113.

12. A. C. Howell, "*Res et Verba:* Words and Things," *Journal of English Literary History* 13 (1946): 131.

13. Francis Bacon, *The Advancement of Learning and The New Atlantis,* ed. Arthur Johnston (Oxford: Clarendon Press, 1974), p. 26.

14. Francis Bacon, *Novum Organon or True Suggestions for the Interpretation of Nature* (London and New York, 1893), pp. 224–25.

15. G. A. Padley, *Grammatical Theory in Western Europe, 1500–1700: The Latin Tradition* (Cambridge: Cambridge University Press, 1976), p. 140.

16. Fenollosa, *The Chinese Written Character as a Medium of Poetry,* ed. Ezra Pound (San Francisco: City Lights Books, 1936).

17. Joyce, *Ulysses* (New York: Vintage, 1966), p. 38.

18. Hulme, "Romanticism and Classicism," *Speculations* (New York: Harcourt, Brace, 1924), p. 131.

19. Benjamin De Mott, "The Sources and Development of John Wilkins' Philosophical Language," *Journal of English and Germanic Philology* 57 (1958): 2.

20. Ogden and Richards, *The Meaning of Meaning* (New York: Harcourt, Brace, 1938), p. 108.

21. Merleau-Ponty, *La Prose du monde* (Paris: Gallimard, 1969), pp. 12–13 (my translation here and throughout). The notion of a universal language is parodied in *Gulliver's Travels,* where Gulliver visits a Laputan Academy in which a scholar has constructed a wooden frame composed of all the words of his language, which can be mechanically rearranged to produce everchanging word strings. By writing down the strings that seem significant, a student is meant to acquire all of knowledge—provided he has the time to discover it in this way.

22. Karcevskij, "Introduction à l'étude de l'interjection," *Cahiers Ferdinand de Saussure* (Geneva: Librarie Droz, 1941), pp. 57–58 (my translation here and throughout for Karcevskij).

23. Karcevskij, "Du dualisme asymétrique du signe linguistique," *Travaux du Cercle linguistique de Prague* 1 (1929): 93. For a more detailed presentation of Karcevskij's theory, see my "Language as Process: Sergej Karcevskij's Semiotics of Language," *Sound, Sign, and Meaning,* ed. L. Matejka (Ann Arbor, Mich.: Michigan Slavic Materials, 1976).

24. Jonathan Swift, *Gulliver's Travels* (London: John Johnson, 1927), p. 256: "since Words are only Names for *Things,* it would be more convenient for all Men to carry about them, such *Things* as were necessary to express the particular Business they are to discourse on . . . which hath only this Inconvenience attending it, that if a Mans Business be very great, and of various kinds, he must be obliged in Proportion to carry a great bundle of *Things* upon his Back. . . . I have often beheld two of those Sages almost sinking under the Weight of their Packs."

25. Carroll, *Complete Works* (New York: Vintage, 1976), pp. 35–42.

26. Robert D. Sutherland, *Language and Lewis Carroll* (The Hague: Mouton, 1970), p. 188.

27. Karcevskij, *Système du verbe russe* (Prague: Plamja, 1927), p. 15.

28. Sanda Golopentia Eretescu, "Formalized Languages: Scientific," *Current Trends in Linguistics,* ed. Thomas A. Sebeok (The Hague: Mouton, 1974), 12: 550–51.

29. Second edition, Washington, D.C., 1974.

30. See Walter Ong, *Ramus: Method and the Decay of Dialogue* (Cambridge, Mass.: Harvard University Press, 1958).

31. See František Daneš, ed., *Papers on Functional Sentence Perspective* (Marienbad: Mouton, 1974). Jan Mukařovský develops a similar conception of dialogue in "Dialogue and Monologue," *The Word and Verbal Art,* ed. and trans. John Burbank and Peter Steiner (New Haven, Conn.: Yale University Press, 1977), pp. 81–111.

32. Peirce, *Collected Papers* 4 (Cambridge, Mass.: Harvard University Press, 1933): 6, and 6 (1935): 338.

33. Wilbur Samuel Howell, *Logic and Rhetoric in England, 1500–1700* (New York: Russell &Russell, 1956), p. 374.

34. Robert Adolph hints at this danger when he writes: "For Bacon, the aphoristic style was also the *clearest*. . . . Ultimately, though, a style which duplicates thought processes most closely is obscure—closer to *Ulysses* or *Finnegans Wake* . . . than to anything in Bacon," *The Rise of Modern Prose Style* (Cambridge, Mass.: M.I.T. Press, 1968), p. 56. Joyce's two later works are in fact very aphoristic in their elimination of discursive connection.

35. Bentham, *Theory of Fictions,* ed. C. K. Ogden (New York: Harcourt, Brace, 1932).

36. Searle, "The Logical Status of Fictional Discourse," *New Literary History* 6 (winter 1975): 325.

37. W. K. Wimsatt, Jr., and M. C. Beardsley, "The Intentional Fallacy," *The Verbal Icon* (Lexington, Ky.: University of Kentucky Press, 1954), pp. 3–18.

38. Tuve, "Imagery and Logic: Ramus and Metaphysical Poetics," *Journal of the History of Ideas* 3 (October 1942): 370.

39. Archibald MacLeish, "Ars Poetica," ll. 23–24, *Collected Poems, 1917–1952* (Boston: Houghton Mifflin, 1952).

40. Brooks, *Modern Poetry and the Tradition,* p. 263.

41. Brooks, "Irony as a Principle of Structure," in Stallman, ed., *Critiques and Essays in Criticism,* p. 731. I have argued in "The Case for Unclear Thinking" that every New Critical depiction of poetry involves this combinatory quality, from Wimsatt's "concrete universal" to Tate's "tension."

42. Booth, *The Rhetoric of Fiction* (Chicago: University of Chicago Press, 1961), p. 16.

43. In Thomas A. Sebeok, ed., *Style in Language* (Cambridge, Mass.: M.I.T. Press, 1960), pp. 353, 357.

44. Victor Sklovskij, "Sterne's *Tristram Shandy:* Stylistic Commentary," in *Russian Formalist Criticism,* ed. Lee T. Lemon and Marion J. Reis (Lincoln, Neb.: University of Nebraska Press, 1965), pp. 25–57.

45. A. C. Baier, "Nonsense," *Encyclopedia of Philosophy* (New York: Macmillan, 1967), p. 520.

46. David Bland, *A History of Book Illustration* (Berkeley: University of California Press, 1969), p. 25.

47. Nelson Goodman, *The Languages of Art* (Indianapolis: Indiana University Press, 1968).

48. Todorov, *The Fantastic: A Structural Approach to a Literary Genre* (Cleveland: Press of Case Western Reserve University, 1973), pp. 120, 139–55.

49. See Roman Jakobson, "Visual and Auditory Signs," *Selected Writings,* vol. 2: *Word and Language* (The Hague: Mouton, 1971), p. 336.

50. Wimsatt, "In Search of Verbal Mimesis," *Day of the Leopards* (New Haven, Conn.: Yale University Press, 1976), p. 61.

51. Breton, *Nadja,* trans. Richard Howard (New York: Grove, 1960), pp. 151–52.

52. Gorey, *Amphigorey* (New York: Berkley Publishing, 1972).

53. Empson, *Some Versions of Pastoral* (London: Chatto & Windus, 1950), p. 257.

54. Robbe-Grillet, *For a New Novel,* trans. Richard Howard (New York: Grove, 1965), p. 164.

55. Fermor, "The Art of Nonsense," *Times Literary Supplement,* 28 Jan. 1977, p. 105.

56. Pritchett, "Lear's Inner Landscape," *New York Review of Books,* 13 Oct. 1977, p. 5.

57. Arnheim, *Visual Thinking* (Berkeley: University of California Press, 1969), p. 44.

58. Lessing, *Laokoön, Selected Prose Works of G. E. Lessing,* ed. Edward Bell, trans. E. C. Beasley and Helen Zimmern (London: G. Bell, 1879), p. 5.

59. "Allegory does not accept doubt; its enigmas show instead an obsessive battling with doubt. It does not accept the world of experience and the senses; it thrives on their overthrow, replacing them with ideas" (Angus Fletcher, *Allegory: The Theory of a Symbolic Mode* [Ithaca, N.Y.: Cornell University Press, 1964], pp. 322–23).

60. Lavater's 8th aphorism underlined by Blake and Lavater's 201st aphorism to which Blake appended the comment "Sweet!" in "Annotations to Lavater's Aphorisms on Man," *The Complete Writings of William Blake,* ed. Geoffrey Keynes (London: Oxford University Press, 1966), pp. 65, 71.

61. Blake, "A Descriptive Catalogue of Pictures, Poetical and Historical Inventions," *Complete Writings,* p. 585.

62. Todorov isolates the fantastic at the moment of hesitation between a natural and a supernatural explanation (pp. 24–40). "The operation which consists of reconciling the possible with the impossible accurately illustrates the word 'impossible' itself. And yet literature *exists;* that is the greatest paradox" (p. 175).

63. Horace, "Ars poetica," ll.1–9, *Horace's Satires and Epistles,* trans. Jacob Fuchs (New York: W. W. Norton, 1977), p. 85.

64. Rensselaer W. Lee, *Ut Pictura Poesis* (New York: W. W. Norton, 1967), p. 35.

65. Jean Hagstrum, *The Sister Arts* (Chicago: Chicago University Press, 1958), pp. 4, 82.

66. Worth, "Pictures Can't Say Ain't," *Vs.* 12,3, (1975): 85, 105.

67. Bruno Ernst, *The Magic Mirror of M. C. Escher* (New York: Ballantine Books, 1976), p. 77.

68. Caroline H. MacGillavry, *Fantasy and Symmetry: The Periodic Drawings of M. C. Escher* (New York: Harry N. Abrams, 1976), p. ix.

Three
A Cubist Historiography

1. Matthew Arnold, "Heinrich Heine," *Works,* vol. 3: *Essays in Criticism,* ed. Robert Super (New York: AMS Press, 1920), p. 171.

2. Heinrich Wölfflin, *Renaissance and Baroque,* trans. Kathrin Simon (London: Fontana, 1964), pp. 79–80.

3. Georges Lemaître, *From Cubism to Surrealism in French Literature* (Cambridge, Mass.: Harvard University Press, 1941), pp. 71–72.

4. Bram Dykstra, *The Hieroglyphics of a New Speech: Cubism, Stieglitz, and the Early Poetry of William Carlos Williams* (Princeton, N.J.: Princeton University Press, 1969), pp. 13–14.

5. Wylie Sypher, *Rococo to Cubism in Art and Literature* (New York: Random House, 1960), pp. xx–xxi.

6. Claudio Guillén, *Literature as System: Essays toward the Theory of Literary History* (Princeton, N.J.: Princeton University Press, 1971), pp. 331–32.

7. Gerald Kamber, *Max Jacob and the Poetics of Cubism* (Baltimore and London: Johns Hopkins University Press, 1971), p. 24; Elly Jaffé-Freem, *Alain Robbe-Grillet et la peinture cubiste* (Amsterdam: J. M. Meulenhoff, 1966), p. 71; Wendy Steiner, *Exact Resemblance to Exact Resemblance: The Literary Portraiture of Gertrude Stein* (New Haven, Conn.: Yale University Press, 1978), pp. 144–45, 158.

8. Hugh Kenner, *The Pound Era* (Berkeley: University of California Press: 1971), pp. 140–41.

9. James Breslin, "William Carlos Williams and Charles Demuth: Cross-Fertilization in the Arts," *Journal of Modern Literature* 6 (April 1977): 254.

10. Timothy Materer, *Vortex: Pound, Eliot, and Lewis* (Ithaca N.Y.: Cornell University Press, 1979), p. 162; Dykstra, *Hieroglyphics of a New Speech,* p. 102.

11. Mukařovský, *Structure, Sign, and Function: Selected Essays by Jan Mukařovský,* trans. and ed., John Burbank and Peter Steiner (New Haven, Conn.: Yale University Press, 1978), pp. 129–49.

12. For a summary of this debate, see Frank J. Warnke, *Versions of Baroque: European Literature in the Seventeenth Century* (New Haven, Conn.: Yale University Press, 1972), chap. 1, and René Wellek, "The Concept of the Baroque," *Concepts of Criticism* (New Haven, Conn.: Yale University Press, 1963), pp. 69–114.

13. Walzel, "Shakespeares dramatische Baukunst," *Jahrbuch der Shakespearegesellschaft* 52 (1916): 3–35.

14. I. A. Richards, *Practical Criticism* (London: Kegan Paul, 1928).

15. Giambattisto Vico, *The New Science,* trans. Thomas Goddard Bergin and Max Harold Fisch (Ithaca, N.Y.: Cornell University Press, 1968), pp. 22–23, 75.

16. Mario Praz, *Mnemosyne* (Princeton, N.J.: Princeton University Press, 1970).

17. T. S. Eliot, "The Metaphysical Poets," *Selected Essays,* new ed. (New York: Harcourt, Brace, 1950), p. 247.

18. Ernest Gilman, *The Curious Perspective* (New Haven, Conn.: Yale University Press, 1978), p. 14.

19. Arthur O. Lovejoy did "deconstruct" the term romanticism in "On the Discrimination of Romanticisms," *PMLA* 29 (1924): 229–53, and Wellek in turn tried to resurrect it in "The Concept of Romanticism in Literary History," *Concepts of Criticism,* pp. 128–98. Neither has had much effect on the critical usage of the term.

20. "Tuer l'art est ce qui me paraît le plus urgent," quoted by Michel Sanouillet, "Dada à Paris," *Cahiers: Dada et surréalisme* 1 (1966): 16.

21. Renato Poggioli, *The Theory of the Avant-Garde* (Cambridge, Mass.: Harvard University Press, Belknap Press, 1968), p. 52.

22. Thomas S. Kuhn, *The Structure of Scientific Revolutions* (Chicago: University of Chicago Press, 1962), p. 160.

23. Kuhn, of course, would not consider painting a field capable of having paradigms in the strict sense of the word, since it, unlike the sciences, does not have a well-governed community of practitioners who accept the paradigm by operating within its assumptions and enforcing it among their students. Though such single-mindedness and its institutions do not exist outside science proper, artists do tend to be controlled by a leading set of questions, insofar as they understand them. Moreover, the militance and programmatic nature of so much modern art imply that artists thought of their activity and tried to present it to the world as a new paradigm, an approach for which they sought the consensus of the community of practitioners and consumers.

24. Williams, *Autobiography* (New York: Random House, 1951), p. 148.

25. Gertrude Stein, *The Autobiography of Alice B. Toklas* (New York: Random House, 1933), pp. 89, 123–24.

26. Eliot, *The Sacred Wood* (London: Methuen, 1920), p. 49.

27. Ernest Fenollosa, *The Chinese Written Character as a Medium for Poetry,* ed. Ezra Pound (San Francisco: City Lights Books, 1936), p. 10.

28. Ezra Pound, *A Memoir of Gaudier-Brzeska* (New York: New Directions, 1970), p. 86.

29. Harold Bloom, *The Anxiety of Influence* (London: Oxford University Press, 1973), p. 51.

30. Roman Jakobson and Jurij Tynjanov, "Problems in the Study of Literature and Language," trans. Herbert Eagle, in *Readings in Russian Poetics: Formalist and Structuralist Views,* ed. Ladislav Matejka and Kristyna Pomorska (Cambridge, Mass.: M.I.T. Press, 1971), pp. 79–80.

31. Elmar Holenstein, *Roman Jakobson's Approach to Language; Phenomenological Structuralism* (Bloomington, Ind.: Indiana University Press, 1976), pp. 30–31.

32. Felix Vodička, "Literárně-historické studium ohlasu literárních děl," *Slovo a slovesnost* 7 (1941): 118.

33. Hayden White, "Historical Text as Literary Artifact," in *The Writing of History,* ed. Robert H. Canary and Henry Kozicki (Madison, Wis.: University of Wisconsin Press, 1978), pp. 49–50.

34. T. E. Hulme, "Romanticism and Classicism," *Speculations: Essays on Humanism and the Philosophy of Art,* ed. Herbert Read (New York: Harcourt, Brace, 1924), p. 131; MacLeish, "Ars Poetica," ll. 23–24, *Collected Poems 1917–1952* (Boston: Houghton Mifflin, 1952); Ernest Fenollosa, *The Chinese Written Character as a Medium for Poetry,* p. 9.

35. John Crowe Ransom, *The World's Body* (Baton Rouge, La.: Louisiana State University Press, 1938), pp. 113–20.

36. Augusto de Campos, Heraldo de Campos, Décio Pignatari, "Pilot Plan for Concrete Poetry," *Structurist* 12 (1972–73): 56.

37. Charles Morris, "Esthetics and the Theory of Signs," *Journal of Unified Science* 8 (1939): 136.

38. For example, Umberto Eco, after discarding a "shared properties" theory of iconicity (as suggested, he claims, in Morris), settles for a "shared relations" theory: "le signe iconique construit un modèle de relations (entre phénomènes graphiques) homologue au modèle de relations perceptives que nous construisons en connaissant et en nous rappelant l'objet. Si le signe a des propriétés communes avec quelque chose, il les a non avec l'objet, mais avec le modèle perceptif de l'objet; it est constructible et reconnaissable d'après les mêmes opérations mentales que nous accomplissons pour construire le perçu, indépendamment de la matière dans laquelle ces relations se réalisent" (Eco, "Sémiologie des messages visuels," *Communications* 15 [1970]: 21).

39. "The pointer between *M* and *O*, Bense's 'Mittel' standing for 'material "means"' and the 'object,' goes both ways to indicate the immediacy between the two [see above]. . . . The iconic triad therefore represents *object-relations* that must originate with their material foundation in the constitution of the Concrete poem. These object-relations function as the *connective* on the basis of which the full interpretant-relations can go into effect" (Liselotte Gumpel, *"Concrete" Poetry from East and West Germany* [New Haven, Conn.: Yale University Press, 1976], p. 65).

It is interesting, however, that for a large number of concretists, "semiotic" is understood very narrowly as pertaining to semaphor and other specialized sign codes. Typically, this notion is manifested in poems with a legend or vocabulary appended to acquaint the viewer with the code concocted by the artist. The Invençao group of Brazil produces such poems, and several Japanese poets exploit the pictogram similarly. An amusing example of this approach is Furnival's "Semiotic Folk Poem" (fig. 40) in which iconic signs for "laddie," "lassie," and "rye" are used to translate into a visual sequence the Scottish song, "Coming through the Rye"; Ian Hamilton Finlay has also tried his hand at a "Semi-Idiotic Poem" (fig. 41).

40. Quoted in Mary Ellen Solt, "A World Look at Concrete Poetry," in *Concrete Poetry: A World View,* ed. Mary Ellen Solt (Bloomington, Ind.: Indiana University Press, 1968), p. 10.

41. Lessing, *Laokoön, Selected Prose Works of G. E. Lessing,* ed. Edward Bell (London: G. Bell, 1879), p. 91.

42. See the discussion in P. Steiner and W. Steiner, "The Axes of Poetic Language," in *Language, Literature, and Meaning,* vol. 1: *Problems of Literary Theory,* ed. John Odmark (Amsterdam: John Benjamins, 1979).

43. "Sequential perception . . . characterizes experience in all aesthetic media, the spatial as well as the temporal ones. What distinguishes the media in this respect is that in music, literature, film, etc., the sequence is inherent in the presentation and is therefore imposed as a constraint upon the consumer. In the timeless arts of painting, sculpture, and architecture the sequence pertains to the process of apprehension only: it is subjective, arbitrary, and alien to the structure and character of the work" (Arnheim, "The Unity of the Arts: Time, Space, and Distance," *Yearbook of Comparative and General Literature* 25 [1976]: 9).

44. David Noton and Lawrence Stark, "Eye Movements and Visual Perception," *Scientific American* 224 (June 1971): 35–43.

45. Roman Jakobson, "On the Relation between Visual and Auditory Signs," *Selected Writings* 2 (The Hague: Mouton, 1971): 344: "there exists a profound dissimilarity between the spatial and temporal arts, and between spatial and temporal systems of signs in general. When the observer arrives at the simultaneous synthesis

Fig. 40.
John Furnival, "Semiotic Folk Poem,"
from Milton Klonsky, ed., *Speaking
Pictures*

Fig. 41.
Ian Hamilton Finlay, "Semi-Idiotic
Poem," from Emmett Williams, ed.,
Anthology of Concrete Poetry

of a contemplated painting, the painting as a whole remains before his eyes, it is still present; but when the listener reaches a synthesis of what he has heard, the phonemes have in fact already vanished. They survive as mere afterimages, somewhat abridged reminiscences, and this creates an essential difference between the two types of perception and percepts."

46. See Miroslav Cervenka, "The Literary Artifact," *The Sign in Music and Literature*, ed. Wendy Steiner, (Austin: Texas University Press, 1981).

47. Gerald L. Bruns, "Mallarmé: The Transcendence of Language and the Aesthetics of the Book," *Journal of Typographical Research* 3 (July 1969): 228.

48. Jacques Derrida, *Of Grammatology* (Baltimore and London: Johns Hopkins University Press, 1974), p. 25.

49. See Derrida, *Of Grammatology*, p. 292; James Bunn, "Circle and Sequence in the Conjectural Lyric," *New Literary History* 3 (spring 1972): 511–26.

50. Sergej Karcevskij, "Du dualisme asymétrique du signe linguistique," *Travaux du Cercle linguistique de Prague* 1 (1929): 93.

51. Augusto de Campos, "The Concrete Coin of Speech" *Structurist* 12 (1972–73): 61.

52. Lewis Carroll, *Complete Works* (New York: Vintage, 1976), p. 1274.

53. Is this perhaps a play on the Duchess's motto, "Take care of the sense, and the sounds will take care of themselves!" in *Alice's Adventures in Wonderland*, a further development in the parody of the plain style (see pp. 102–3)?

54. Hans Arp, "Concrete Art," in *The Modern Tradition*, ed. Richard Ellmann and Charles Feidelson (Oxford and New York: Oxford University Press, 1965), p. 53.

Bibliography

Abrams, M. H. *The Mirror and the Lamp*. New York: Oxford University Press, 1953.

Adolph, Robert. *The Rise of Modern Prose Style*. Cambridge, Mass.: M.I.T. Press, 1968.

Alpers, Svetlana, and Alpers, Paul. "Ut Pictura Noesis? Criticism in Literary Studies and Art History." *New Literary History* 3 (spring 1972): 437–58.

Apollinaire, Guillaume. "Pure Painting" (from *Cubist Painters*). In *The Modern Tradition*. Edited by Richard Ellmann and Charles Feidelson. Oxford and New York: Oxford University Press, 1965.

Arnheim, Rudolf. *Visual Thinking*. Berkeley: University of California Press, 1969.

———. "Visual Aspects of Concrete Poetry." *Yearbook of Comparative Criticism* 7 (1976): 91–109.

———. "The Unity of the Arts: Time, Space, and Distance." *Yearbook of Comparative and General Literature* 25 (1976): 7–14.

Arnold, Matthew. "Heinrich Heine." *The Works of Matthew Arnold,* vol. 3: *Essays in Criticism*. Edited by Robert Super. New York: AMS Press, 1970.

Arp, Hans. "Concrete Art." In *The Modern Tradition*. Edited by Richard Ellmann and Charles Feidelson. Oxford and New York: Oxford University Press, 1965.

Augustine, Saint. *Confessions*. Translated by Edward B. Pusey. New York: Cardinal, 1951.

Babbitt, Irving. *The New Laokoön: An Essay on the Confusion of the Arts*. Boston and New York: Houghton Mifflin, 1910.

Bacon, Francis. *The Advancement of Learning and The New Atlantis*. Edited by Arthur Johnston. Oxford: Clarendon Press, 1974.

———. *Novum Organon for True Suggestions for the Interpretation of Nature*. London and New York, 1893.

Baier, A. C. "Nonsense." *Encyclopedia of Philosophy*. New York: Macmillan, 1967.

Bakhtin, Mikhail. *Problems of Dostoevsky's Poetics*. Ann Arbor, Mich.: Ardis, 1973.

Barbi, Luce Marinetti. "Marinetti and Futurism." *Structurist* 12 (1972–73): 51–56.

Barthes, Roland. *Eléments de sémiologie*. Paris: Seuil, 1964.

Bentham, Jeremy. *Theory of Fictions*. Edited by C. K. Ogden. New York: Harcourt, Brace, 1932.

Birdwhistell, Ray L. *Introduction to Kinesics*. Louisville, Ky.: University of Kentucky Press, 1952.

Black, Max. *Models and Metaphors*. Ithaca, N.Y.: Cornell University Press, 1962.

Blake, William. *The Complete Writings of William Blake*. Edited by Geoffrey Keynes. London: Oxford University Press, 1966.

Bland, David. *A History of Book Illustration*. Berkeley: University of California Press, 1969.

Bloom, Harold. *The Anxiety of Influence.* London: Oxford University Press, 1973.

Booth, Wayne. *The Rhetoric of Fiction.* Chicago: Chicago University Press, 1961.

Breslin, James. "William Carlos Williams and Charles Demuth: Cross-Fertilization in the Arts." *Journal of Modern Literature* 6 (April 1977): 248–63.

Breton, André. *Manifestoes of Surrealism.* Ann Arbor, Mich.: University of Michigan Press, 1972.

———. *Nadja.* Translated by Richard Howard. New York: Grove Press, 1960.

Brooks, Cleanth. *Modern Poetry and the Tradition.* Chapel Hill, N.C.: University of North Carolina Press, 1935.

Bruns, Gerald L. "Mallarmé: The Transcendence of Language and the Aesthetics of the Book." *Journal of Typographical Research* 3 (July 1969): 219–40.

———. *Modern Poetry and the Idea of Language.* New Haven, Conn.: Yale University Press, 1974.

Bunn, James. "Circle and Sequence in the Conjectural Lyric." *New Literary History* 3 (spring 1972): 511–26.

Carroll, Lewis. *Complete Works.* New York: Vintage, 1976.

Casey, Edward. "Meaning in Art." In *New Essays in Phenomenology.* Edited by James Edie. Chicago: Quadrangle, 1969.

———. "Truth in Art." *Man and World* 3 (November 1970): 351–69.

———. "Expression and Communication in Art." *Journal of Aesthetics and Art Criticism* 30 (winter 1971): 197–208.

Cervenka, Miroslav. "The Literary Artifact." In *The Sign in Music and Literature.* Edited by Wendy Steiner. Austin: Texas University Press, 1981.

Conarroe, Joel. "The Measured Dance: Williams' 'Pictures from Brueghel.'" *Journal of Modern Literature* 1 (May 1971): 565–77.

Cummings, E. E. *One Hundred Selected Poems.* New York: Grove, 1923.

Daneš, František, ed. *Papers on Functional Sentence Perspective.* The Hague: Mouton, 1974.

de Campos, Augusto. "The Concrete Coin of Speech." *Structurist* 12 (1972–73): 57–61.

de Campos, Augusto; de Campos, Heraldo; and Pignatari, Décio. "Pilot Plan for Concrete Poetry." *Structurist* 12 (1972–73): 56.

De Mott, Benjamin. "The Sources and Development of John Wilkins' Philosophical Language." *Journal of English and Germanic Philology* 57 (1958): 1–13.

Derrida, Jacques. *Speech and Phenomena and Other Essays on Husserl's Theory of Signs.* Evanston, Ill.: Northwestern University Press, 1973.

———. *Of Grammatology.* Baltimore and London: Johns Hopkins University Press, 1974.

Dryden, John. *The Works of John Dryden.* Edited by Walter Scott. London: William Miller, 1808.

Dykstra, Bram. *The Hieroglyphics of a New Speech: Cubism, Stieglitz, and the Early Poetry of William Carlos Williams.* Princeton, N.J.: Princeton University Press, 1969.

Eco, Umberto. "Sémiologie des messages visuels." *Communications* 15 (1970): 11–51.

Eisenstein, Sergei. "Colour and Meaning." *Film Sense.* Translated by Jay Leyda. London: Faber, 1948.

Eliot, T. S. *The Sacred Wood.* London: Methuen, 1920.

———. "The Metaphysical Poets." *Selected Essays.* New edition. New York: Harcourt, Brace, 1950.

Empson, William. *Some Versions of Pastoral.* London: Chatto & Windus, 1950.

Eretescu, Sanda Golopentia. "Formalized Languages: Scientific." In *Current Trends in Linguistics,* vol 12. Edited by Thomas A. Sebeok. The Hague: Mouton, 1974.

Ernst, Bruno. *The Magic Mirror of M. C. Escher.* New York: Ballantine Books, 1976.

Fenollosa, Ernest. *The Chinese Written Character as a Medium for Poetry.* Edited by Ezra Pound. San Francisco: City Lights Books, 1936.

Fermor, Patrick Leigh. "The Art of Nonsense." *Times Literary Supplement,* 28 January 1977, p. 105.

Fletcher, Angus. *Allegory: The Theory of a Symbolic Mode.* Ithaca, N.Y.: Cornell University Press, 1964.

Foucault, Michel. *Les Mots et les choses.* Paris: Gallimard, 1966.

Fowler, Alistair. "Periodization and Interart Analogues." *New Literary History* 3 (spring 1972): 487–510.

Frank, Joseph. "Spatial Form in Modern Literature." *The Widening Gyre.* New Brunswick, N.J.: Rutgers University Press, 1963.

Genette, Gérard. *Mimologiques: Voyage en Cratylis.* Paris: Seuil, 1976.

Gilman, Ernest. *The Curious Perspective.* New Haven, Conn.: Yale University Press, 1978.

Goethe, E. *Dichtung und Wahrheit* 8. Translated by Minna Smith. London: G. Bell, 1908.

Gombrich, E. H. "Image and Code: Scope and Limits of Conventionalism in Pictorial Representation." In *Image and Code.* Edited by Wendy Steiner. Ann Arbor, Mich.: Rackham Humanities Series, 1981.

Gombrich, E. H.; Hochberg, Julian; and Black, Max. *Art, Perception, and Reality.* Baltimore: Johns Hopkins University Press, 1972.

Goodman, Nelson. *The Languages of Art.* Indianapolis: Indiana University Press, 1968.

Gorey, Edward. *Amphigorey.* New York: Berkley Publishing, 1972.

Guillén, Claudio. *Literature as System: Essays toward the Theory of Literary History.* Princeton, N.J.: Princeton University Press, 1971.

Gumpel, Liselotte. *"Concrete" Poetry from East and West Germany.* New Haven, Conn.: Yale University Press, 1976.

Hagstrum, Jean. *The Sister Arts: The Tradition of Literary Pictorialism and English Poetry from Dryden to Gray.* Chicago: University of Chicago Press, 1958.

Hankiss, Elemér. "Semantic Oscillation: A Universal of Artistic Expression." In *The Sign in Music and Literature.* Edited by Wendy Steiner. Austin: Texas University Press, 1981.

Holenstein, Elmar. *Roman Jakobson's Approach to Language: Phenomenological Structuralism.* Bloomington, Ind.: Indiana University Press, 1976.

Horace. "Ars Poetica." *Horace's Satires and Epistles.* Translated by Jacob Fuchs. New York: W. W. Norton, 1977.

Howell, A. C. *"Res et Verba:* Words and Things." *Journal of English Literary History* 13 (1946): 131–42.

Howell, Wilbur Samuel. *Logic and Rhetoric in England, 1500–1700.* New York: Russell & Russell, 1956.

Hughes, Robert. *The Complete Paintings of Bruegel.* London: Weidenfeld & Nicolson, 1969.

Hulme, T. E. "Romanticism and Classicism." *Speculations: Essays on Humanism and the Philosophy of Art.* Edited by Herbert Read. New York: Harcourt, Brace, 1924.

Husserl, Edmund. *Zur Phänomenologie des inneren Zeitbewußtsein* (1893–1917). In *Husserliana,* 10. Edited by H. L. van Breda. The Hague: M. Nijhoff, 1966.

Huxley, Aldous. *Essays New and Old.* New York: H. W. Wilson, 1932.

Ingarden, Roman. *The Literary Work of Art.* Translated by G. G. Grabowicz. Foreword by David M. Levin. Evanston, Ill.: Northwestern University Press, 1973.

Jaffé-Freem, Elly. *Alain Robbe-Grillet et la peinture cubiste.* Amsterdam: J. M. Meulenhoff, 1966.

Jakobson, Roman. "Linguistics and Poetics." In *Style in Language.* Edited by Thomas A. Sebeok. Cambridge, Mass.: M.I.T. Press, 1960.

———. "Quest for the Essence of Language." *Diogenes* 51 (1965): 21–37.

———. "The Poetry of Grammar and the Grammar of Poetry." *Lingua* 21 (1968): 597–609.

———. *Shakespeare's Verbal Art in "Th'Expense of Spirit."* The Hague: Mouton, 1970.

———. *Selected Writings,* vol. 2. The Hague: Mouton, 1971.

————. *"On Realism in Art."* Translated by K. Magassy. In *Readings in Russian Poetics: Formalist and Structuralist Views.* Edited by Ladislav Matejka and Kristyna Pomorska. Cambridge, Mass.: M.I.T Press, 1971.

Jakobson, Roman, and Tynjanov, Jurij. "Problems in the Study of Literature and Language," translated by Herbert Eagle. In *Readings in Russian Poetics: Formalist and Structuralist Views.* Edited by Ladislav Matejka and Kristyna Pomorska. Cambridge, Mass.: M.I.T. Press, 1971.

Joyce, James. *Ulysses.* New York: Vintage, 1966.

Kamber, Gerald. *Max Jacob and the Poetics of Cubism.* Baltimore and London: Johns Hopkins University Press, 1971.

Karcevskij, Sergej. "Du dualisme asymétrique du signe linguistique." *Travaux du Cercle linguistique de Prague* 1 (1929).

————. *Système du verbe russe.* Prague: Plamja, 1927.

————. "Introduction à l'étude de l'interjection." *Cahiers Ferdinand de Saussure,* 1, Geneva: Librarie Droz, 1941.

Kenner, Hugh. *The Pound Era.* Berkeley: University of California Press, 1971.

Klonsky, Milton, ed. *Speaking Pictures.* New York: Harmony Books, 1975.

Kuhn, Thomas S. *The Structure of Scientific Revolutions.* Chicago: University of Chicago Press, 1962.

Laude, Jean. "On the Analysis of Poems and Paintings." *New Literary History* 3 (spring 1972): 471–86.

Leatherdale, W. H. *The Role of Analogy, Model, and Metaphor in Science.* Amsterdam: North-Holland Publishing Co., 1974.

Lee, Rensselaer W. *Ut Pictura Poesis: The Humanistic Theory of Painting.* New York: W. W. Norton, 1967.

Lemaître, Georges. *From Cubism to Surrealism in French Literature.* Cambridge, Mass.: Harvard University Press, 1941.

Leonardo da Vinci. *Treatise on Painting,* vol. 1. Translated and annotated by A. Philip McMahon. Princeton, N.J.: Princeton University Press, 1956.

Lessing, G. E. *Selected Prose Works of G. E. Lessing.* Edited by Edward Bell, translated by E. C. Beasley and Helen Zimmern. London: G. Bell, 1879.

Lotman, Jurij. *The Structure of the Artistic Text.* Translated by Ronald Vroon. Ann Arbor, Mich.: Michigan Slavic Materials, 1977.

Lovejoy, Arthur O. "On the Discrimination of Romanticisms." *PMLA* 3 (1924): 229–53.

MacGillavry, Caroline H. *Fantasy and Symmetry: The Periodic Drawings of M. C. Escher.* Preface by M. C. Escher. New York: Harry N. Abrams, 1976.

MacLeish, Archibald. *Collected Poems, 1917–1952.* Boston: Houghton Mifflin, 1952.

Marijnissen, Roger H. *Bruegel*. New York: Putnam, 1971.

Martz, Louis. "*Paterson:* A Plan for Action." *Journal of Modern Literature* 1 (May 1971): 512–22.

Matejka, L., and Pomorska, K., eds. *Readings in Russian Poetics*. Cambridge, Mass.: M.I.T. Press, 1971.

Materer, Timothy. *Vortex: Pound, Eliot, and Lewis*. Ithaca, N.Y.: Cornell University Press, 1979.

Mazzaro, Jerome. *William Carlos Williams: The Later Poems*. Ithaca and London: Cornell University Press, 1973.

Merleau-Ponty, Maurice. *La Prose du monde*. Paris: Gallimard, 1969.

Mitchell, W. J. T. "Spatial Form in Literature." *Critical Inquiry* 6 (spring 1980): 539–67.

Morpurgo, J. E. "Introduction." *Keats*. Edited by J. E. Morpurgo. London: Penguin, 1953.

Morris, Charles. "Esthetics and the Theory of Signs." *Journal of Unified Science* 8 (1939): 131–50.

Mukařovský, Jan. *The Word and Verbal Art*. Edited and translated by John Burbank and Peter Steiner. New Haven, Conn.: Yale University Press, 1977.

———. *Structure, Sign, and Function*. Edited and translated by John Burbank and Peter Steiner. New Haven, Conn.: Yale University Press, 1978.

Nemerov, Howard. "The Painter Dreaming in the Scholar's House." *Structurist* 12 (1972–73): 38.

Noton, David, and Stark, Lawrence. "Eye Movements and Visual Perception." *Scientific American* 224 (June 1971): 34–43.

Ogden, C. W., and Richards, I. A. *The Meaning of Meaning*. New York: Harcourt, Brace, 1938.

Ong, Walter. *Ramus: Method and the Decay of Dialogue*. Cambridge, Mass.: Harvard University Press, 1958.

Padley, G. A. *Grammatical Theory in Western Europe, 1500–1700: The Latin Tradition*. Cambridge: Cambridge University Press, 1976.

Panofsky, Erwin. *Early Netherlandish Painting*. Cambridge, Mass.: Harvard University Press, 1953.

Passmore, John. "History of Art and History of Literature: A Commentary." *New Literary History* 3 (spring 1972): 575–87.

Peirce, Charles S. *Collected Papers*. Vols. 2 and 4. Cambridge, Mass.: Harvard University Press, 1932, 1977.

Poggioli, Renato. *The Theory of the Avant-Garde*. Cambridge, Mass.: Harvard University Press, Belknap Press, 1968.

Pound, Ezra. *A Memoir of Gaudier-Brzeska*. New York: New Directions, 1970.

Praz, Mario. *Mnemosyne*. Princeton, N.J.: Princeton University Press, 1970.

Pritchett, V. S. "Lear's Inner Landscape." *New York Review of Books,* 13 October 1977, pp. 5–6.

Ransom, John Crowe. *The World's Body*. Baton Rouge, La.: Louisiana State University Press, 1938.

Richards, I. A. *Principles of Literary Criticism*. London: Kegan Paul, 1924.

———. *Practical Criticism*. London: Kegan Paul, 1928.

Riddel, Joseph. *The Inverted Bell*. Baton Rouge, La.: Louisiana State University Press, 1974.

Robbe-Grillet, Alain. *For a New Novel*. Translated by Richard Howard. New York: Grove Press, 1965.

Sanouillet, Michel. "Dada à Paris." *Cahiers: Dada et surréalisme* 1 (1966): 16–30.

Sapir, Edward. *Language*. Oxford and New York: Oxford University Press, 1921.

Saussure, Ferdinand de. *Course in General Linguistics*. Translated by Wade Baskin. New York: McGraw-Hill, 1966.

Schapiro, Meyer. "On Some Problems in the Semiotics of Visual Art: Field and Vehicle in Image-Signs." *Semiotica* 1 (1969): 223–42.

———. *Words and Pictures: On the Literal and the Symbolic in the Illustration of a Text*. The Hague: Mouton, 1973.

Schweizer, Niklaus Rudolf. *The Ut Pictura Poesis Controversy in Eighteenth-Century England and Germany*. Bern and Frankfurt: Herbert Lang & Peter Lang, 1972.

Searle, John R. "The Logical Status of Fictional Discourse." *New Literary History* 6 (winter 1975): 319–32.

Sklovskij, Victor. "Sterne's *Tristram Shandy:* Stylistic Commentary." In *Russian Formalist Criticism*. Edited by Lee T. Lemon and Marion S. Reis. Lincoln, Neb.: University of Nebraska Press, 1965.

Smith, Barbara Herrnstein. *On the Margins of Discourse*. Chicago: University of Chicago Press, 1978.

Solt, Mary Ellen, ed. *Concrete Poetry: A World View*. Bloomington, Ind.: Indiana University Press, 1968.

Sprat, Thomas. *The History of the Royal-Society of London*. London, 1667.

Stallman, Robert, ed. *Critiques and Essays in Criticism*. New York: Ronald Press, 1949.

Stechow, Wolfgang. *Pieter Bruegel the Elder*. New York: Harry N. Abrams, 1970.

Stein, Gertrude. *The Autobiography of Alice B. Toklas*. New York: Random House, 1933.

Steinberg, Leo. *Other Criteria*. New York: Oxford University Press, 1972.

Steiner, Peter. "Jan Mukařovský and Charles Morris: Two Pioneers of the Semiotics of Art." *Semiotica* 19 (1977): 321–34.

Steiner, Peter, and Steiner, Wendy. "The Axes of Poetic Language." In *Language, Literature, and Meaning*, vol. 1: *Problems of Literary Theory*. Edited by John Odmark. Amsterdam: John Benjamins, 1979.

Steiner, T. R. *English Translation Theory, 1650–1800*. Amsterdam and Essen: Van Gorcum, 1975.

Steiner, Wendy. "Language as Process: Sergej Karcevskij's Semiotics of Language." In *Sound, Sign, and Meaning*. Edited by L. Matejka. Ann Arbor, Mich.: Michigan Slavic Materials, 1976.

————. *Exact Resemblance to Exact Resemblance: The Literary Portraiture of Gertrude Stein*. New Haven, Conn.: Yale University Press, 1978.

————. "The Case for Unclear Thinking: The New Critics versus Charles Morris." *Critical Inquiry* 6 (winter 1979): 257–69.

Stewart, Susan. *Nonsense: Aspects of Intertextuality in Folklore and Literature*. Baltimore: Johns Hopkins University Press, 1979.

Sutherland, Robert D. *Language and Lewis Carroll*. The Hague: Mouton, 1970.

Swift, Jonathan. *Gulliver's Travels*. London: John Johnson, 1927.

Sypher, Wylie. *Rococo to Cubism in Art and Literature*. New York: Random House, 1960.

Todorov, Tsvetan. *The Fantastic: A Structural Approach to a Literary Genre*. Cleveland: Press of Case Western Reserve University, 1973.

Tuve, Rosamund. "Imagery and Logic: Ramus and Metaphysical Poetics." *Journal of the History of Ideas* 3 (October 1942): 365–400.

Uspenskij, Boris. *A Poetics of Composition: The Structure of the Artistic Text and Typology of Compositional Form*. Translated by Valentina Zavarin and Susan Wittig. Berkeley: University of California Press, 1973.

Vallier, Dora. "Malévich et le modèle linguistique en peinture." *Critique* 31 (March 1975): 284–96.

Veltruský, Jiří. "Some Aspects of the Pictorial Sign." In *Semiotics of Art*. Edited by L. Matejka and I. R. Titunik. Cambridge, Mass.: M.I.T. Press, 1976.

Vico, Giambattisto. *The New Science*. Translated by Thomas Goddard Bergin and Max Harold Fisch. Ithaca, N.Y.: Cornell University Press, 1968.

Vodička, Felix. "Literárně-historické studium ohlasu literárních děl." *Slovo a slovesnost* 7 (1941): 113–32.

Walzel, Oskar. "Shakespeares dramatische Baukunst." *Jarhbuch der Shakespearegesellschaft* 52 (1916): 3–35.

Warnke, Frank J. *Versions of Baroque: European Literature in the Seventeenth Century*. New Haven, Conn.: Yale University Press, 1972.

Wellek, René. "The Parallelism between Literature and the Arts." *English Institute Annual*. New York: Columbia University Press, 1941.

————. *Concepts of Criticism*. New Haven, Conn.: Yale University Press, 1963.

White, Hayden. "Historical Text as Literary Artifact." In *The Writing of History*. Edited by Robert H. Canary and Henry Kozicki. Madison, Wis.: University of Wisconsin Press, 1978.

Whorf, Benjamin Lee. *Language, Thought, and Reality*. Cambridge, Mass.: M.I.T. Press, 1956.

Wildman, Eugene, ed. and arranger (in a musical sense). *Anthology of Concretism*. Chicago: Swallow Press, 1969.

Williams, Emmett, ed. *Anthology of Concrete Poetry*. New York: Something Else Press, 1967.

Williams, William Carlos. *Autobiography*. New York: Random House, 1951.

————. *Pictures from Brueghel*. New York: New Directions, 1962.

————. *Paterson*. New York: New Directions, 1963.

————. *Collected Later Poems*. Norfolk, Conn.: New Directions, 1963.

————. *Imaginations*. Edited by Webster Schott. New York: New Directions, 1970.

Wimsatt, W. K., Jr. *Day of the Leopards*. New Haven, Conn.: Yale University Press, 1976.

Wimsatt, W. K., Jr., and Beardsley, M. C. "The Intentional Fallacy." *The Verbal Icon*. Lexington, Ky.: University of Kentucky Press, 1954.

Wölfflin, Heinrich. *Renaissance and Baroque*. Translated by Kathrin Simon. London: Fontana, 1964.

Worth, Sol. "Pictures Can't Say Ain't." *Vs.* 12,3 (1975): 85–108.

Index

257